AN AMERICAN IN EUROPE

VENUES OF THE EXHIBITION

MUSEUM FÜR ANGEWANDTE KUNST KÖLN
COLOGNE, GERMANY
SEPTEMBER 20, 2000 — JANUARY 28, 2001

NORTON MUSEUM OF ART
WEST PALM BEACH, FLORIDA
FEBRUARY 24 — APRIL 29, 2001

MEMPHIS BROOKS MUSEUM OF ART
MEMPHIS, TENNESSEE
MAY — JUNE, 2001

COLUMBUS MUSEUM OF ART
COLUMBUS, OHIO
JANUARY — MARCH, 2002

FRYE ART MUSEUM
SEATTLE, WASHINGTON
APRIL 6 — JUNE 16, 2002

Cover Illustration:
Folkwang-Auriga Verlag/Ernst Fuhrmann
Prunus cerasus (Sour Cherries), c. 1930 (Detail)

ISBN 3-7757-0973-8

"AN AMERICAN IN EUROPE" IS ORGANIZED
BY THE NORTON MUSEUM OF ART,
WEST PALM BEACH, FLORIDA

AN AMERICAN IN EUROPE

THE PHOTOGRAPHY COLLECTION OF BARONESS JEANE VON OPPENHEIM FROM THE NORTON MUSEUM OF ART

WITH ESSAYS BY
JAMES D. BURKE, GUEST CURATOR
AND BARONESS JEANE VON OPPENHEIM

FOREWORD BY
CHRISTINA ORR-CAHALL
DIRECTOR, NORTON MUSEUM OF ART

CONTENTS

CHRISTINA ORR-CAHALL

"An American in Europe: Baroness Jeane von Oppenheim and Photography" is an exhibition drawn from the almost 700 photographs donated by the Baroness to the Norton Museum of Art at the eve of the 21st century. With her marriage 39 years ago to Alfred von Oppenheim, now the senior member of the Oppenheim banking family, Jeane knew that she had to assimilate fully into Germany. Using her knowledge of photography, Jeane sought to understand the culture from the inside out. If she knew what the artists were thinking, she would understand the historic and contemporary fiber of the country.

If she could practice the language in her own environment, she would become fluent. If she could contribute to Germany's awareness of its photographic heritage, she could feel a part of the whole. If she could transcend the borders and bring German photographers into greater focus in Europe, maybe she could help the artists. If she could amass a collection which accurately represented the gist of European photography in the 20th century, she could consummate her love affair with the medium and advance scholarship. If she could contribute this collection to a museum in her mother country, she could share her hard-won knowledge and her cultural understanding of Germany and Europe as an ambassador-at-large. And, Baroness von Oppenheim has achieved all of this and more, with the greatest humility. In selecting the Norton Museum of Art as the destination for her gift, she has transformed, in one fell swoop, a fledgling photography collection into one of worldclass note.

The Norton Museum is most grateful to Baroness von Oppenheim. We are grateful for her generosity and her understanding of true philanthropy which involves giving the best that you have while enduring the pain of parting in order to meet the greater good – sharing with the public. We appreciate her willingness to work alongside our curators and our guest curator, Dr. James Burke, to produce this exhibition and catalogue. There is no one more knowledgeable about these works and these photographers than the Baroness. Her thoroughness in research is to be commended. Indeed, Baroness von Oppenheim has also gifted the Norton her library which is essential to our custodianship of her collection and for those visiting scholars who wish to conduct further research. The Museum is also grateful to Jeane for her continued support for the acquisition of photographs. But, above all, we have learned that we have a friend in Jeane von Oppenheim, one who shares our mission, respects our role, represents us ably, and speaks on the international stage on our behalf. Through her gift we have come to understand Germany and Europe in an enlightened way, as we can see through her American eyes the unique contributions of the medium which will most closely be associated with the 20th century.

Many people have played signature roles in the development of this exhibition and publication. In particular, the Norton Museum would like to thank Dr. James Burke, the recently retired Director of The St. Louis Art Museum and a photography scholar, for his catalogue essay. The artists' biographies were carefully researched and prepared by Gérard Goodrow to whom great thanks are due. Dr. Victoria Scheibler has done an outstanding job of editing the publication in both English and German, while Natalie Gaida so accurately researched and prepared the checklist of exhibited works and the bibliography. Photography for the catalogue was the work of Friedrich Rosenstiel, the quality of whose work clearly speaks for itself in this publication. The Museum is also most grateful to the publishers, Hatje Cantz Publishers, who have produced exceptional books to accompany this exhibition and collection.

Funding for this project has come from a variety of sources, including the Alfred Freiherr von Oppenheim-Stiftung zur Förderung der Wissenschaft, to whom we are most grateful for the support of the publication. The Ralph H. and Elizabeth C. Norton Philanthropic Trust has also provided support for the research and presentation of the exhibition and collection.

Staff at the Norton Museum who are to be acknowledged for their work on this project include Chief Curator, Dr. Karl Willers; Former Chief Curator, David Setford; Curatorial Assistant, Tara McDonnell; Assistant to the Director, Jane Wattick; Registrar, Pam Parry; Assistant Registrar, Kelli Marin; and Assistant Curator of Education, Jerry Dobrick. Early research work was provided by Christian Gerstheimer, a graduate art history intern at the Norton from the University of Michigan. Sarah Flynn, our Director of Public Affairs and Marketing, has also played a significant role.

In Europe, the Norton Museum is very grateful to Dr. Susanne Anna, the Director of the Museum fur Angewandte Kunst, whose vision brought this exhibition to Germany as the showcase for "photokina." Dr. Anna selected 300 works for presentation, while the American version of the exhibition will feature 125 works. In the United States, the Norton is grateful to the following museums who will participate in the exhibition's tour. In particular, we give special acknowledgement to their directors: Kaywin Feldman, Director of the Memphis Brooks Museum of Art (May – July, 2001); Irvin M. Lippman, Director of The Columbus Museum of Art (January – March, 2002); and Richard V. West, Director of the Frye Art Museum (April 6 – June 16, 2002).

The Norton Museum is pleased to present these exhibitions of the Baroness von Oppenheim Collection at the Norton Museum to an international audience. We know that the first opportunity to view this extraordinary collection will be welcomed by the informed photographic community and by the museum-going public. We are honored to have this collection and we will use it wisely and well.

West Palm Beach, Florida
Christina Orr-Cahall, Director
September, 2000

AN INNOVATIVE COLLECTION: REFLECTIONS ON 100 YEARS OF PHOTOGRAPHY

JAMES D. BURKE

A capsulate of twentieth century photography in Germany and central Europe, the collection of Baroness Jeane von Oppenheim reflects the main artistic forces of that time. Germany has enjoyed an active history in this art form, an innovative nation in the art of the camera. For decades, German photographers prospered, and the medium developed both in its scientific and artistic aspects. Artistic movements and counter-movements rose and fell in the world of photography as in the other arts. The core of this collection, images dating as early as 1900 and extending to the 1990s, illustrates the major issues. Here we find the dramatic abstractions of "new vision" photography, the carefully observed documents of Renger-Patzsch and his followers, postwar images of loss and renewal, and the disciplined observations of the Bechers and their followers: the whole course of German photography in the twentieth century.

The grandfather figure is Karl Blossfeldt. He studied in Berlin at the Royal Academy for Decorative Arts, in the early days of the *Jugendstil* movement. By the mid-1890s, new art was closely based on the detailed observation of plant forms; all kinds of art and architecture were covered with swirling motifs derived from the graceful curves of plants.

In the 1880s, Blossfeldt worked as an assistant in a seven-year study photographing plant forms, not for botanical but rather for artistic purposes.[1] Continuing until the late 1920s, Blossfeldt photographed details of such plants, in order to acquaint his students with firsthand images to inspire their designs. His photographs were initially conceived as lantern slides for teaching art in the era when the *Jugendstil* philosophy was certain that every art form derived from Nature. The idea quickly became a consuming passion for Blossfeldt, who made hundreds of such photographic studies, tirelessly seeking every possible visual aspect of the botanical world. Finally, in the twilight of life, his famous book *Urformen der Kunst (Art Forms in Nature)*

was published in 1928 to great acclaim, and the modern photographers heralded him as one of their own.[2]
Blossfeldt often altered the plants, removing leaves or blossoms, photographing cross sections, and taking other liberties with his subjects. The uniform backgrounds and standardized formats seem cool, neutral and elegant. We see the images as form and design, and are invited to omit our knowledge of botany. Their serial character, the aggregate of their images is important; it is not only derived from science but also intrinsic to the art of the later twentieth century. Blossfeldt's photographs possess a perfection of form; they enter the Modernist age.[3]

Ernst Fuhrmann also made plants the subject of photographs, although he made no photographs himself. He was consumed with a passion for knowledge about the basic elements of the botanical world, in which he saw the underlying knowledge of all things. If only he could study and see it, all would become known in the unknowable. He was a close friend with Albert Renger-Patzsch and Lotte Jacobi, who made images for him, although it is known that he closely directed the images that today appear associated with his name.

No two Fuhrmann images seem the same, but is that a matter of choice or of the photographer? Some are formally perfect, with crisp details that approach Blossfeldt's (No. 24); some are clinical and confused in the extreme (No. 31). Some look like botanical specimens (No. 25, *Sour Cherries*), some like parts of animals (No. 28). Random, wildly diverse, messy and never uniform, Fuhrmann's pictures are unpredictable and disarming. Their very awkwardness and disparate nature speak volumes about modern science and the products of a restless mind, seeking order in the natural world.[4]

The most famous figure in German photography between the wars is August Sander. Established in his own studio in

Cologne, Sander commenced an ambitious sociological study of the German people by the end of the First World War. There he would describe, as an anthropologist with a camera, the many classes and professions of the people of his own time. Eventually, this would be published as *Menschen des 20. Jahrhunderts (Men of the 20th Century)* in 1980. In 1929, he had published a forecast in his small book, *Antlitz der Zeit (The Face of Time)*, a selection of sixty portrait images.

Some are simply portraits, closely related to conventional studio portraits from the twenties or thirties (No. 75). Some are persons photographed in the course of their jobs (No. 73, *Flute Quartet of Brühl*). Some are persons in scenes, notably the Westerwald region farm people photographed in the out-of-doors (No. 80, *Farm Girls from Westerwald,* 1927). Some are only faces. Some have names (No. 78, *The Painter Anton Räderscheidt,* 1926); most do not. All are types, each image standing for or in a category in the sociology of Cologne and its region.

The images are not retouched, as so much portrait photography was then. They are factual. They are not conventional studio portraits designed to please their customers; Sander asked people to pose for him. The people appear with an unflinching eye, under a gaze that never seems to blink. Many subjects stare directly into the camera; they are often considered to be Sander's best images (No. 77). These works, then so uncompromisingly real, are often compared to *Neue Sachlichkeit* art, a confrontational realism that appeared in German painting after 1918.

Sander's frank images of people simply do not conform to the racial stereotyping of ideal physical traits that were such a hallmark of National Socialist propaganda. The types were too tall, too skinny, too stout, and too rustic to conform to the Nazi obsessions with youth and sports fitness. They are hardly "Nordic" types. Predictably, shortly after Hitler came to power as Chancellor, the government ordered Sander's book removed from circulation and the unsold copies destroyed.

As documents, Sander's images live on, objective and true. He was one of the first prominent photographers to adopt a "documentary style," as the American photographer Walker

Evans was later to name it. Germany had a huge communications industry after 1918 with many lively weekly newspapers and magazines illustrated with photographs, which reported news and features of the day. But Sander's work stood apart from glossy photojournalism, in its lack of pretense. Today, with the benefit of several decades of documentary photographers and filmmakers to draw on, we find Sander one of the clearest spokesmen for this approach in the twentieth century. Sander saw in these images the faces of the people of Cologne and the Westerwald, in all their hopes, joys, seriousness, humor and forthrightness. We don't see the faces of the Nazi propaganda posters here.

With his humane book banned, Sander turned to a less politically charged subject, the Westerwald landscape. Through most of the late thirties and the first half of the forties, he made a fine series of images of the Siebengebirge, the Rhine valley, and the intimate places of the regional farmland (Nos. 84–93). There is also a small group of nature studies, plants and clumps of vegetation in natural settings. At the onset of the War, the Sanders moved back to the country, and their city house, containing thousands of negatives, was destroyed in the bombing.

After 1945, and a group of photographs of the ruins of his beloved Cologne, he abandoned any new work and devoted himself to printing his old negatives. As was the case with Blossfeldt, the critics hailed his serial approach, the very ambitious scope of his huge undertaking, as an indicator of his greatness.

Today, it is hard to recall that these images were made in a terrible period of social upheaval, unimaginable inflation, immense unemployment, political violence and unrest. After all, Germany in the period immediately following 1918 was near chaos, with political consensus absent, and the arts moving in many disparate directions. By the mid-twenties, the economy had settled into some degree of recovery, but political life was uncertain. Sander's world does not reflect this. He has removed himself from domestic events to study people and their place in the society. And although the images are certainly documentary, any sense of current events is strangely absent, with the noteworthy exception of a small group of portraits of persecuted persons.

The New Vision and the Bauhaus

The great avant-garde movement in photography in the first half of the century was centered at the Bauhaus, a new school of art that stressed the concept of design. Founded just after the First World War, the Bauhaus masters included some of the most important figures in twentieth-century art: Paul Klee, Wassily Kandinsky, Walter Gropius, Josef Albers, László Moholy-Nagy, Johannes Itten, Herbert Bayer. The individual art forms were downplayed – painting, sculpture, printmaking, architecture, photography, graphic design and filmmaking – subsumed into teaching the principles of design, and enabling the students to work in many media while exploring modern design aesthetics that broke with the old ways.

At the same time as the Bauhaus, many new ideas were quickly developing in art and photography, inspired by changes in technology and society. Photography was used extensively in advertising from the early 1920s, giving rise to new visual forms. Graphic designers worked with photos as never before. The rise of photo-illustrated journals and magazines created a huge demand for images, and expanded the public perception of photography as a medium. Photography was immensely popular, resulting in many exhibits and trade fairs for professional and amateur alike. In Europe and in America, the years between the world wars saw the rise of photography as a hobby, an expanded market for products.

Coupled with revived consumer production, the later years of the Weimar Republic had a lively mercantile culture, despite inflation. Much was made of the modernity of new products, new packaging, new media and the new infatuation with the machine. Automobiles, trains, airplanes, radio and print media all were influenced by the aesthetic love of machines and machine-like images. Photography was perceived as a modern item, too. The camera, made in new designs and in new smaller sizes, could appeal to consumers as a modern product; this modern machine could make modern images.[5]

The Bauhaus' catalyst was László Moholy-Nagy, a protean artist who moved easily between media. Although head of the metalworking shop, he is mainly remembered for his tracts and experiments in photography. He was the philosopher-king of the "new vision", as he named it. He saw the world as a design challenge, an opportunity to reorder the world into pure planes of abstraction, first in his paintings and watercolors, later in photography and graphic design.

Moholy-Nagy believed that painting was at the end of its validity as an art form. He wrote articles embracing photography as the new art form, surpassing all others. Moholy-Nagy's influential book *Painting Photography Film* (1925) boldly announced that the creative leadership of art had transferred to photography. He believed that the world of technology would completely transform art. His essays were polemical, but they positioned him as the spokesman of the new art style. In photography, he could see the world through the camera's eye as planar organizations. The "new vision" turned out to be short-lived, a stylish vogue that had mostly run its course by the early thirties.[6]

The collection of Jeane von Oppenheim includes a large group of artists who were at the Bauhaus: Kattina Both, Alfred Ehrhardt, Florence Henri, Lucia Moholy, Lotte Stam-Beese, UMBO (Otto Umbehr) and WOLS (Alfred Otto Wolfgang Schulze). Often Constructivist in nature, often more closely related to "pure design" as taught by Albers and others, they were the pioneer generation in modern art.

Kattina Both was a student at the Bauhaus from 1924 to 1928, and took her design principles course under Moholy-Nagy; she eventually practiced as an architect. Her photograph of shoes in a drawer (No. 18) has the strong diagonal organization of "new vision" photographs, so much that the first impression is not of shoes at all, but of planar and linear composition.[7]

Nature was the inspiration for Alfred Ehrhardt's photographs (Nos. 20 and 21), where tiny waves of sand in the seaside flats appear as abstract compositions. He found beauty in the natural world, but guided the lens to find abstracted patterns of landscape. These were influenced by Josef Albers' photographs of similar subjects made about 1929; Albers was his teacher for the Bauhaus preliminary course in 1927–28. Ehrhardt's career and publications were devoted to landscape and nature, a rich exploration of the quasi-abstract microcosms of the natural world as seen by his camera.[8]

The wife of Moholy-Nagy, Lucia Moholy, who was the photographer for Bauhaus publications, edited and translated the articles and manifestos of her husband, did darkroom work for him, and made portraits of Bauhaus teachers and friends. She joined her husband in photographic experiments in the early twenties, which produced the brilliant photograms. Having taken a photography course, she had the technical skills he lacked. In her Bauhaus portraits of the 1920s, faces fill up the pictorial space and thus have a striking emotional intensity (Nos. 47 and 48). This close-up format seems to be her unique invention and, although quickly adopted by many other photographers, is considered a Bauhaus hallmark today.

An ideal representative of Bauhaus photography in its inseparable relationship to design, is the unique photograph by Lotte Stam-Beese included here (No. 100). It depicts an abstract paper construction made for the preliminary course in 1927 as taught by Josef Albers, made more abstract by means of the strong 45-degree camera angle. Her photograph is exactly in the "new vision" aesthetic, with its patterns of light and dark, gear-like forms and strong diagonal planes.[9]

Florence Henri was a student at the Bauhaus in Moholy-Nagy's preliminary design course in 1927. Drawing from her Paris background in Cubist art, she devised architectural elements, sheets of paper and mirrors to divide up the picture surface into abstract planes. Each had differing diagonals in composition, with their shifted perspectives and irrational spaces. Some have the Cubist penchant for multiple views of the same object. Even when she turned to advertising for clients like Jeanne Lanvin, the images have a strong abstract arrangement.

In 1928, no less than Moholy-Nagy wrote an essay of appreciation for her work. By 1929, she was included with many of the Bauhaus masters in the notable "Film und Foto" exhibit, part of the "Deutsche Werkbund Ausstellung," an exhibition of global importance, in Stuttgart. In the same year, her work was seen in the influential "Fotografie der Gegenwart" (Contemporary Photography) exhibition at Essen, which later traveled to Hannover, Berlin, London, Vienna and Dresden.

In the thirties, her photographs included photomontage, a collage of photographic images themselves rephotographed in still life compositions, again with mirrors and clear rectilinear planes. Her reputation only increased, as she had a one-person show in Essen (1933), and enjoyed inclusion in major shows in New York, Paris, Basel, Amsterdam, London, and Copenhagen in that decade.[10]

UMBO (Otto Umbehr) was a student early in the history of the Bauhaus, from 1921 to 1923, but was expelled for his "lack of interest."[11] After a checkered start, he set up as a portrait photographer in 1926, making a series of dramatic, even startling close-up portraits. His brilliant images included montages, multiple exposures, night scenes, and photographs of the bohemian life in Berlin. He made some of the best photojournalist images seen in the German magazines, and photographs for advertising clients.

In 1928, when one of his friends was working in a firm that made display window mannequins for department stores, UMBO photographed them (Menjou en gros, No. 102). Five of these images were exhibited in the Stuttgart exhibition, a group was reproduced in a series for a Frankfurt illustrated magazine in 1929[12], and again in "Gebrauchsgraphik, International Advertising Art" in 1930. In 1932, some were shown in the famous surrealism exhibition at the Julien Levy Gallery in New York.

The remaining important photographer who studied at the Bauhaus was WOLS (Alfred Otto Wolfgang Schulze). Today he is mainly known for his avant-garde paintings that emerged after 1945.[13] He was a student at the Bauhaus in 1932–33, and moved to Paris afterwards and began to photograph. He published in fashion magazines, and was the photographer for the Pavillon de l'Elégance at the Paris World's Fair.[14]

WOLS seems to represent a new generation, for his photographs leave Bauhaus values behind. The Paris views, with architectonic order, are closest to the "new vision," yet have a psychological distance from people and things. There are urban views with homeless people (No. 115), seen from above.

Probably dating from 1933–35, WOLS made a series of heads of models (Nos. 118, 119, 122 and 124). By carefully masking out the background with black fabric, he displays only heads, floating and ideal, but somehow unearthly. Their striking beauty is distancing from the viewer, as they look away, disengaged. It seems to herald a new kind of portraiture, slightly surreal and absolutely new. They are tangible yet caught in a dream.

The most perplexing of his photographs occur at the outbreak of the war, around 1938. WOLS was a German living in Paris who had refused conscription and was thus labeled as a deserter. Somehow at that uncertain time, he made photographs of what he ate: the slice of bread, the baguettehead and the beans, etc. (Nos. 128, 126 and 127). Photographed on the floor, from above, or on the edge of a beat-up table, they are ironic artifacts that will soon be consumed. "He went shopping and cooked..." his wife later reported, "but first everything was photographed."[15] They are ghastly, tragic, deeply moving. They imply a state of despair. There is even a bucket with a dirty rag (No. 129).

Nothing else in photography seems to approach them. They represent a new form of art: existential, derived from Surrealism. They coincide with Jean-Paul Sartre, whose writings WOLS knew and admired.[16]

The Dutch photographer Piet Zwart (1885–1977) was self-taught, and had been in touch with the artistic movements of abstraction in The Netherlands. In 1929 he visited the Bauhaus as a guest lecturer. By then, he had an established career as a designer and photographer, infused with Constructivist design styles. Zwart's industrial photograph of a factory scene with high-tension wires and a smokestack (No. 132), with its raked angle of perspective, strong contrast and emphasis on machine forms, fits the "new vision" exactly. Zwart was multi-talented, designing industrial products and advertising. His photographs were shown in many exhibitions, and he was responsible for the Dutch entries in the benchmark "Film und Foto" exhibit at Stuttgart in 1929.[17]

Related to the Bauhaus are two documentary photographs from the famous "Triadic Ballets" (Nos. 34 and 35). With music by Paul Hindemith, and sets and costumes by Oskar Schlemmer, they represent the major effort of Schlemmer's artistic output in the early to mid-twenties. In this production, which Schlemmer developed over ten years, figures were abstracted or took forms derived from machines. Calling the figures "living machines," the dances included costumes made of ellipses and spirals, circles and ovals, in addition to more solid forms. They were, in effect, sculptures in motion. Today, Schlemmer is primarily remembered as an important painter and sculptor, although the drawings for the figures still exist, along with diagrams for the dances.[18]

Other New Visions

Following the example of her father, grandfather and great-grandfather, Lotte Jacobi began to work with a pinhole camera at age eleven. After a brief study of acting and an unsuccessful marriage, she moved with her family to Berlin. She finally entered the photography technical school at Munich in 1925, at age 29. Lacking art training, her early images are conventional types of the time. After she established her own studio in Berlin in 1927, she frequented the theater world. In 1928 and 1929, she purchased her first mini-cameras; these new inventions greatly changed her style of working. With their greater portability and ease of use, the snapshot was possible, in wider lighting conditions than before.

Jacobi was in demand by the magazines and illustrated weeklies, where her work appeared with frequency. She covered celebrities and all sorts of plum assignments in the competitive world of the professional photojournalist. The superb portrait of Lotte Lenya (No. 39), taken during a break in rehearsals for *The Three-penny Opera* in Berlin, 1928, was possible only because of her familiarity with the cast and the (then little known) actress, and the versatility of the small cameras.

From 1928 to 1932, she photographed modern dance. Utilizing the fast shutter mini-cameras, she sought to capture movement (No. 38), letting shadows and light from windows cut the image into parts. Jacobi's photographs were less regimented than "new vision" art, and more grounded in tradition while still being modern.[19]

The Czech photographer Adolf Schneeberger (1897–1977) was known for unretouched, straight images and participated in the major exhibits of modernist photography in Czechoslovakia in the 1920s. Around 1930, he made a series of abstractions of film spools with long shadows to create a kind of constructed image that he could photograph (No. 99).[20] This had a "new vision" look. Czech photographers were leading figures in the new photography in the twenties, and Schneeberger had been exposed to these advanced ideas.

Graphic design and architecture were the arts most closely allied with photography as it approached its Constructivist vision. Anton Stankowski was trained in Essen, where he studied photography and graphic design. During his studies, he made brilliant photograms, images made by exposing objects against light-sensitive paper in the darkroom. Pattern and design are paramount (No. 101), graphic design at its most basic. Later, Stankowski would head the design studio for a Zurich advertising agency from 1929 to 1932, working with the most important figures in Swiss graphic design, Herbert Matter and Max Bill.[21]

Willy Zielke studied photography in Munich, where he made beautiful light abstractions and still images with delicacy and precision. These were in demand for advertising, with their elegant balance between abstraction and realism (No. 131). He was a notable filmmaker, producing the first part of Leni Riefenstahl's film *Olympia*.

The Russian photographer Alexander Rodchenko is acknowledged to be one of the world leaders in the new photography. Through close connections to the Russian Constructivists, he began to make photomontages in the early 1920s. He soon took up photography, first absorbing the photojournalism of the photo-illustrated weeklies. His brilliant work ran from photojournalism to portraits that have a strong aspect of the new objectivity of the 1920s about them; he was indirectly aware of the avant-garde movements in Germany.

His most famous images have the "Rodchenko foreshortening" about them, a unique ability to find startling, nearly abstract angles and dramatic, even radical perspectives.[22] There is no better example of his dynamic angles than the *Ladder*, 1925 (No. 69); the image is turned upside-down for effect. It thus becomes a composition of rectangles and lines. His photograph of *Stairs*, 1930 (No. 70) takes from the observed world a scene that can be tilted and abstracted, giving it a graphic appearance. This alone was a radical approach, much admired by his contemporaries, one of whom remarked, "the camera can see things that man is not accustomed to seeing."[23]

Born in Hungary, André Kertész worked in Paris from 1925 until 1936. With friends like Mondrian, Léger and Chagall, he joined in the Paris vanguard. His images are decidedly modern, and often used the angles and tricks of the new vision photographers. His most remarkable images, such as the streetscape called "*Du-Dubon-Dubonnet*" after the wall advertisements in it (No. 42), seem to belong to a new genre. There is a subjective reality at work, a contrast between the stylish advertising, displayed in such an abstract and artful manner, and the emotions of the people on the sidewalk. Witty and urbane, it records a brief moment of perception. In this, he is related to the photographers of decisive instants, like Henri Cartier-Bresson. He was a major contributor to the German illustrated weeklies, and was sought after by the magazines and picture agencies.[24]

Clearly the most important figure in German photography between the wars alongside August Sander, was Albert Renger-Patzsch. He photographed plants with Ernst Fuhrmann, joined a picture agency in Berlin, and became an independent photographer by 1925. His best-known book, *Die Welt ist schön (The World is Beautiful)*, was published in 1928, a collection of images of both the industrial and natural worlds, suggesting that their aesthetic footing was equal.[25]

Renger-Patzsch's images are descriptive and always precise. His photographs are purposeful, like the small detail of a staircase in a modern house (No. 67). Some are industrial scenes (No. 65); unlike his Bauhaus contemporaries, their function is readily evident. He represents the antithesis of the dramatized Bauhaus "new vision" style. In the clear image of an ice cream sundae in its cup (No. 64), what he called his "joy before the object" is evident.[26] The object is the center of our attention, a fact standing before us, yet inviting our close inspection. As a response to "new vision" abstraction, Renger-Patzsch's generation wanted the truth told by a camera that would not mimic either

painting or graphic design, that would somehow stand on its own.

Renger-Patzsch established a visual philosophy that would endure through the rest of the century. During his varied career, he photographed historic buildings (No. 63), nature, landscapes, industrial sites (No. 65) and people. "The absolutely correct rendering of form, the subtlety of tonal gradation from the brightest highlight to the darkest shadow, impart to a technically expert photograph the magic of experience. Let us therefore leave art to the artists, and let us try to use the medium of photography to create photographs that can endure because of their photographic qualities..." he wrote in 1927.[27]

Another Vision

Dr. Paul Wolff, who left medicine to become a fulltime photographer in 1926, was an enthusiastic advocate of the new Leica 35 millimeter cameras first introduced in that decade. Derived from motion picture cameras, they were small, lightweight and offered a new vehicle to explore. Wolff published a book on his Leica photographs in 1934, and in another book (1938) dared the viewer to guess if the images were made with a large or small format camera, cementing his role as an advocate for amateur photography.[28]

Wolff was politically in favor with the National Socialists, and his career thrived when Hitler and the Nazis came to power. He was commissioned to photograph for propaganda books on the glories of industrial production. His photographs of the 1936 Olympic games at Berlin were published in Paris and New York (No. 105).[29] He photographed for his own agency, making images of developments such as the new Rhine Bridge at Duisburg (No. 113). There are even a few images from a series on textile industry production, made during the war, which mimic the "new vision" photographers (Nos. 110 and 114).

Wolff's most characteristic photos look like an amateur took them. There are a lot of images of sports (No. 109), and the Hitler Youth (No. 104). His work includes many images made for the group travel and vacations of the "Kraft durch Freude" (Strength through Joy) organization under the aegis of the Nazi government. These, and his images of attractive models enjoying sports in the outdoors (No. 112) were made for Nazi propaganda.[30]

After the War

One notable Cologne photographer, Hermann Claasen (1899–1987) managed to photograph during the war with a hidden camera. After the war, he made a series of photographs of the ruins of his home city (No. 19), later published as a book.[31] There was much documentary photography of ruins after the war in Germany, but few have the human touch of a person displaced as in this image.[32]

Karl Hugo Schmölz (1917–1986) provided some of the most lucid images of the spectacle of destruction (No. 96); he made a specialty of photos of the Cologne Cathedral, eventually publishing a book on it.[33] For a few years after the war, the competing philosophies of the twenties and thirties gave way to a time when documentary images prevailed.

Advertising and fashion photography were soon revived, as consumer production increased. F. C. Gundlach, (b. 1926) was the leading figure in fashion shoots for magazines and advertising (No. 36); his large photography collection is well known today.[34] Willy Kessels' (1898–1974) image of a box of candy (No. 43) recalls the stylish advertising images of the "new vision" age, which again came into vogue for commercial work in the fifties.

The Czech photographer Vilém Reichmann (1908–1991) came to prominence just before the war, with images like "*Caught in a Snare,*" 1940 (No. 60). Symbolic of the plight of his nation, his work has an emotional charge that is unique. After the War, he documented his city, Brno, in a series of images under the title *Wounded City* (1945–48). In the 1960s, he readapted some imagery from before the war, such as torn wall posters, into photos of unusual power and feeling (No. 62). Later images were lyrical recollections of Surrealism (*Sibilla,* No. 61). Today, he is considered one of the great figures in Czech photography.[35]

Three years after leaving the Düsseldorf Academy of Art, Sigmar Polke (b. 1941), made a series of photographs in

Paris (Nos. 49–58). Having experimented with photography in art school by throwing away the instruction book, Polke's photographs were both art and not art. His paintings, prints and photographs have always worked with images appropriated from film, television, magazines, newspapers, folk art and cartoons, to greater and lesser extents.

His experiments with photography in art school yielded many successful images, slightly documentary in nature, often with multiple exposures or viewpoints, and frequently irrational. They mean more in the aggregate than as single images. Sometimes they refer to the complex image building that transpires in his more compelling paintings. The Geneva prints, seen here, were first printed in that city, in a long session in a friend's darkroom from photographs made earlier on his first trip to Paris. Using a small Leica, he snapped quick images into collages on the negative. Often unevenly printed, containing such imperfections as developer stains, burns, or paper discontinuities, these images, like Polke himself, represent altered states of mind, restless, conflicted, humorous and indeterminate.[36]

Engineered Vision

In the second half of the century, the most important photographers in Germany are the husband-and-wife team of Bernd and Hilla Becher (No. 1). Their collaboration began as students in the Düsseldorf Academy of Art, although the early images appeared only under his name. Today, their work is world-renowned, and since 1976, Bernd Becher has been the Professor of Photography at the Düsseldorf Academy of Art.

Their photographs mainly concentrate on industrial structures and regional vernacular architecture. They seem to continue and expand on the spirit of Albert Renger-Patzsch, who had photographed both industrial structures and the settings of similar industrial townscapes and landscapes in the 1920s and 1930s.

The Bechers concentrated on wooden half-timbered house types as an early subject of their work (No. 2), addressing the buildings in an individual manner.[37] They moved to serial images of mine heads (No. 4), gas tanks, stone crushers, grain elevators, coal loaders, blast furnaces, water towers (No. 9 and 11), tipples, and cooling towers.[38] Each was photographed with a minimum of background, typically provided by a cloudy day, from nearly the same frontal point of view, with a standardized exposure, and absent people. The result is a marvel: the viewer is allowed to focus on the specific and unique characteristics of each structure.

The Bechers inventory a world of structures made by engineers rather than architects. Their building types have taken them from their beginnings in North Germany to Wales, the United States (No. 12, *Findlay, Ohio*), France, Belgium and Japan. We find their industrial discoveries beautiful, a revelation.

Their widely published work has been included in many exhibitions, and praised for its simplicity, serial qualities, and focus. This has been aided by their preference to present the images in grids, sets of nine, twelve or more images of the same subject, arranged to intensify the impact of the type (Nos. 5 and 6).[39]

Their presence at the Düsseldorf Academy of Art has attracted many outstanding students there, including Thomas Struth, Thomas Ruff, Candida Höfer (No. 37) and Jörg Sasse (No. 94).

This collection, assembled over the years by Jeane von Oppenheim, contains many artists and subjects relating to Cologne, where she lives. Photographers such as August Sander, Karl Hugo Schmölz and Hermann Claasen are directly identified with the city, and others, such as Bernd and Hilla Becher and Albert Renger-Patzsch belong to the larger region surrounding Cologne. Still, the collection tells the story of photography in Germany from Blossfeldt to the present, with an emphasis on both the Bauhaus artists and the factual photographers from the 1920s to the end of the century. Whether abstract or factual, with coded messages or documentary facts, the main artistic forces of this fascinating medium are present: the machine that makes artistic images, at its artistic height in the century past. But the machine is nothing without the photographer, the real image-maker. And, the photographer needs the audience in the form of the collector and ultimately, for the worthiest images made, the museum and its public. In the case of the works in this exhibition and the photographers who made them, a

keen eye, in the person of Jeane von Oppenheim, has brought to us just such worthy works. Americans and Europeans may view this exhibition differently, given our cultural roots, but in both instances learning is the result and dialogue is the benefit.

Notes

1 Blossfeldt's photographs of plants were first published in M. Meurer, *Pflanzenformen und Pflanzenbilder*, Dresden 1909.

2 Karl Blossfeldt, *Urformen der Kunst*, Berlin 1928; on the reception of his work, see C. Schreier, "Nature as Art – Art as Nature, Blossfeldt's Photography," in: A. and J. Wilde, eds., *Karl Blossfeldt Photography*, Ostfildern, 1997, pp. 11 f.

3 Ute Eskildsen, "Innovative Photography in Germany between the Wars," in: *Avant-Garde Photography in Germany 1919–1939*, exh. cat., San Francisco Museum of Modern Art 1981, p. 40.

4 Ernst Fuhrmann, *Die Pflanze als Lebewesen*, Frankfurt 1930.

5 On camera technologies see Petr Tausk, *Photography in the Twentieth Century*, London 1980.

6 On photography at the Bauhaus see J. Fiedler, ed., *Photography at the Bauhaus*, Cambridge 1990, which includes a chapter on Moholy-Nagy; *László Moholy-Nagy Fotogramme 1922–1943*, exh. cat., Essen and Munich 1996; Maria Morris Hambourg and Christopher Phillips, *The New Vision, Photography between the World Wars*, New York 1989, pp. 80 f.

7 Fiedler 1990 (see note 6), p. 342; photographs of her, and two of her designs for furniture, appear in: Erich Consemuller, *Fotografien Bauhaus-Dessau*, Munich 1989, pl. 4–8, 87 and 88.

8 Fiedler 1990 (see note 6), p. 344, Van Deren Coke, *Avant-Garde Photography in Germany, 1919–1939*, New York, 1982, pp. 16 f., fig. I, pl. 81–82.

9 Fiedler 1990 (see note 6), p. 341, pl. 140, 150, 163–5.

10 Ann Wilde, "Memories of Florence Henri," in: Fiedler 1990 (see note 6), pp. 54 f.; Diana Du Pont, *Florence Henri, Artist-Photographer of the Avant-Garde*, exh. cat., San Francisco Museum of Modern Art 1990.

11 Fiedler 1990 (see note 6), p. 356.

12 Herbert Molderings, *UMBO, Otto Umbehr, 1902–1980*, Düsseldorf 1995, pp. 133 f.; Reportagen, No. 3.

13 Werner Haftmann, *Deutsche Abstrakte Maler*, Baden-Baden 1953, Carla Schulz-Hoffmann, "WOLS," in: C. Joachimides, N. Rosenthal and W. Schmied, eds., *Kunst im 20. Jahrhundert: Malerei und Plastik 1905–1985*, Munich 1986, pp. 458 f.

14 Fiedler 1990 (see note 6), p. 356.

15 Quoted in: K. Jagals, *WOLS als Photograph*, exh. cat., Von der Heydt Museum, Wuppertal 1978, n. p.

16 The best recent study is C. Mehring, *WOLS Photographs*, exh. cat., Harvard University Art Museums, Cambridge 1999. The author reports only prints in the Gilman Paper Company Collection, the J. Paul Getty Museum, and the Harvard University Art Museums in the United States.

17 Fridolin Muller, ed., *Piet Zwart*, New York 1966; *Piet Zwart*, exh. cat., Haags Gemeentemuseum, The Hague 1973.

18 Oskar Schlemmer, László Moholy-Nagy, Farkas Molnar, *Die Bühne im Bauhaus*, (facsimile reproduction after the original edition of 1925), Mainz and Berlin 1965, p. 27 and 35; Karin von Maur, *Oskar Schlemmer*, exh. cat., Stuttgart 1977, pp. 197 f., repr. P. 221; Nancy J. Troy, "The Art of Reconciliation: Oskar Schlemmer's Work for the Theater," Arnold Lehman and Brenda Richardson, eds., *Oskar Schlemmer*, exh. cat., Baltimore Museum of Art 1986, pp. 127 f., repr. p. 133.

19 Marion Beckers and Elisabeth Moortgat, *Atelier Lotte Jacobi – Berlin – New York*, Berlin 1998, passim.

20 Jaroslav Andel, ed., *Czech Modernism, 1900–1945*, exh. cat., Museum of Fine Arts, Houston 1989, p. 101, 252; The image is related to a poster designed by Schneeberger for the Czech Club for Amateur Photographers exhibit in 1931, and to a photograph in the collection of the St. Louis Art Museum, Olivia Lahs-Gonzales, Photography in Modern Europe, *St. Louis Art Museum Bulletin*, Spring 1996, pp. 54 f.

21 Van Deren Coke (see note 8), p. 28 and 52; A. Stankowski, *Funktion und ihre Darstellung in der Werbegrafik*, Teufen 1967; see also A. Stankowski, *Was ist wenn: 39 Bildpläne mit 1 Foto*, Stuttgart 1990; Stefan von Wiese, ed., *Anton Stankowski: frei und angewandt, 1925–1995: Grafik, Gemälde, Grafik-Design, Gestaltung in der Architektur, Fotografie, Dokumentation*, Berlin 1996.

22 Alexander Lavrentiev, *Alexander Rodchenko – Photography 1924–1954*, Edison 1996, pp. 12 f.

23 Ossip Brik, quoted in: Maria Morris Hambourg and Christopher Phillips, *The New Vision, Photography between the World Wars*, New York 1989, p. 84.

24 *André Kertész, with an essay by Carol Kismaric*, London, Millerton and Paris 1977, André Kertész, *Paris vu par André Kertész*, Paris 1934.

25 Ann and Jürgen Wilde and Thomas Weski, eds., *Albert Renger-Patzsch, Photographer of Objectivity*, London 1997, pp. 171 f.

26 *Albert Renger-Patzsch: Joy Before the Object*. With an introduction by Weston Naef and an essay by Donald Kuspit, New York and Malibu 1993.

27 Quoted in: idem, n. p.

28 Paul Wolff, *Meine Erfahrungen mit der Leica*, Frankfurt/Main 1934 and 1939; Paul Wolff, *Gross-oder-Kleinbild*, Frankfurt/Main 1938.

29 Paul Wolff, *Arbeit! 200 Tiefdruckbildseiten mit Geleitworten*, Frankfurt am Main ca. 1937; Paul Wolff, *Les jeux olympiques Berlin 1936: Dr. Paul Wolff, pionnier du Leica*, (reprint), Strasbourg 1999; Paul Wolff, *Sport shots: Dr. Paul Wolff's Leica: more than one hundred and fifty action photographs of the Eleventh Olypmic Games*, New York ca. 1937.

30 Peter Reichel, "Images of the National Socialist State," in: Klaus Honnef, Rolf Sachsse and Karin Thomas, eds., *German Photography 1870–1970*, Cologne 1997, pp. 74–76, and Rolf Sachsse, "Photography as a NS State Design: Power's abuse of a medium," idem, pp. 89 f.;

Jan Bruning, "Dr. Paul Wolff, ein Fotograf im Kraftfeld seiner Zeit," in: *Fotogeschichte*, 1996, vol. 16, no. 61, pp. 31–46.

31 Hermann Claasen, *Das Ende. Kriegzerstörungen im Rheinland*, with text by Heinrich Böll, Cologne 1983.

32 Hermann Glaser, "Images of two German Post-War States: The Federal Republic of Germany – Examples from the History of Everyday Life," in: Klaus Honnef, Rolf Sachsse and Karin Thomas, eds., *German Photography 1870–1970*, Cologne 1997, pp. 102–121; Reinhold Misselbeck, *Sammlung Gruber, Photographie des 20. Jahrhunderts*, Cologne 1984, p. 219.

33 Reinhold Misselbeck, ed., *Dom-Ansichten: Fotografien des Kölner Doms von Karl Hugo Schmölz: 1939 bis 1962*. Cologne 1997.

34 *German Photography 1870–1970*, pl. 300–302, p. 317; Robert Lebeck, "Foto-Termin ohne Kamera," in: *Art (Hamburg)*, 1996, no. 6, June, pp. 44–49; Ursula Strate, *Déjà vu: Moden 1950–1990*, Heidelberg 1994.

35 Antonin Dufek, "Imaginative Photography," in: *Czech Modernism 1900–1945*, exh. cat., Museum of Fine Arts, Houston 1989, pp. 124–126, 251.

36 *Sigmar Polke Photoworks: When Pictures Vanish*, exh. cat., Museum of Contemporary Art, Los Angeles 1995; Gary Garrels, *Photography in Contemporary German Art: 1960 to the Present*, exh. cat., Walker Art Center, Minneapolis 1992, pp. 25 f.

37 Bernd und Hilla Becher, *Fachwerkhäuser des Siegener Industriegebietes*, Munich 1977.

38 Bernd und Hilla Becher, *Fördertürme, Chevalments, Mineheads*, Munich 1985; Bernd und Hilla Becher, *Gasbehälter*, Munich 1993; Bernd und Hilla Becher, *Hochöfen*, Munich 1990; Bernd und Hilla Becher, *Pennsylvania Coal Mine Tipples*, Munich 1991; Bernd und Hilla Becher, *Wassertürme*, Munich 1988.

39 Bernd und Hilla Becher, *Typologien*, Bonn 1990; *Bernd und Hilla Becher: Grundformen, mit einem Essay von Thierry de Duve*; Munich 1993.

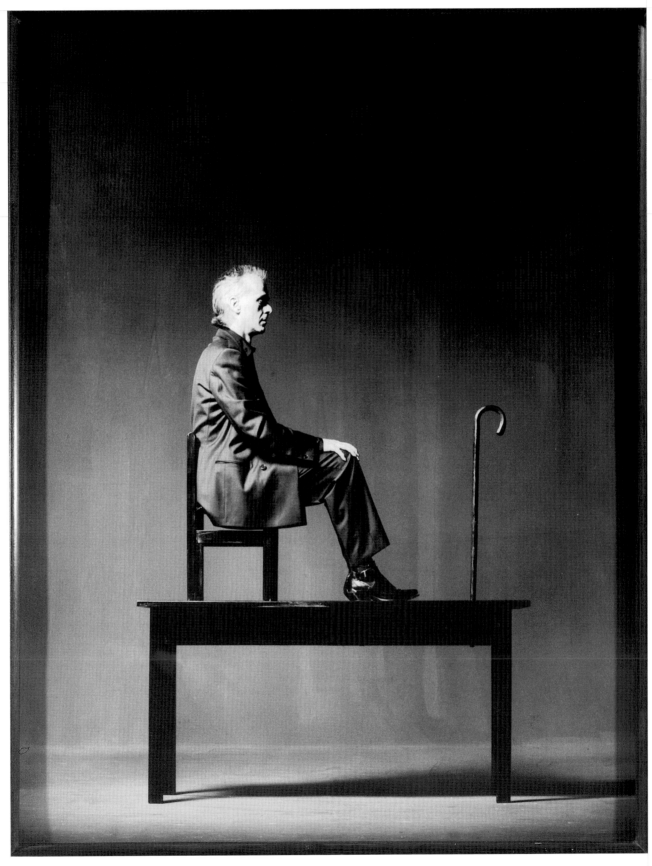

Jürgen Klauke, *Sunday's Neurosis,* 1991 (No. 44)

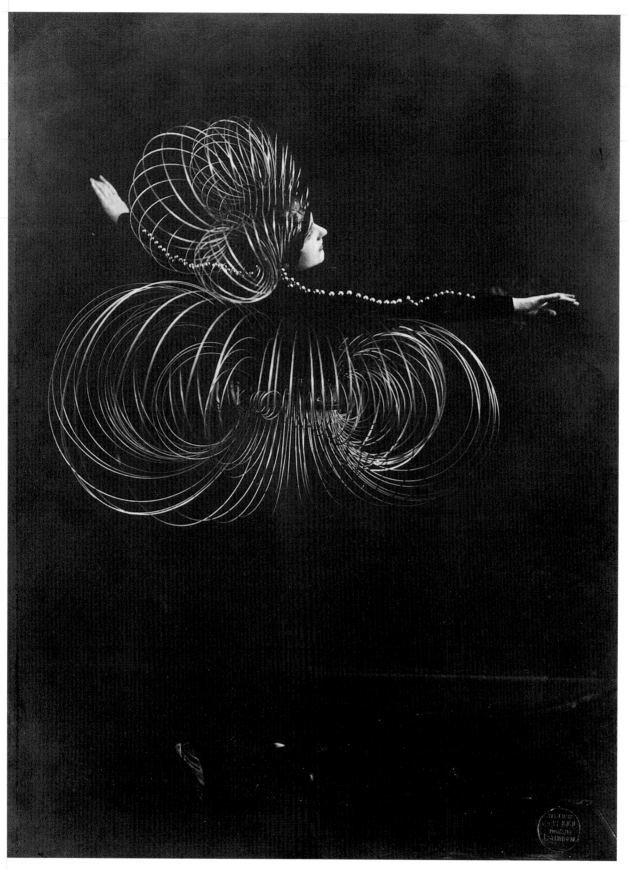

Karl Grill, *Daisy Spies, "Triadic Ballet"*, 1926 (No. 34)

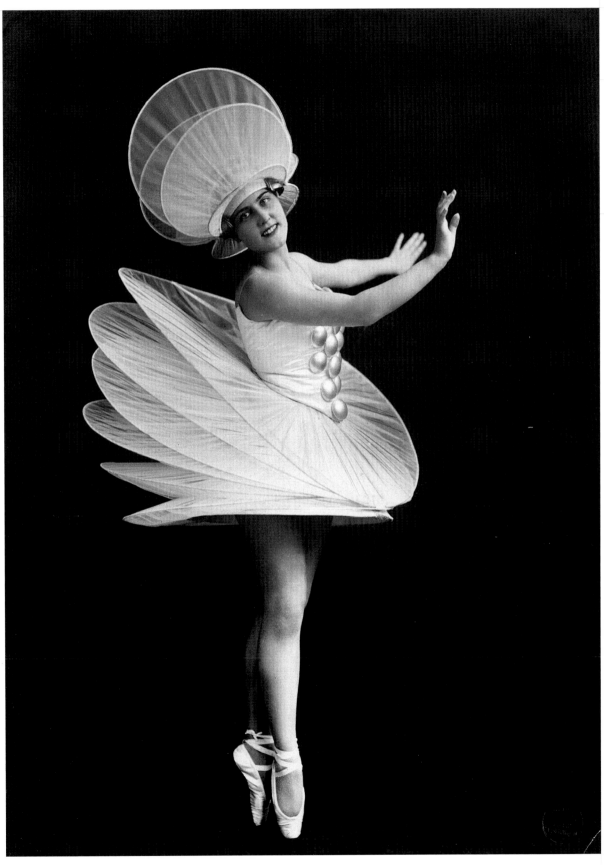

Karl Grill, *Untitled (Daisy Spies),* 1926 (No. 35)

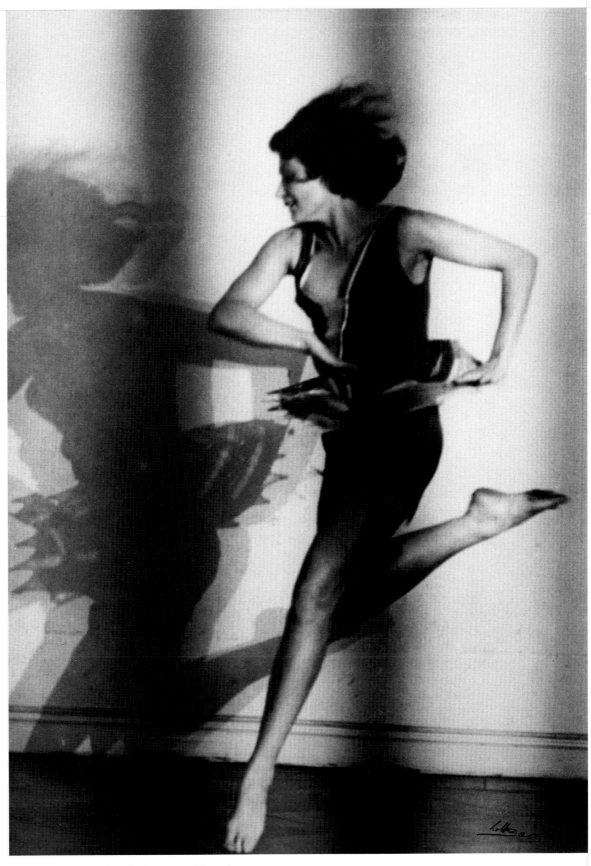

Lotte Jacobi, *The Turn,* 1928 (No. 38)

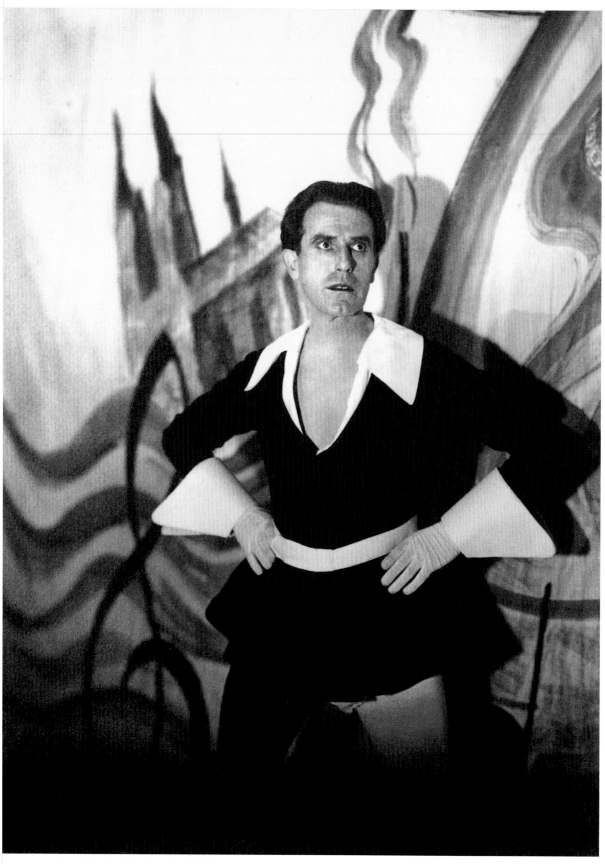

August Sander, *The Actor Carl de Vogt,* 1925–1930 (No. 74)

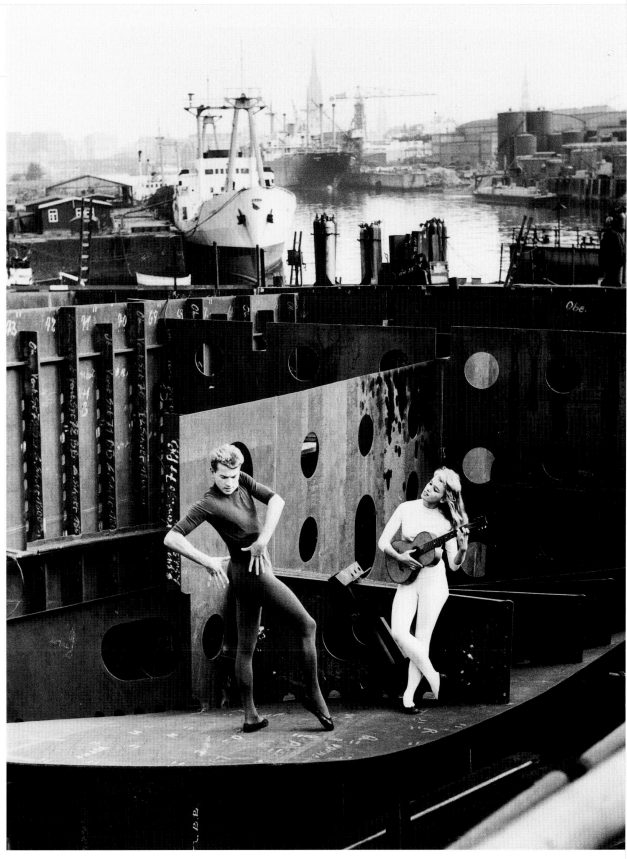

F. C. Gundlach, *Hamburg,* 1957 (No. 36)

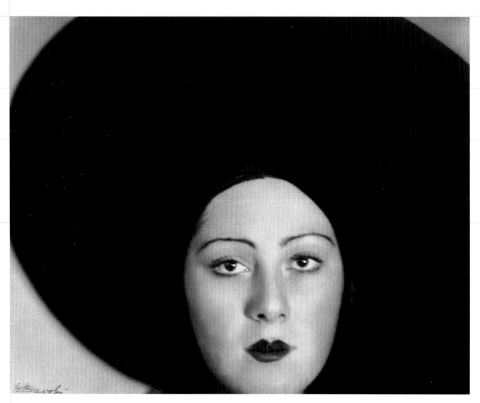

Lotte Jacobi, *Head of a Dancer,* 1929 (No. 40)

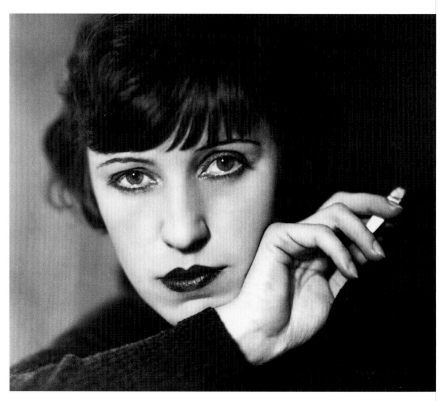

Lotte Jacobi, *Lotte Lenya,* 1928 (No. 39)

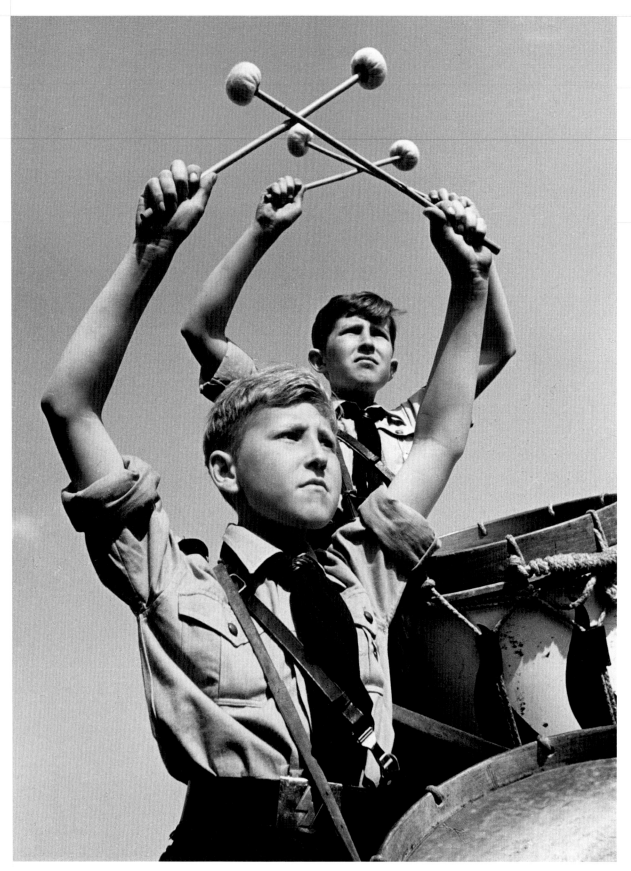

Dr. Paul Wolff, *Hitler Youth,* 1936 (No. 104)

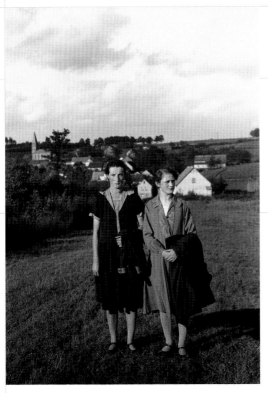

August Sander, *Farm Girls from Westerwald,*
1927 (No. 80)

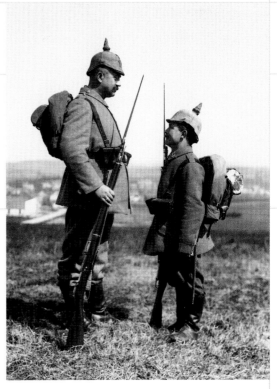

August Sander, *Different Heights of Soldiers,*
1915 (No. 72)

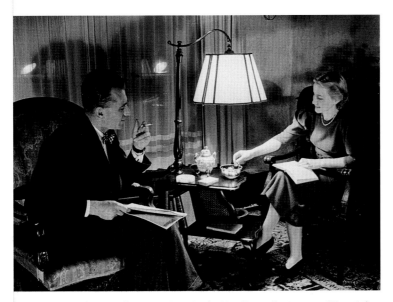

Dr. Paul Wolff, *Conversation in the Evening at Home,* 1937 (No. 107)

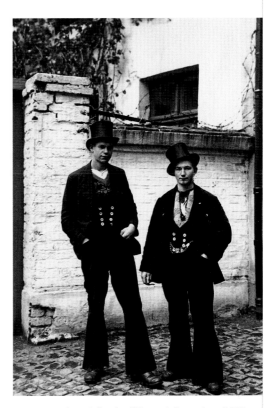

August Sander, *Itinerant Carpenters,* 1928
(No. 81)

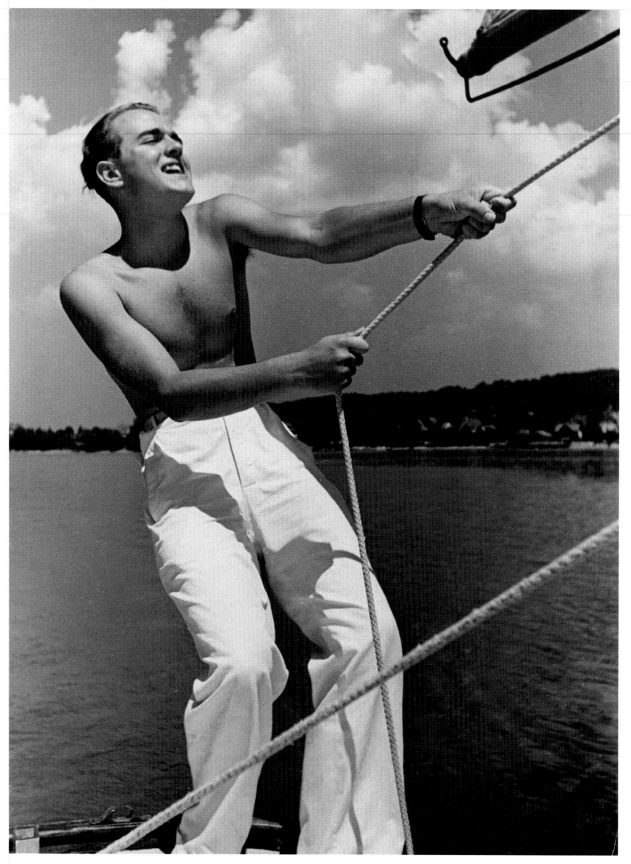

Dr. Paul Wolff, *Enjoying the Holidays, Strong Ropes,* 1937 (No. 109)

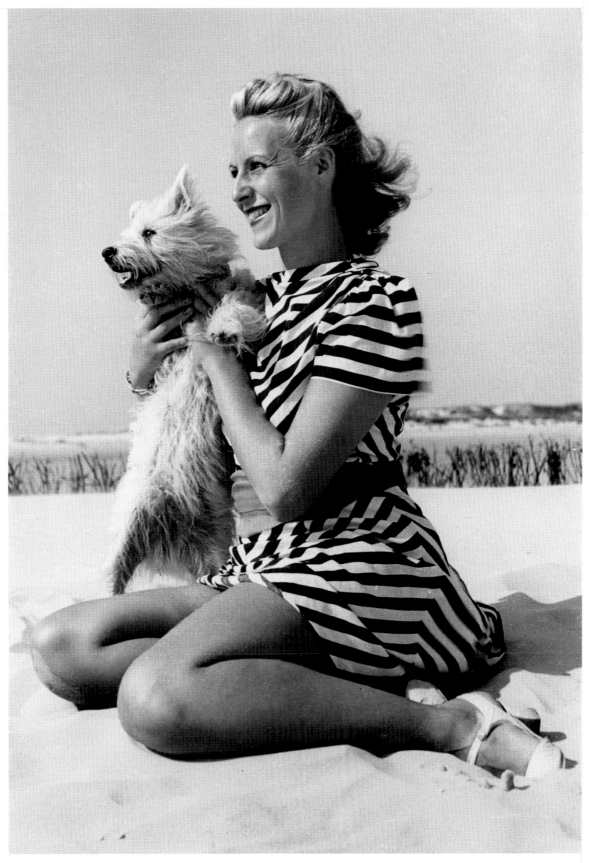

Dr. Paul Wolff, *Holidays at the Seaside at North Sea Beach,* 1939 (No. 112)

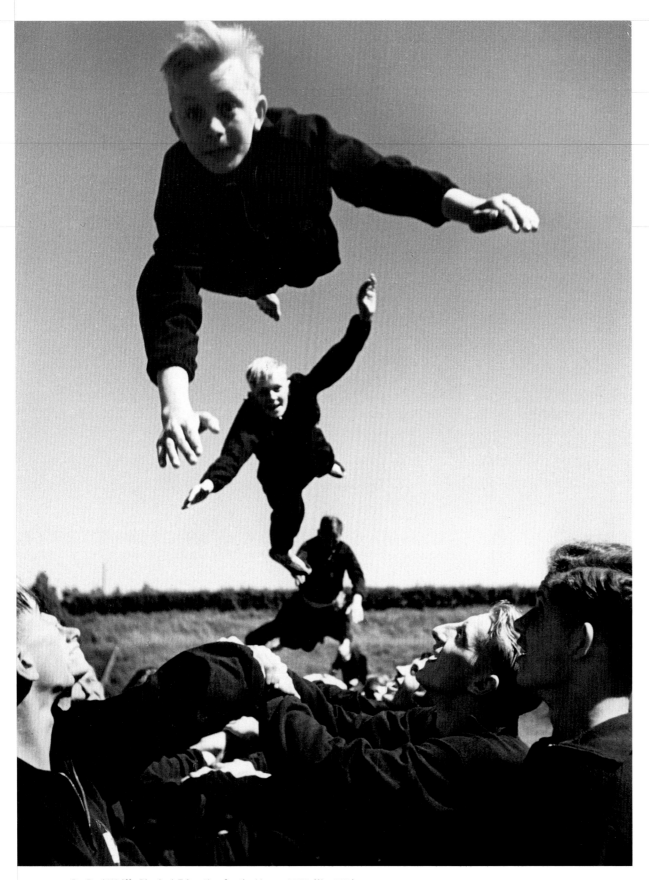

Dr. Paul Wolff, *Physical Education for the Young,* 1938 (No. 111)

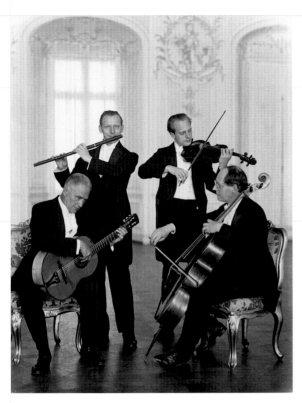

August Sander, *Flute Quartet of Brühl,* 1925
(No. 73)

August Sander, *Young Farmers,* c. 1926 (No. 76)

August Sander, *Painter,* 1925–1930
(No. 75)

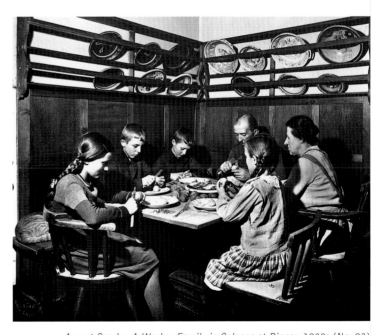

August Sander, *A Worker Family in Cologne at Dinner,* 1930s (No. 83)

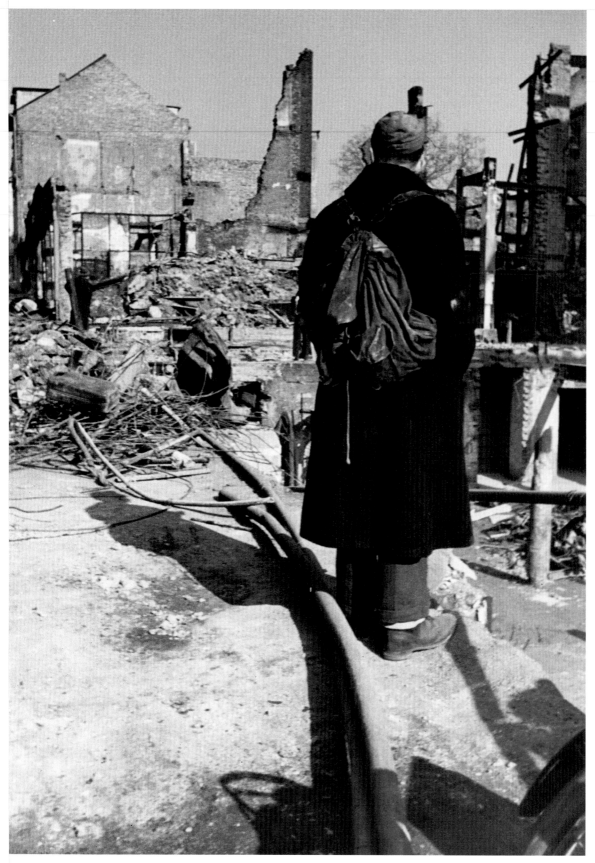

Hermann Claasen, *Returnee at the Site of the Ruins of His House,* 1947 (No. 19)

SPACES

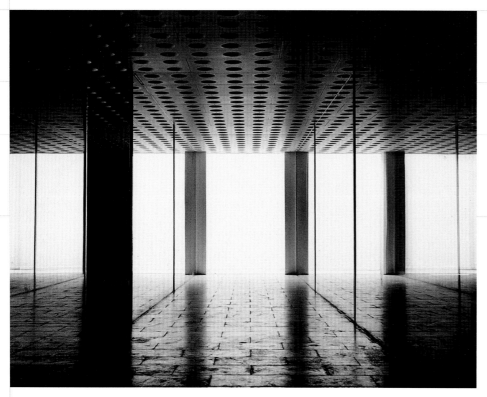

Karl Hugo Schmölz, *Pesch-Store, Cologne,* c. 1957 (No. 97)

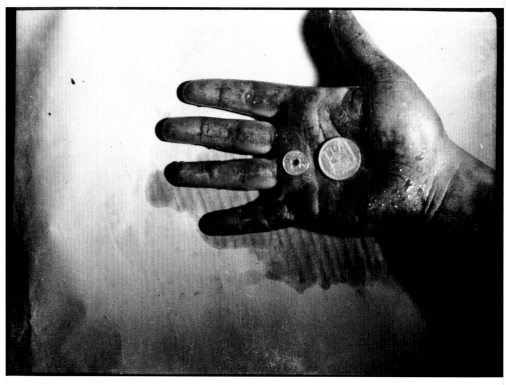

WOLS, *Untitled (Hand and Coins),* n.d. (No. 117)

WOLS, *Untitled (Radio Parts on a Mirror)*, n.d. (No. 120)

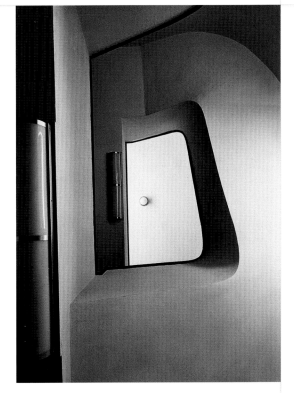

Albert Renger-Patzsch, *House "Rocca Vispa" in Ascona*, 1928 (No. 67)

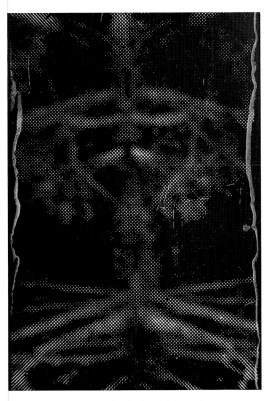

Sigmar Polke, *Untitled*, 1992 (No. 59)

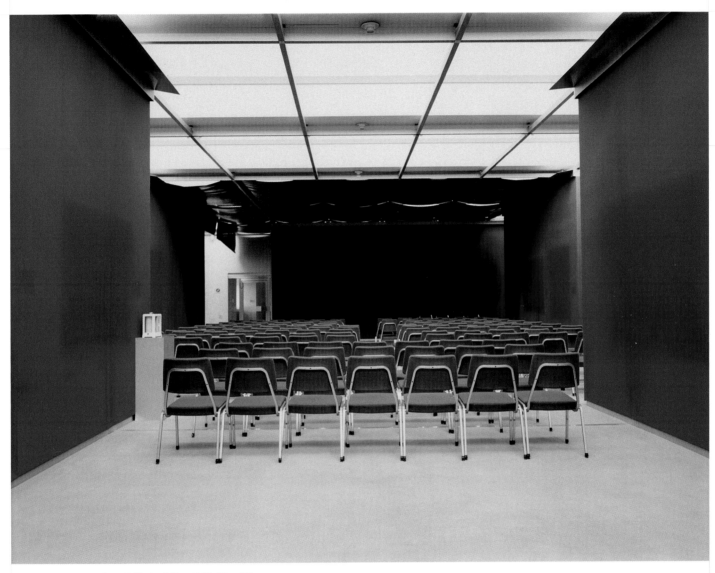

Ute Lindner, *Wilhelmshöhe,* 1996 (No. 45)

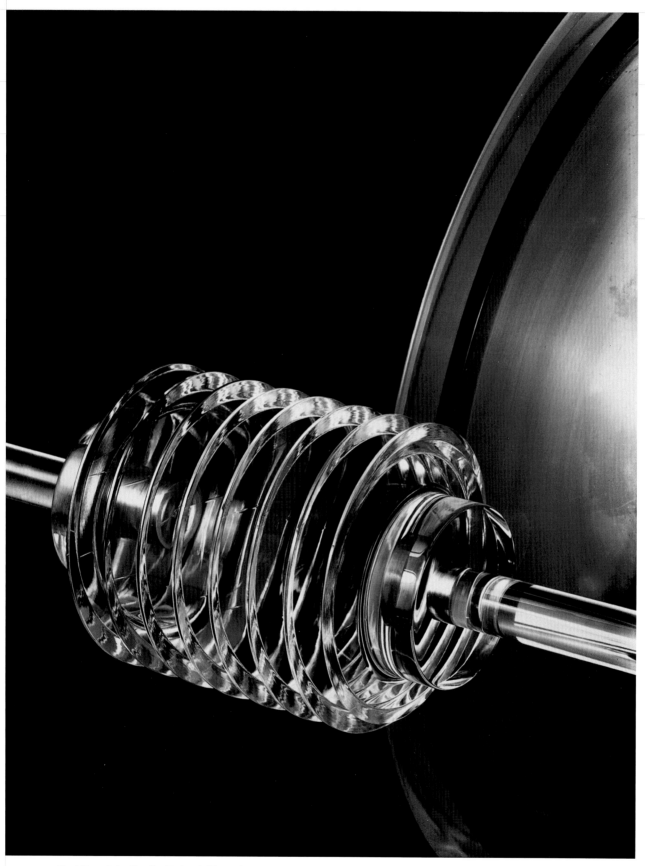

Karl Hugo Schmölz, *Untitled,* n.d. (No. 95)

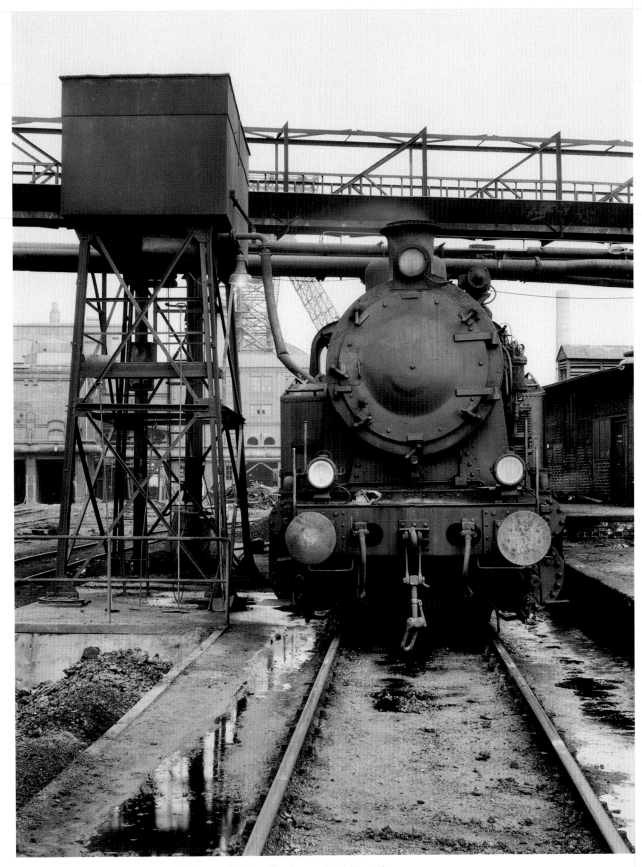

Bernd and Hilla Becher, *The Concordia Mine, Oberhausen,* 1967 (No. 10)

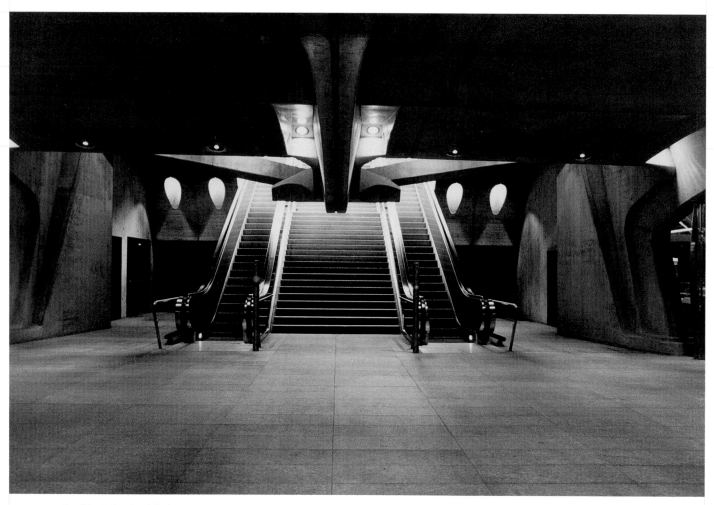

Candida Höfer, *Stadelhofen Train Station Zurich,* 1991 (No. 37)

CONSTRUCTIONS

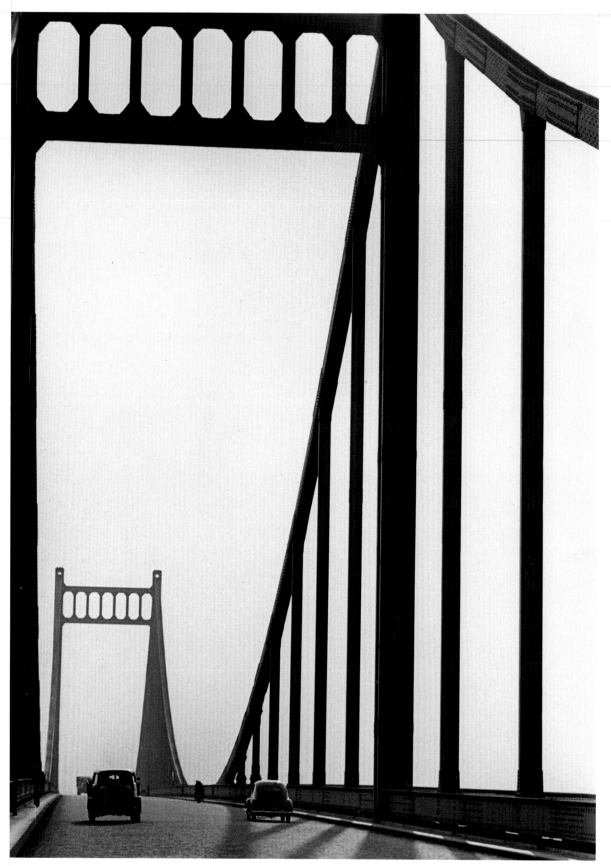

Dr. Paul Wolff, *New Bridge over the Rhine River at Duisburg,* 1939 (No. 113)

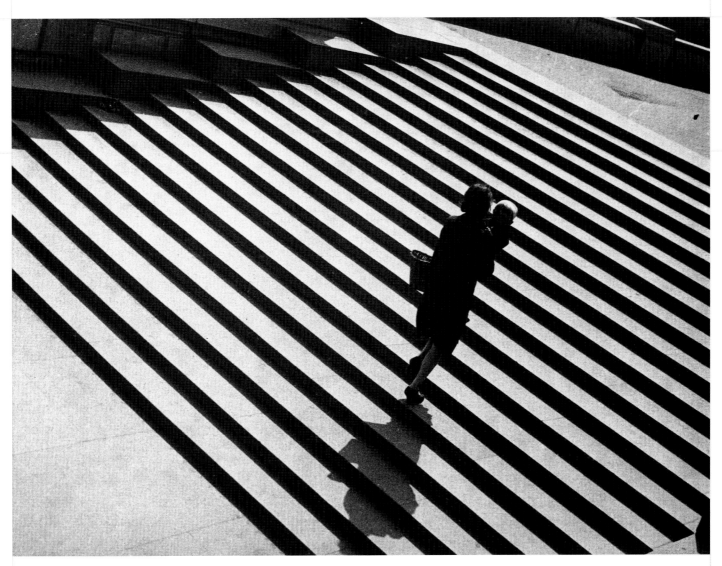

Alexander Rodchenko, *Stairs,* 1930 (No. 70)

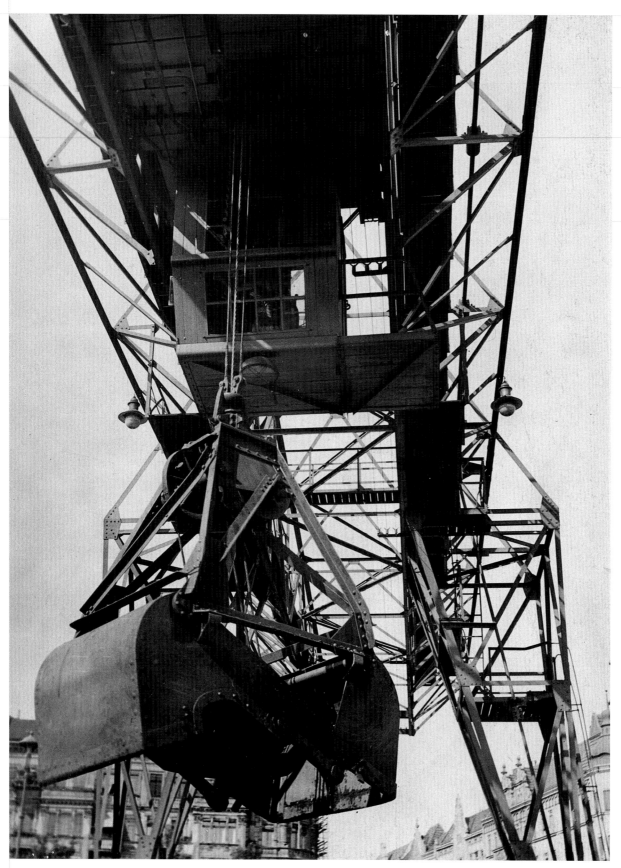

Albert Renger-Patzsch, *Crane,* c. 1927/28 (No. 65)

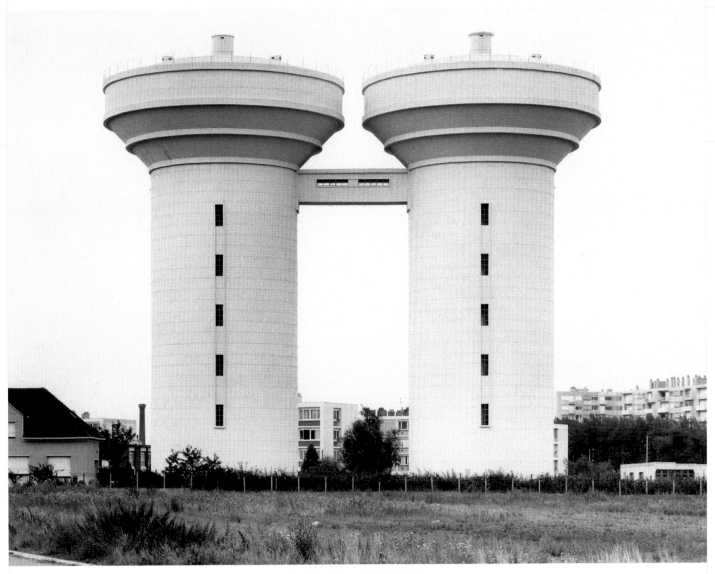

Bernd and Hilla Becher, *Double Watertower Douay, Northern France,* 1967 (No. 8)

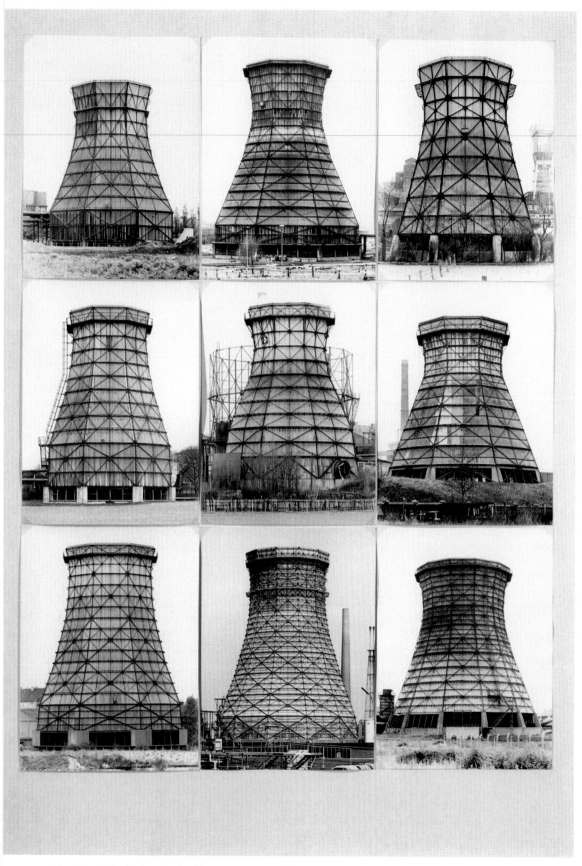

Bernd and Hilla Becher, *Cooling Towers,* 1963–1973 (No. 5)

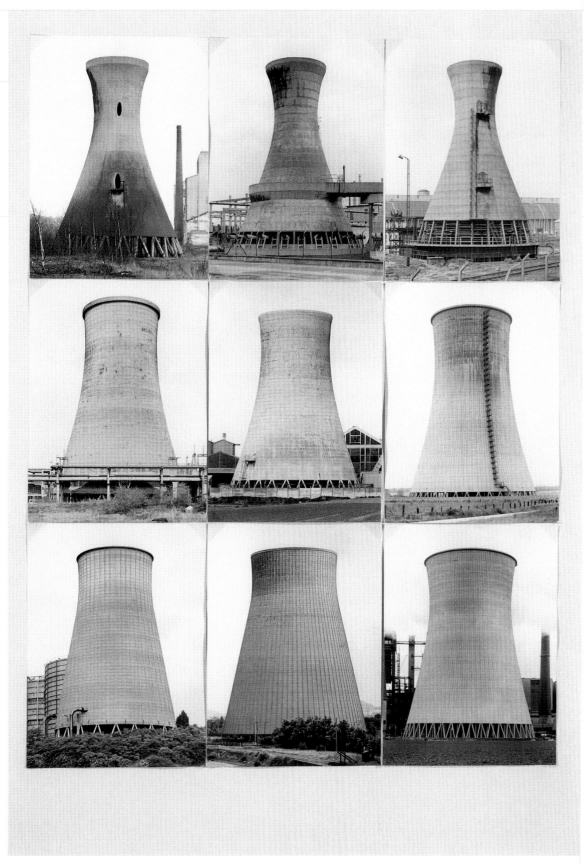

Bernd and Hilla Becher, *Cooling Towers,* 1963–1973 (No. 6)

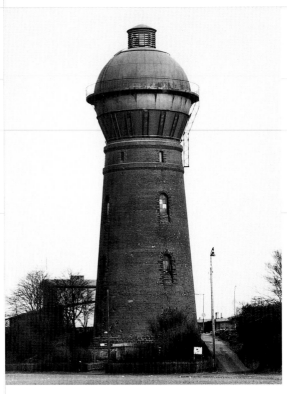

Bernd and Hilla Becher, *Watertower, Duisburg, Heidrich,* c. 1975 (No. 11)

Alexander Rodchenko, *Ladder,* 1925 (No. 69)

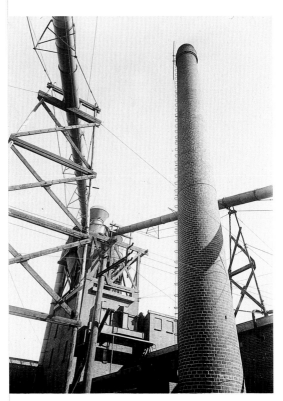

Piet Zwart, *Factory Chimney,* 1931 (No. 132)

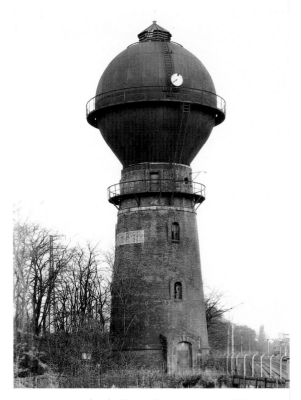

Bernd and Hilla Becher, *Watertower, Cologne-Kalk,* 1967 (No. 9)

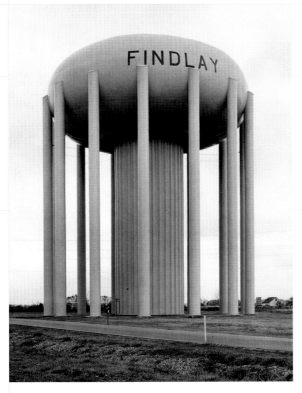

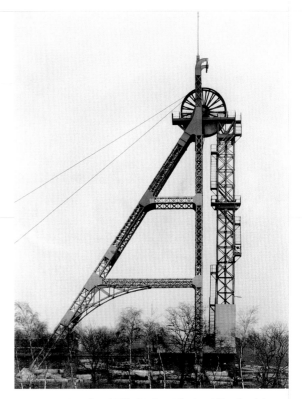

Bernd and Hilla Becher, *Watertower, Findlay, Ohio,*
1977 (No. 12)

Bernd and Hilla Becher, *Minehead Neu-Iserlohn,*
Pit 3, Bochum-Werne, Ruhr Area, 1963 (No. 4)

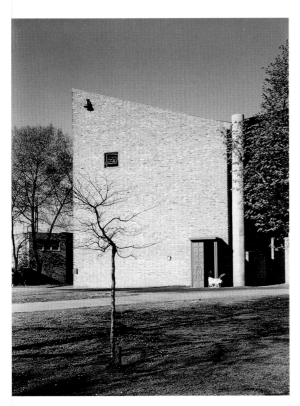

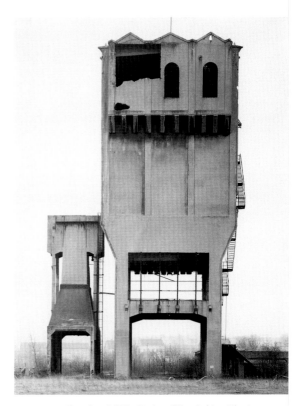

Karl Hugo Schmölz, *Church of St. Alban, Cologne,*
1957 (No. 98)

Bernd and Hilla Becher, *Silo, Coking Plant*
"Eschweiler Reserve", near Aachen, 1966 (No. 7)

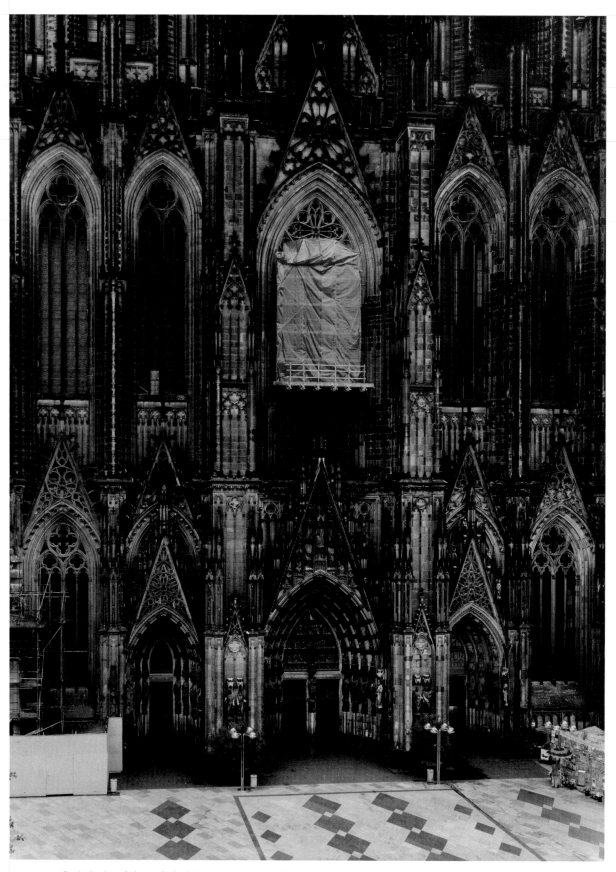

Boris Becker, *Cologne Cathedral, West Facade,* 1993 (No. 13)

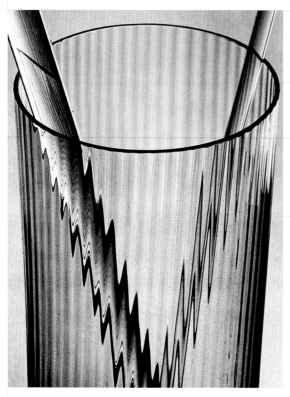

Willy Zielke, *Glass Distortion I,* 1929 (No. 130)

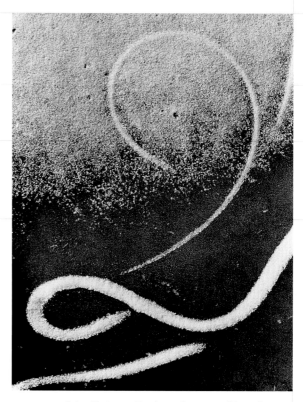

Peter Keetman, *Tracks on Ice,* 1982 (No. 41)

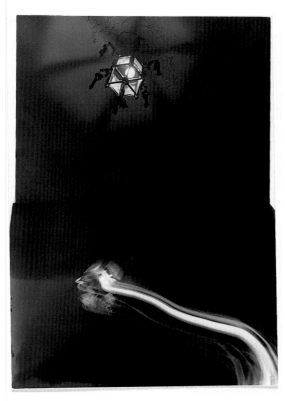

Sigmar Polke, *Untitled (Geneva),* 1970 (No. 57)

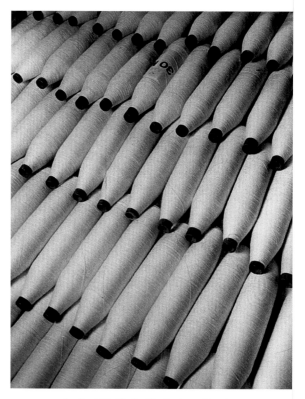

Dr. Paul Wolff, *Textile Factory, Spools,* 1943 (No. 114)

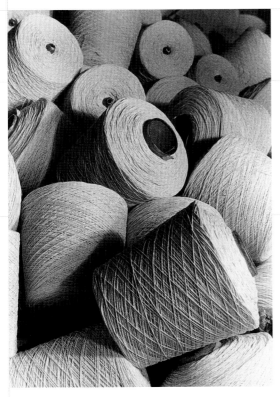

Dr. Paul Wolff, *Textile Factory: Spinning Mill,
Different Kinds of Cross Spools,* 1937 (No. 110)

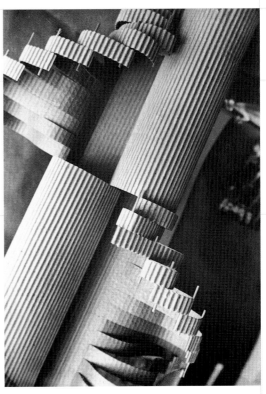

Lotte Stam-Beese, *Paper Construction for
Josef Albers' "Preliminary Course,"* 1927
(No. 100)

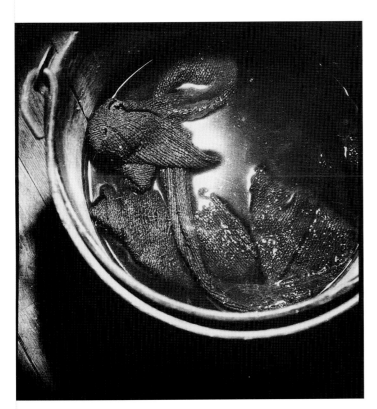

WOLS, *Untitled (View in Bucket),* c. 1938/39 (No. 129)

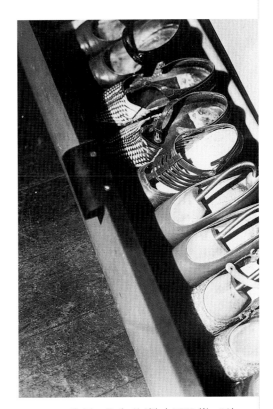

Kattina Both, *Untitled,* 1929 (No. 18)

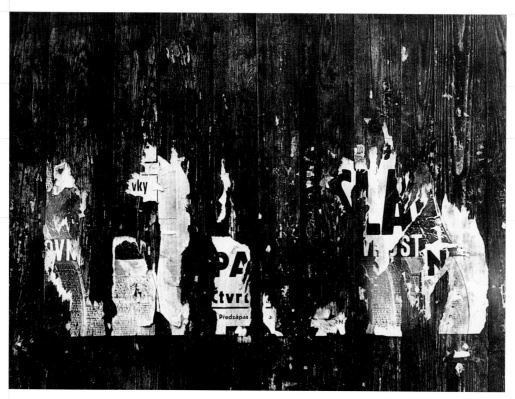

Vilém Reichmann, *Some Figures of Different Sexes and Temperaments,* 1965 (No. 62)

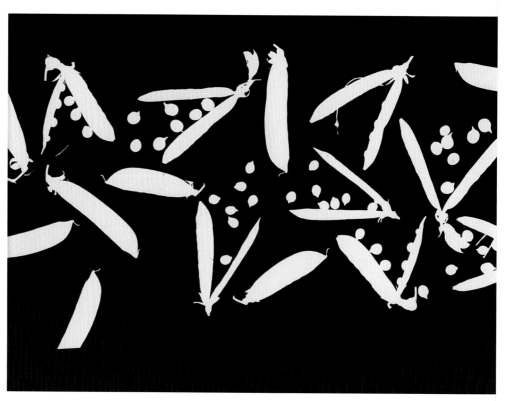

Anton Stankowski, *Peas,* 1928 (No. 101)

Boris Becker, *Field 1297,* 1995 (No. 14)

Dr. Paul Wolff, *Conerci,* 1937 (No. 108)

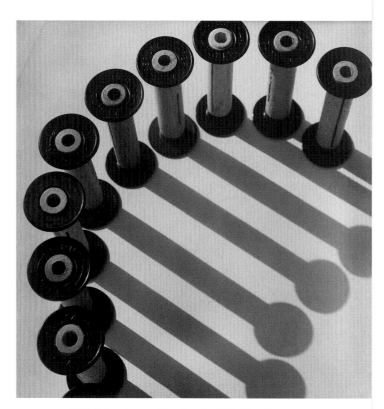

Adolf Schneeberger, *Film Spools,* 1931 (No. 99)

CITYSCAPES

Jörg Sasse, *Hamburg,* 1992 (No. 94)

Sigmar Polke, *Untitled (Geneva),* 1970 (No. 53)

Sigmar Polke, *Untitled (Geneva),* 1970 (No. 55)

Sigmar Polke, *Untitled (Düsseldorf),* 1970 (No. 50)

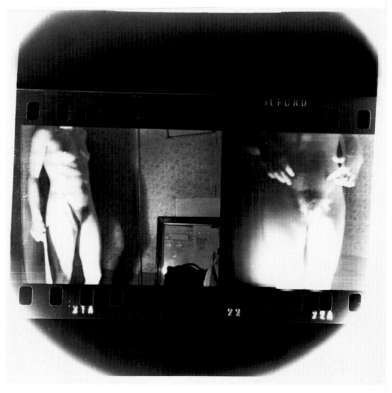

Sigmar Polke, *Untitled (Geneva),* 1970 (No. 51)

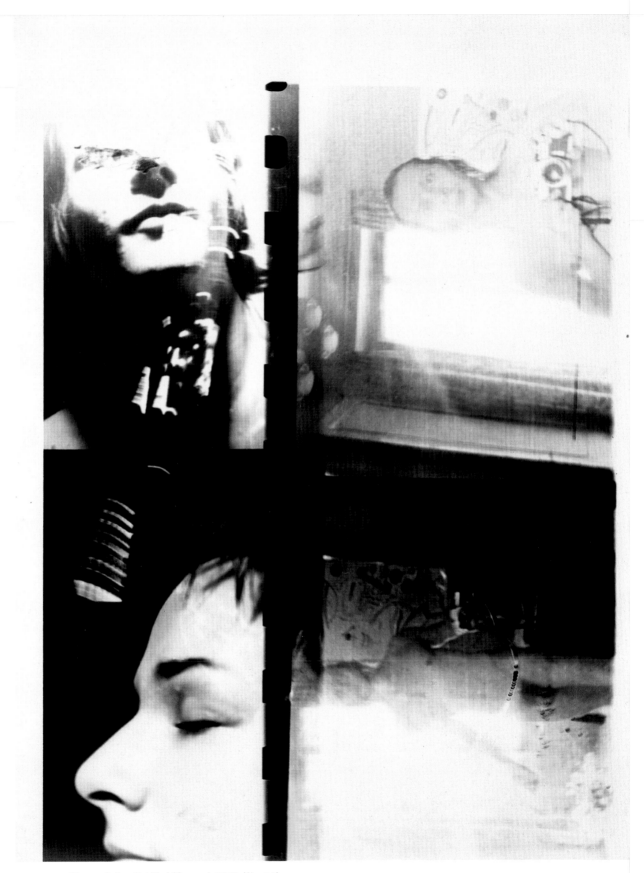

Sigmar Polke, *Untitled (Geneva),* 1970 (No. 54)

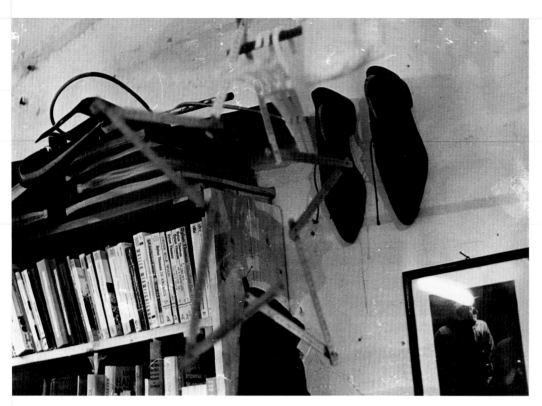

Sigmar Polke, *Untitled (Hamburg),* 1971 (No. 58)

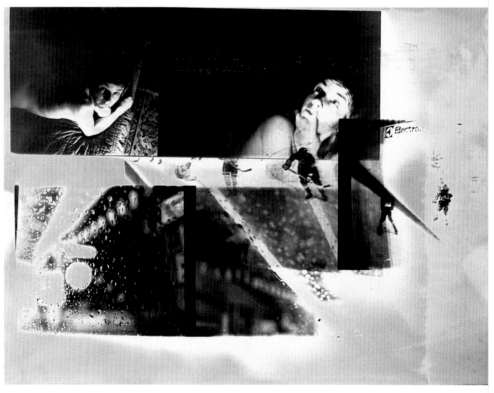

Sigmar Polke, *Untitled (Geneva),* 1970 (No. 52)

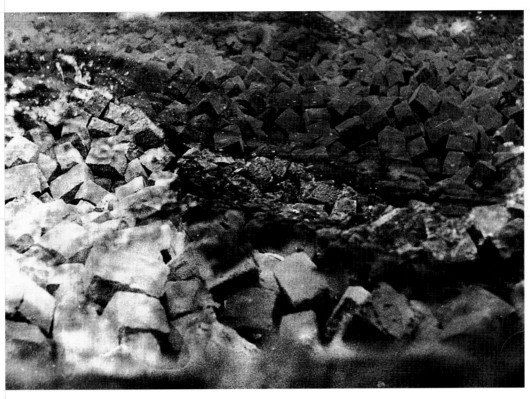

Sigmar Polke, *Untitled (Düsseldorf),* 1969 (No. 49)

Sigmar Polke, *Untitled (Geneva),* 1970 (No. 56)

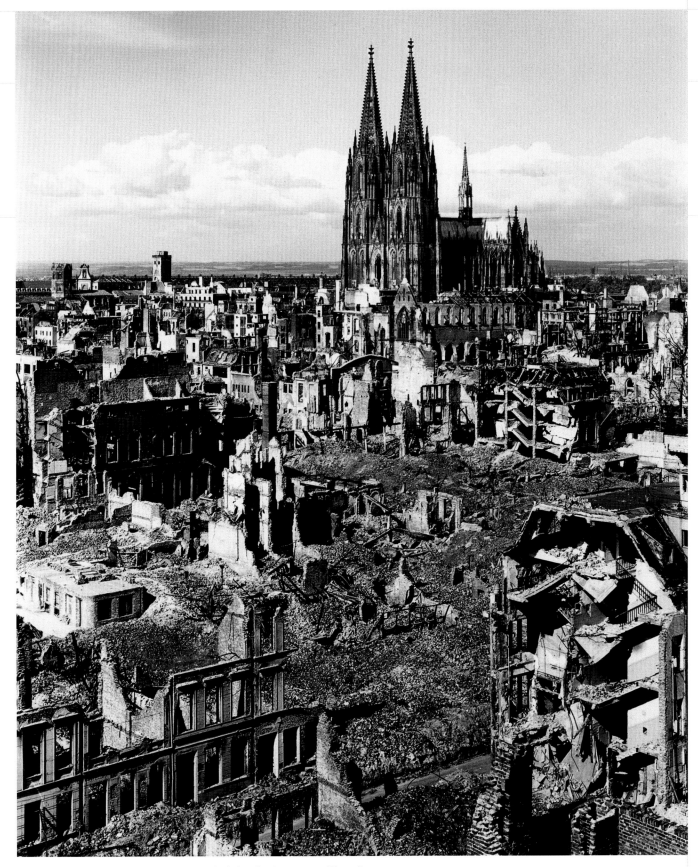

Karl Hugo Schmölz, *Cologne, Cathedral and Ruins,* c. 1945 (No. 96)

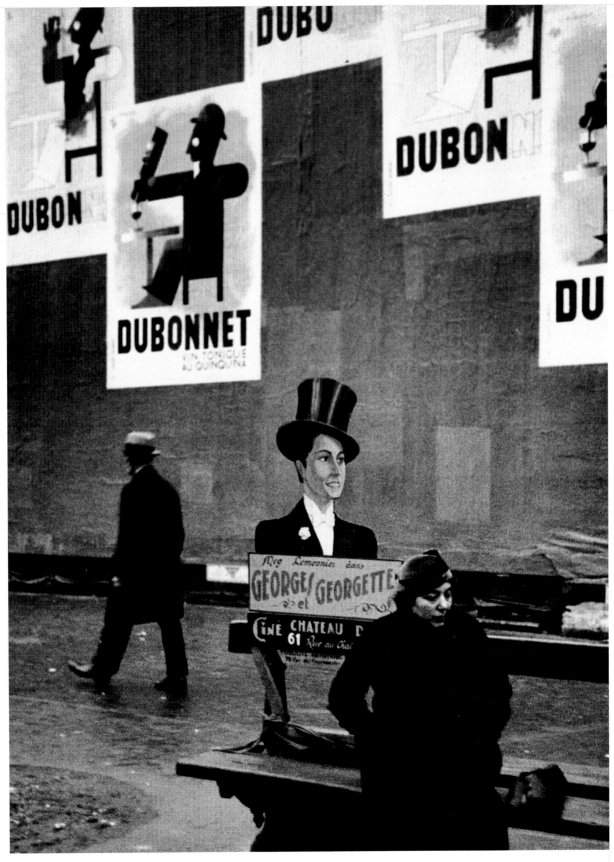

André Kertész, *Du-Dubon-Dubonnet,* 1934 (No. 42)

Dr. Paul Wolff, *Waiting for the Olympic Games in Berlin, Olympic Stadium,* 1936 (No. 105)

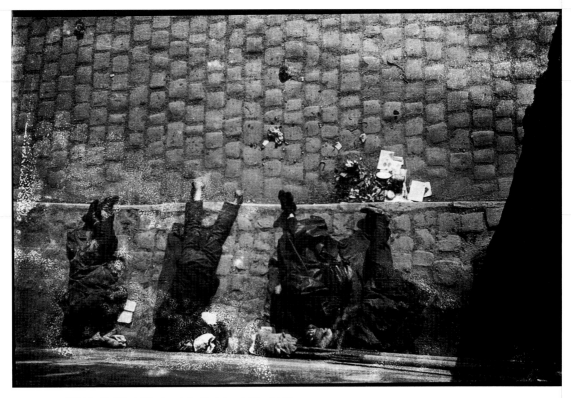

WOLS, *Untitled (Clochards in Paris),* n.d. (No. 115)

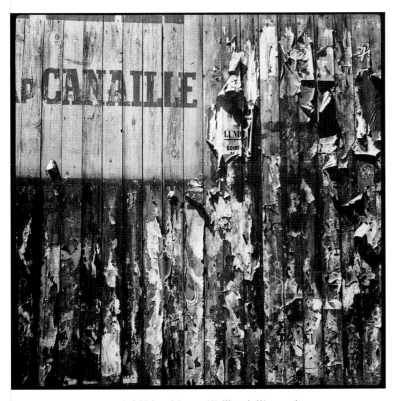

WOLS, *Untitled (Advertising on Wall),* n.d. (No. 123)

BARONESS JEANE VON OPPENHEIM

Since this story has a happy end, let us start with the end. More than one hundred photographs are featured in this catalogue in honor of the exhibition, "An American in Europe." These images, among the 670 works collected by me since the late sixties, have found a permanent home at the Norton Museum of Art in West Palm Beach, Florida. How this came about was relatively uneventful but seems to be the logical and natural conclusion to years of amassing works by European and American photographers before the real "photoboom" at auctions and galleries began.

There was never any intention on my part to "collect" in the classical sense, I never considered my acquisitions to be a "collection." There was no specific period in time, subject, or art historical aspect which inspired me to seek out a certain image. It wasn't until I had tried to put some order into the full drawers and stacks of photos, that I realized with what intensity I had actually acquired works over a period of thirty-some years. Never considering this an investment, I only bought what I could afford, and never traded or paid on installment, these being traits which define a true collector.

Having been born as a "visual" rather than "literary" person and growing up in New York in a home full of beautiful art and objects, I especially loved looking at pictures. Whether on a wall, in a book or magazine, I would study them intensely and try to memorize and interpret the images in my mind. On Saturdays, my father would take me to one of New York's museums and we would just walk around and look. Even at that time, about five years old, I loved the photography exhibits the most. To me there is truth in the saying "A picture says more than a thousand words." One observes a split second in time but sees the complete truth (that is, before the invention of digital photography). Looking at the truth is also learning, and there is endless knowledge to be acquired from looking. As an American not having lived in Europe before, photographs definitely helped me to understand the past, even to the extent of experiencing what it was like, and how it was to deal with all that was lost.

My goal was, however, to be a promoter of photography as an art form. This missionary calling, the legacy of Alfred Stieglitz, naturally led to the acquisition of photos mainly for exhibition purposes.

There were not many of us "missionaries" at that time, in the early seventies. But I had the fortune to become acquainted with some of the most important figures involved. They opened their doors and their arms to me (photo-lovers are very emotional people) and certainly gave me all the reasons in the world to pursue what was slowly becoming a passion. Among the missionaries who remain foremost in my mind are Beaumont Newhall, former Curator of Photography at MOMA and author of an important volume on the history of photography. I was introduced to him by his close friend, the recently deceased and unforgettable Karl Steinorth, collector of photo books, and super-promoter of photography in Germany. Cornell Capa, the most dedicated missionary and founder of the International Center of Photography in New York introduced me to the major promoter in Europe, the mother of five, widow of the Magnum photographer Werner Bischof (killed on the job in South America), married to yet another Magnum photographer, René Burri. Through my contact and immediate friendship with Rosselina Burri-Bischof I was able to meet a number of French and Swiss photographers, including the incomparable Henri Cartier-Bresson.

If I were to call any of the missionaries my mentor, it would be L. Fritz Gruber of Cologne, Germany, the former initiator and director of the "photokina Bilderschauen" (photokina Picture Show). This mammoth photography exhibition has been the cultural addendum to the renowned "photokina" fair, the world's largest presentation of photographic products shown biennially in Cologne. L. Fritz Gruber is a "walking encyclopedia" on photography, an avid collector in vari-

ous fields, an accomplished journalist, a communicator, a bon-vivant, who to this day, at age 92, still enjoys all good things in life.

At approximately the same time that I met Fritz in Cologne – the introduction having been made by my father-in-law, who had nothing at all to do with photography but was, as well, a great communicator – I was asked by the Director of the Wallraf-Richartz-Museum/Museum Ludwig, Gerhard Bott, to work on Gruber's collection. It had just been purchased as the first-ever photo collection acquired for a museum. What a coincidence and privilege! His collection consisted of more than 1000 photographs, American and European, including all the great masters. Many images were featured in the books he published and are now considered icons in photographic history. (He and his wife, Renate, have since donated at least as many works to the Ludwig Museum; it now belongs to the Ludwig Museum, as it focuses on the 20th century).

The challenge was irresistible: organizing exhibitions from the collection, writing about them and giving lectures – in other words laying the foundation for a Department of Photography. There was, however, one seemingly insurmountable problem. The "American in Europe" could hardly read or write German. All those years of French and Italian at school did me no good at all! Shyly, I dared to ask my colleague, the Curator of Prints and Drawings, whether there might be a person in the museum who could translate my essays into German. He looked at me, inhaled his cigarette deeply and exhaled the following reply: "You'd better start learning the language!" So I did.

Soon thereafter I was sent on a fact-finding mission to New York. Armed with letters of introduction from the Wallraf-Richartz Museum/Museum Ludwig's director, I looked at all the photography collections in New York and met the curators involved. This was a great experience, needless to say. Having been partially brought up in New York, I had no problem finding my way around. The highlight of this experience was meeting and establishing a friendship with the Curator of Prints and Photographs at the Metropolitan Museum, Weston Naef. The cathedral-like aura this institution exuded convinced me that I would be confronted with a very serious, elderly gentleman-scholar. Walking up those breath-taking

museum stairs I nervously reviewed photographic history in my mind, hoping not to be asked a question I could not answer. Mr. Naef turned out to be a man my age, most hospitable and charming. By the end of our meeting he agreed to come to Cologne in a few months' time and give a lecture on Stieglitz and the Photo-Sessionists. He came, as did Beaumont Newhall, and I was proud of being able to offer the museum an opportunity that was too good to be true.

At present, Weston Naef is Curator of Photographs at the Getty Museum, and surely one of the most accomplished and knowledgeable connoisseurs and scholars of photography in the world today. He is responsible for creating the Getty's incredible collection, unique in its depth and volume. Weston was, as well as the others mentioned, a missionary, belonging to the younger generation as did I at the time, who decisively and passionately convinced people to look at photographs as an art form. His discerning eye and intellectual approach to photography greatly influenced my personal judgement in the field. Luckily there were ways in which we would help each other so that we maintained contact to this day. When he came to Cologne on visits, he would ask to look at my photographs. These were some of the very rare opportunities I had to look at them with someone who really appreciated what there was to see.

The last of the missionaries to be mentioned, although there were many more, was a young dealer from Aachen not far from Cologne, who had a gallery for photographs. Rudolf Kicken and his partner, Wilhelm Schuermann, were constantly "on the prowl" for vintage prints by yet to be recognized European photographers. On several occasions we teamed up to persuade the Ludwig Museum to purchase some of these "finds." This was unfortunately to no avail as there was no budget for any more photographs. Kicken, the gallery owner, is today one of the foremost international dealers of fine art photography. His unrelenting conviction that photographs would become an important part of the collectors' market has proven to be correct.

By the mid-seventies I was certain that I needed more photographs for myself. Antiquarian book dealers, flea markets and "shop talk" led me to various sources. Soon thereafter, in 1980, I was elected to the Board of the German Society of Photography, the first woman together with Ute Eskildsen,

presently Chief Curator for Photography at the Folkwang Museum in Essen. Being a member of this elite group of promoters and scholars in Germany enabled me to meet a number of photographers who are today an integral part of photographic history. To mention a few: Gunther Sander, son of August, Lotte Jacobi, Gisèle Freund, Alfred Eisenstaedt, Robert Frank, Richard Avedon, Cartier-Bresson, William Edgerton (a great dancer too!) and Jacques-Henri Lartigue. Knowing these people did not necessarily motivate me to own their work. I was perfectly content with talking to them and looking at their photographs. Therefore many of these names do not appear in the collection. I preferred to make discoveries of my own, to find unknown work by known photographers and to acquire works which affected me personally.

Between the two World Wars, Germany became the creative center of photography in Europe. As artists developed a fascination for the camera, the link between painting and photography became inevitable. Many would-be artists became photographers and vice-versa. Therefore it is no coincidence that two major German artists, WOLS (Alfred Otto Wolfgang Schulze, 1913–1951) and Sigmar Polke are cornerstones in the collection. Before giving the prints to the Norton I invited a knowledgeable collector of WOLS paintings to look at this work, yet unknown to him. He was amazed at the similarity between the images represented as opposed to his paintings, as well as the intensity in WOLS' photographs. The same reaction can be had from the juxtaposition of Polke's paintings and photographic images. It was most fortunate for me to be at the right place at the right time to be able to acquire these rare works.

If you have nothing to do with photography but live in Cologne, you must still know who August Sander was. His documentation of the city before and after World War II fills the city's photo archives. He was actually a prominent portrait photographer whose relationship to local artists encouraged him in his effort to "minimalize" the portrait. In 1925 he decided to leave his studio in the city and take portraits "on location" with the intention of documenting twentieth century people in Germany, including all vocations and classes. An exhibition of this body of work was shown at the Cologne Art Society in 1927 and a book with all the images was published as well. When, in 1934, the National Socialist regime banned his photography, destroying the remainder of the books, Sander chose to leave Cologne and retire to the countryside. During this time of inner resignation he photographed charming landscapes of peaceful areas, apparently far removed from the existing political turmoil. Some of these images, prepared by Sander to be sold as postcards, are in the exhibition and this catalogue. They have never before to my knowledge been reproduced. Through the work of August Sander, it was possible for me to learn about the society in my adopted country that had been the backbone of a devastated nation. His sense of unrelenting curiosity on the one hand, and innate talent at composition on the other, never telling too much of the story, has placed his work at the focal point in German photography. I am proud to have had the sense to acquire these vintage prints not long after his death. Today many are no longer available.

In 1985 I started a travelling exhibition service for photographic shows. Many of them came from institutions such as I. C. P., the International Center of Photography in New York. Museums in Europe were eager to take advantage of this offer which was inexpensive and practical but also drew enthusiastic crowds. I was a link between the two continents which was gratifying and once again opened up opportunities to meet interesting people in both places. Two of the most successful exhibitions, circulating for two years, were the "Robert Capa Retrospective" and "Photographs of the American Indian" by Edward Curtis. These two ambitious hard-working documentarists of different generations both have posthumously become key figures in photography's short history.

By 1989 I also directed a gallery in Cologne, not-for-profit but to host other gallery exhibitions from New York, London, Paris and what had been known until then as East Germany. The art exhibitions were often combined with photography. The gallery existed for six years and, looking back, three exhibitions stand out in my mind: the opening of the gallery with a Robert Mapplethorpe show (he had just recently died), the Edward Curtis exhibition of all his photogravures and books, and my closing exhibition of photographs by Bernd and Hilla Becher.

The Bechers' work being yet another cornerstone in the collection, it was my privilege to get acquainted with them in the early eighties. This couple has my utmost admiration and

respect. Having been shunned by the German photography world for years for being too "artistic," they were in turn shunned by some art experts for being too "technical." It did not faze them: inspired and influenced by the work of August Sander and Albert Renger-Patzsch, they just persisted in doing what they set out to do – the documentation of European and American industrial monuments. While experts spent time deciding in which category they fall, they quietly but definitely caused a revolution in contemporary art and photography. Their work has become the most sought-after among collectors and museums internationally. The Bechers break the barrier between the pristine vintage print and the recognition of an image on paper. Even their offset lithographs command high prices at auction. This having been said, it is no coincidence that the Bechers won the prize for "sculpture" at the Venice Biennial in 1990. Although they were staunch advocates of the black and white print, most of their students at the Düsseldorf Art Academy prefer color. To name a few of the Bechers' students, Andreas Gursky, Thomas Ruff, Thomas Struth, Candida Höfer, Claus Goedicke and Boris Becker, is to simultaneously list some of the international art market's most successful young talent. The work of these artists as an entity is referred to as "The Becher School." Bernd and Hilla Becher continue, in their retirement from teaching, to fulfill their lifelong ambition, undaunted by the enormous impact they have made on the world of art and photography.

In conclusion to my experiences in the field of photography, there is one person not yet mentioned whose influence and guidance I still cherish, years after her death. She was one of many photographers at the Bauhaus and was married to the artist László Moholy-Nagy. She had an extraordinary intellect and was extremely respected by all who knew her.

Upon discovering the "Bauhaus Bücher" (Bauhaus Books), I noticed that most of the photo credits were in the name of Lucia Moholy. I liked the pure, straight photographs as well as her name and decided to try to locate her. After months of inquiries I finally found her in a Zurich suburb. Fleeing Germany before the war, losing her husband to another woman and emigrating to England – not able there to pursue her profession – she chose to live a reclusive life in peaceful Switzerland, where she wrote about photographic theory. To me Lucia Moholy was the epitome of the Bauhaus. Her appear-

ance, her manner of speech and her surroundings fit into my romantic vision of the Bauhaus style. I could listen to her talk for hours. There was never enough time to absorb all she had to offer. She lived to be 95 and, although she had endured so many hardships and disappointments, she always loved to talk about her life at the Bauhaus. In fact, one of her favorite subjects was to revise the many misconceptions that have circulated about the Bauhaus since its demise.

Being an extremely liberal thinker, one of Lucia's credos was that photography was meant to exist for everyone. She deplored the slowly-rising photo market and distrusted collectors and gallery owners. She believed that photographs were not meant to be hoarded by individuals but to be made accessible to anyone who could relate to the medium. This was her fervent message and, in retrospect, this message has been implanted in me ever since Lucia died. I knew that some day my photographs should be placed where they can be seen by any and all.

Deciding on the right institution was not difficult. That it should go to the United States was logical as most of the material is European. A museum that does not yet have a large photography department seemed to make the most sense. The Norton Museum of Art, located in my "second" home-town, is the ideal place for the "American in Europe" to return to. Once again, doors and arms were open to me and to the idea of donating my pictures to this fine institution.
I thank Christina Orr-Cahall, Director of the Norton, the Board of Trustees and the museum staff for their warm welcome.

PORTRAITS

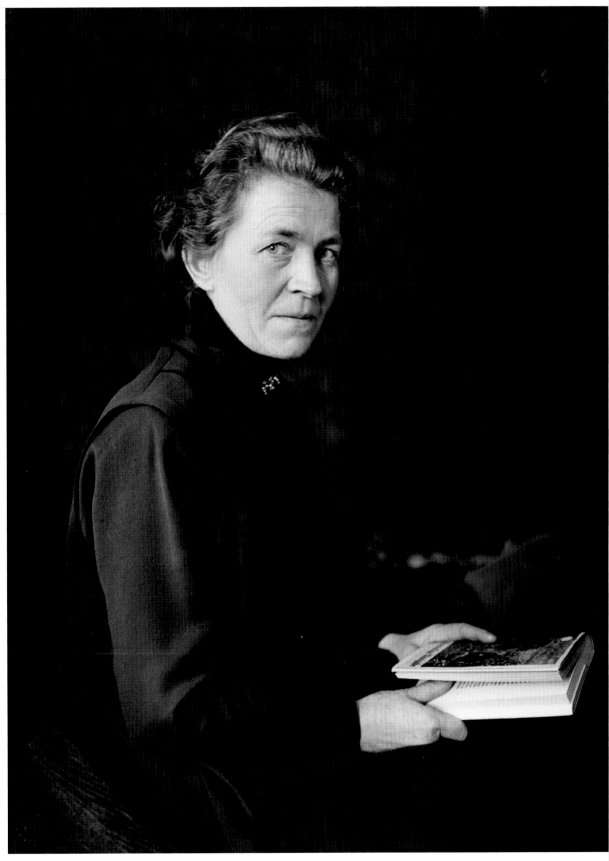

August Sander, *Small-towner*, 1926 (No. 77)

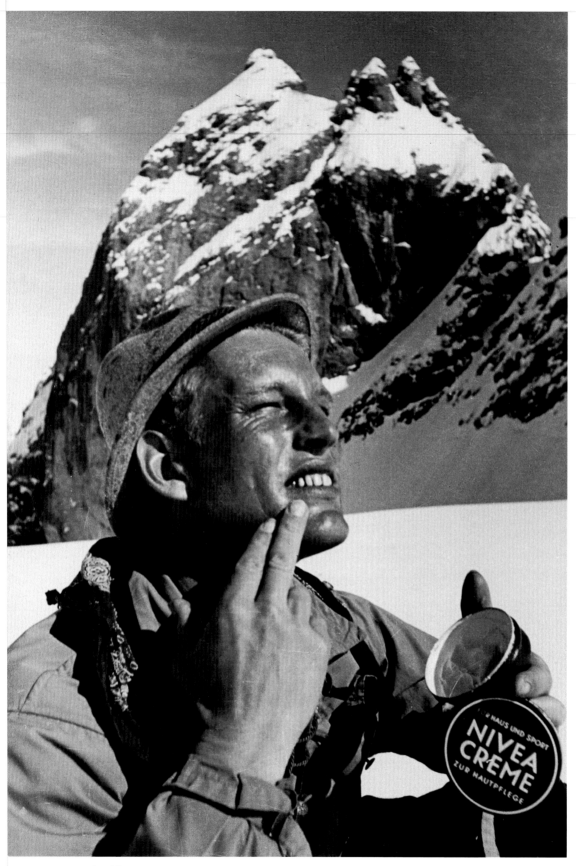

Dr. Paul Wolff, *Mountain Guide in the Dolomites,* 1936 (No. 106)

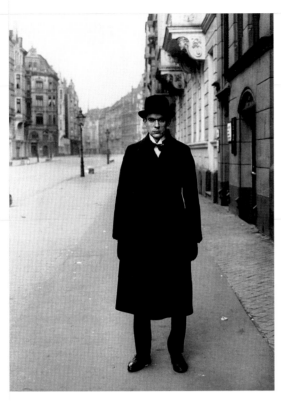

August Sander, *The Painter (Anton Räderscheidt)*, 1926 (No. 78)

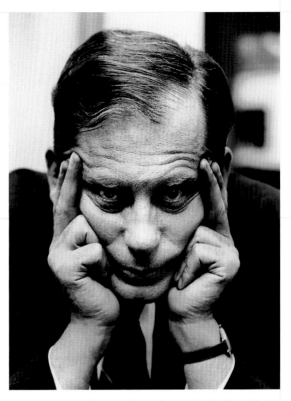

Lucia Moholy, *Walter Gropius,* 1927 (No. 48)

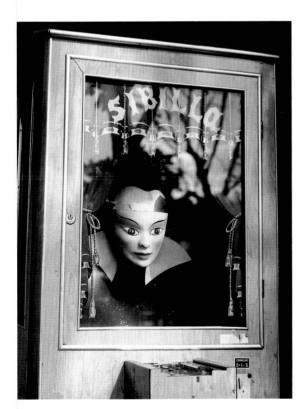

Vilém Reichmann, *Sibilla,* 1975 (No. 61)

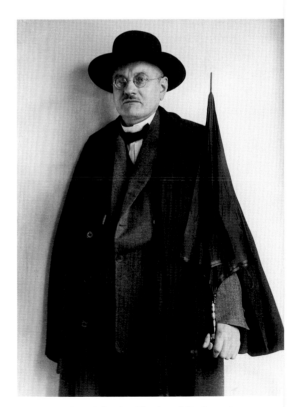

August Sander, *Member of Parliament (Democrat),* 1927 (No. 79)

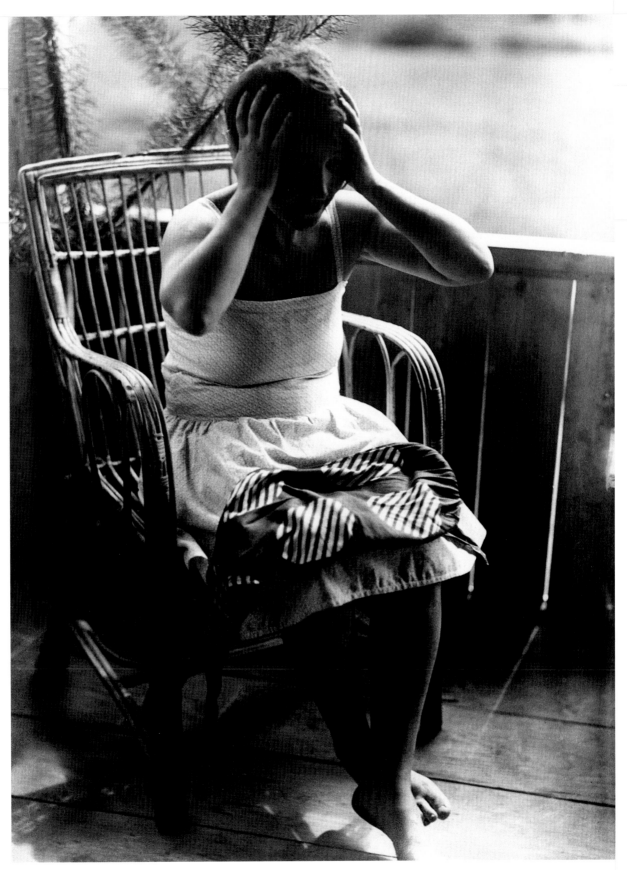

Alexander Rodchenko, *Artist Varvara Stepanova in Pushkino,* 1927 (No. 68)

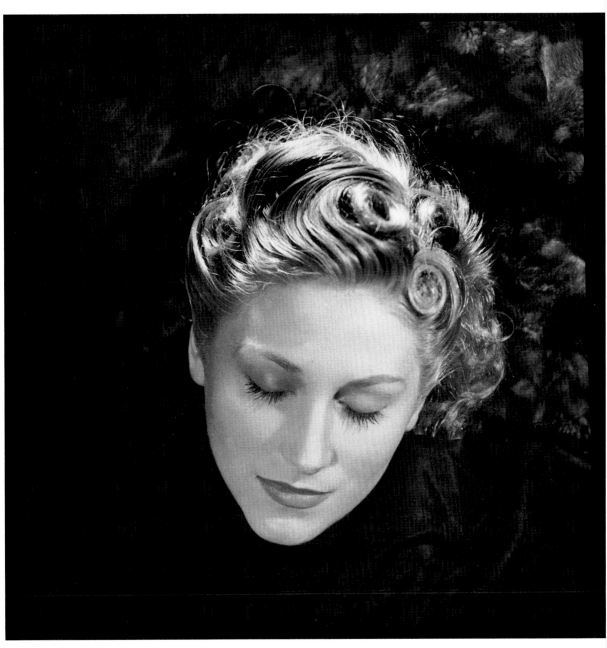

WOLS, *Untitled (Nicole Boubant),* n.d. (No. 119)

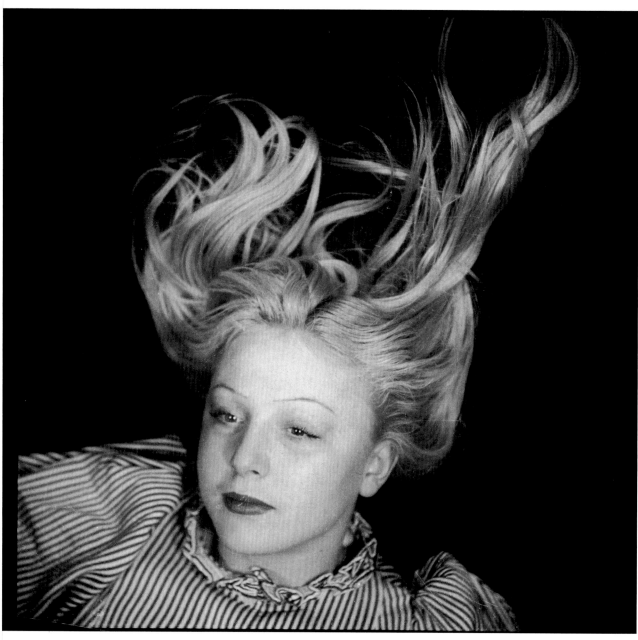

WOLS, *Untitled (Sonia Mossé),* n.d. (No. 124)

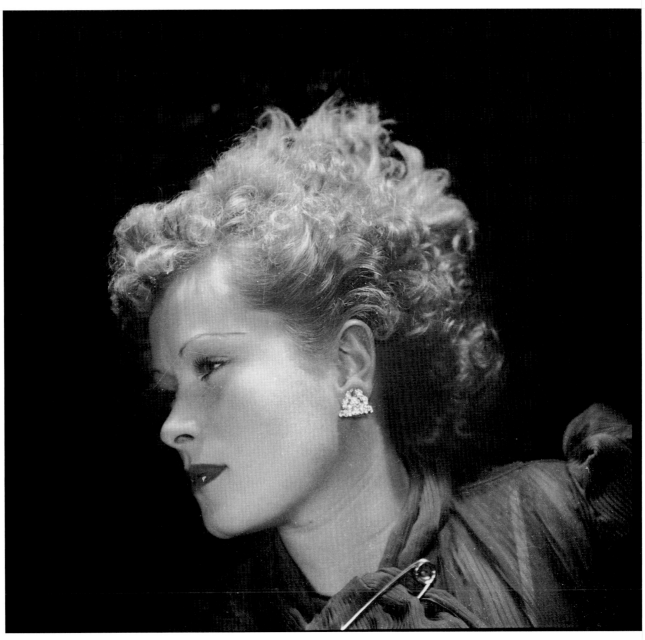

WOLS, *Untitled,* n.d. (No. 118)

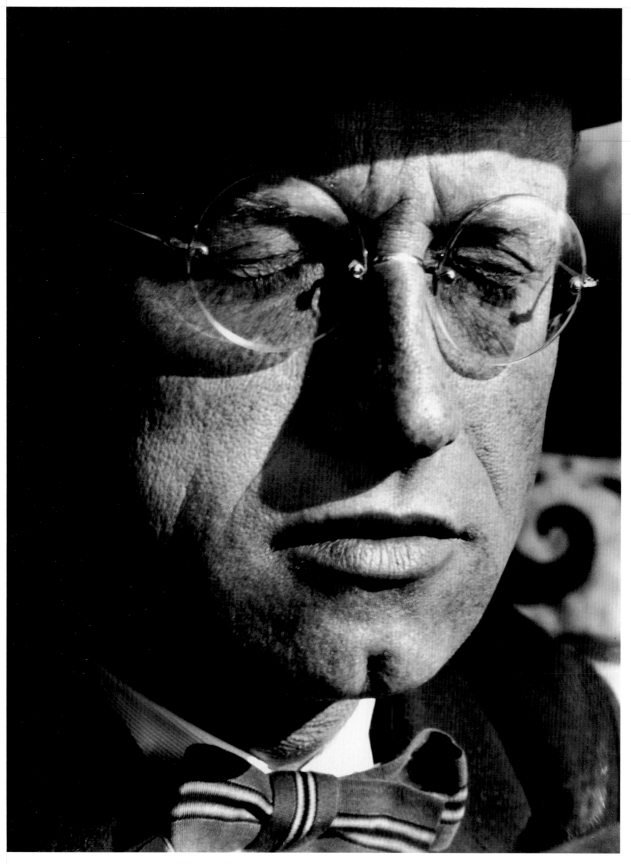

Lucia Moholy, *Franz Roh,* 1926 (No. 47)

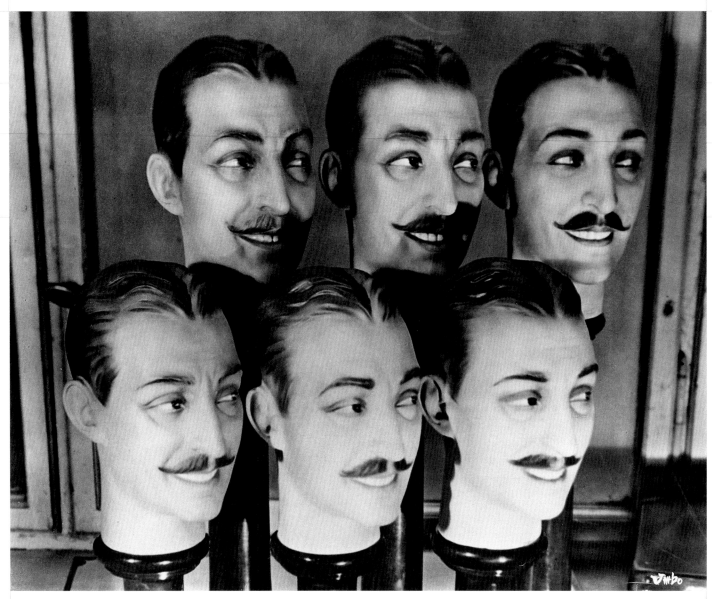

UMBO, *Menjou en gros,* 1928 (No. 102)

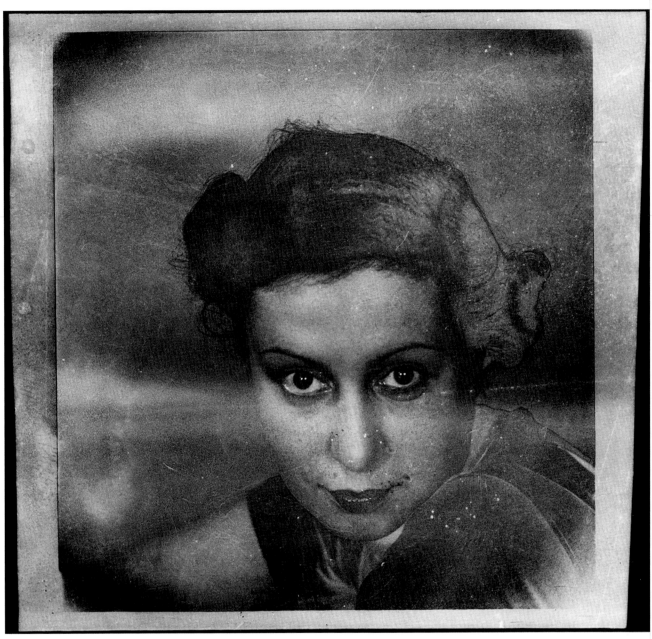

WOLS, *Untitled (Sabine Hettner),* c. 1935 (No. 122)

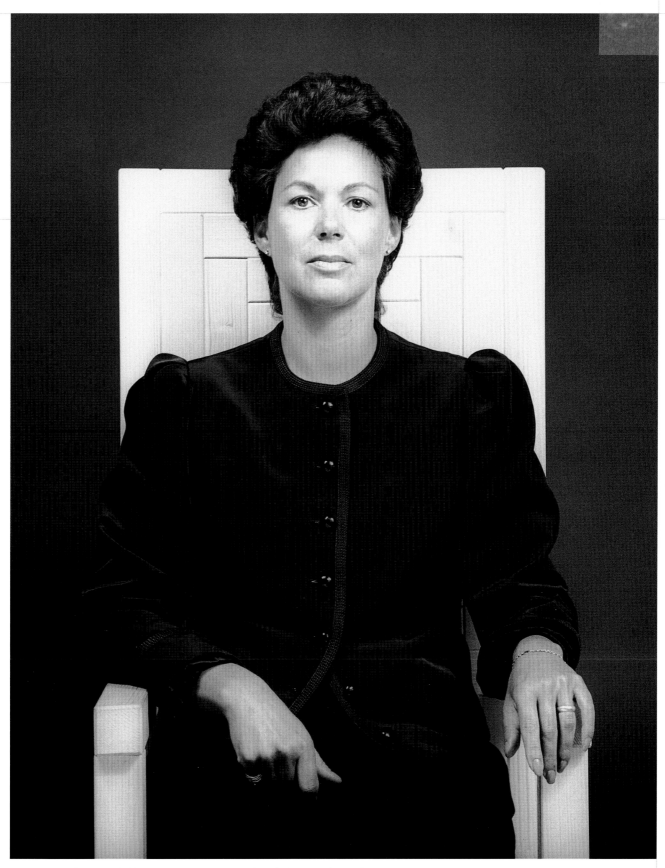

Robert Mapplethorpe, *Baroness Jeane von Oppenheim,* 1983 (No. 46)

LANDSCAPES

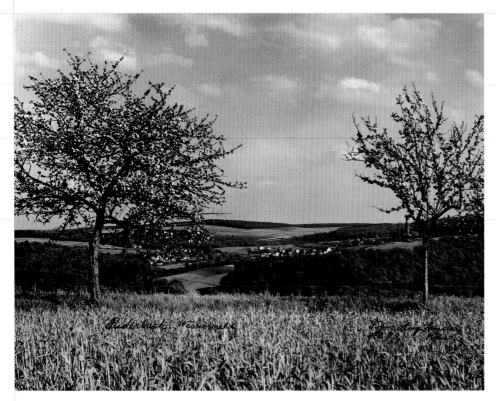

August Sander, *Puderbach, Westerwald,* 1930s (No. 86)

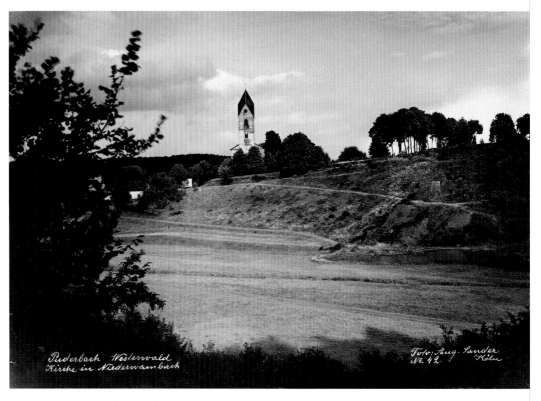

August Sander, *Puderbach, Westerwald, Church at Niederwambach,* 1930s (No. 87)

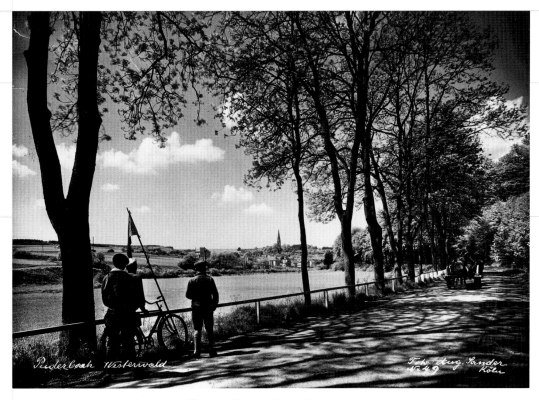

August Sander, *Puderbach, Westerwald,* 1930s (No. 85)

August Sander, *Westerwald, Spring Landscape,* 1930s (No. 91)

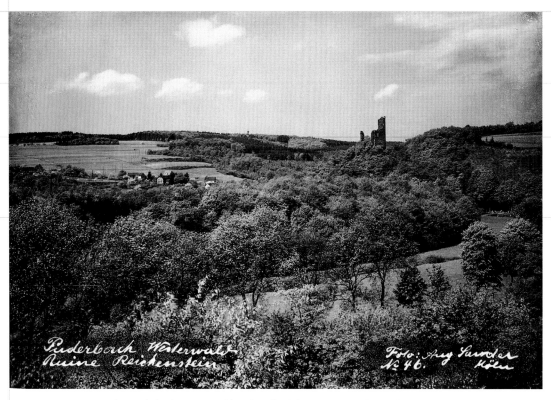

August Sander, *Puderbach, Westerwald, Ruins of Reichenstein,* 1930s (No. 89)

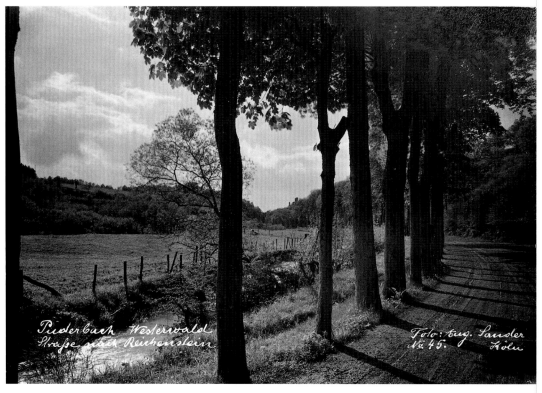

August Sander, *Puderbach, Westerwald, Road to Reichenstein,* 1930s (No. 90)

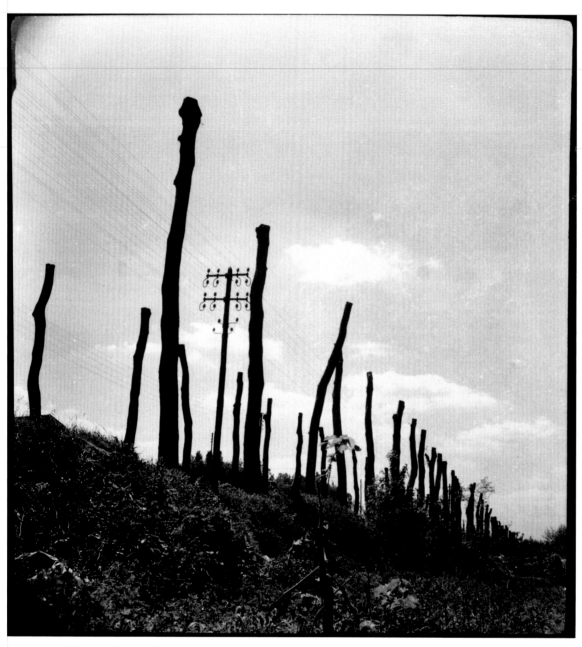

WOLS, *Untitled (Walkway with Pylons),* n.d. (No. 121)

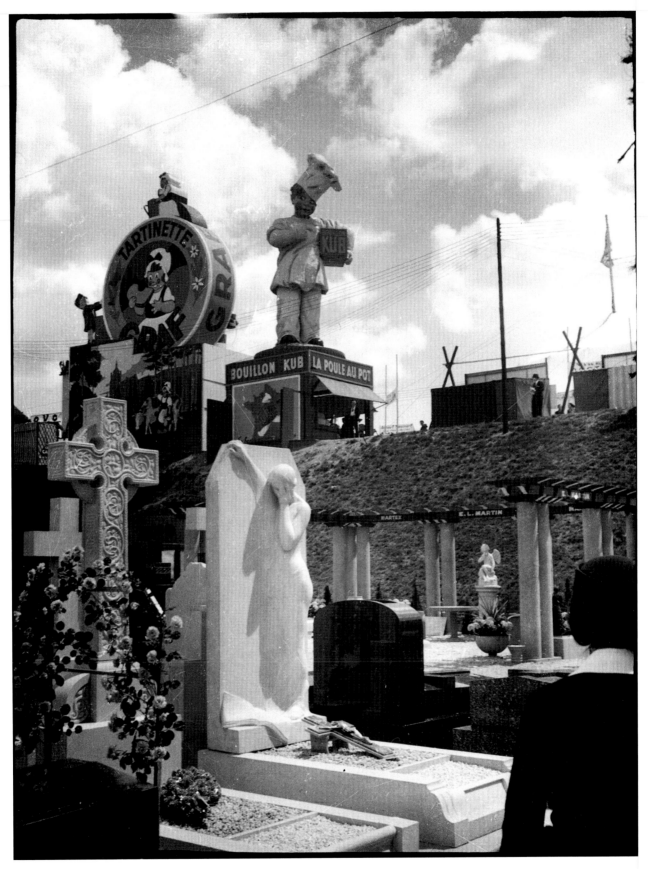

WOLS, *Untitled (Cemetery),* n.d. (No. 125)

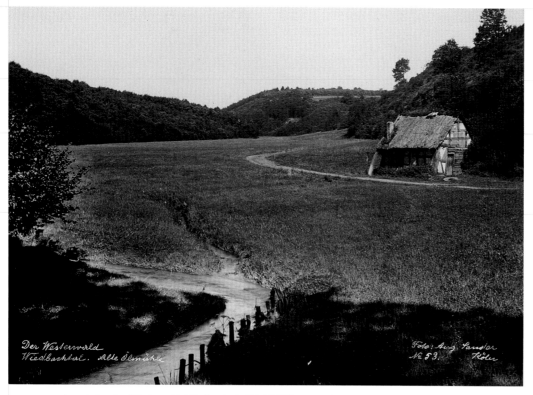

August Sander, *Westerwald, Wiedbachtal, Old Oil Mill,* 1930s (No. 93)

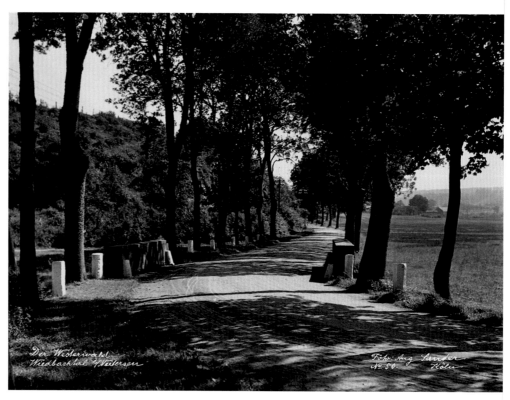

August Sander, *Westerwald, Road from Wiedbachtal to Neitersen,* 1930s (No. 92)

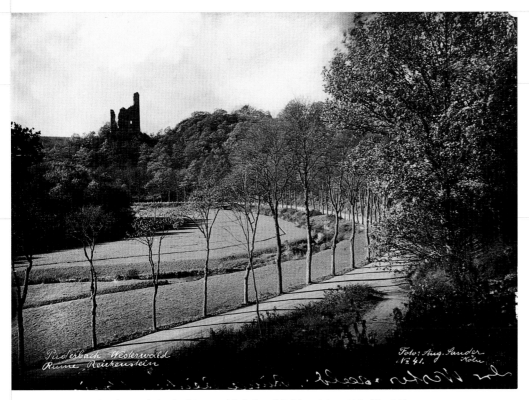

August Sander, *Puderbach, Westerwald, Ruins of Reichenstein,* 1930s (No. 88)

August Sander, *Puderbach, Westerwald,* 1930s (No. 84)

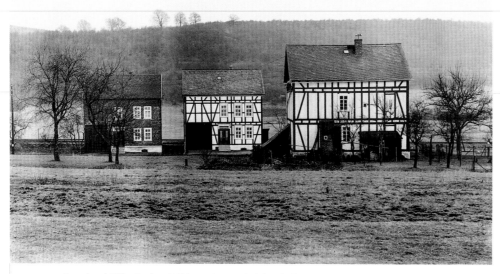

Bernd and Hilla Becher, *Wildener Street, Salchendorf,* 1961 (No. 2)

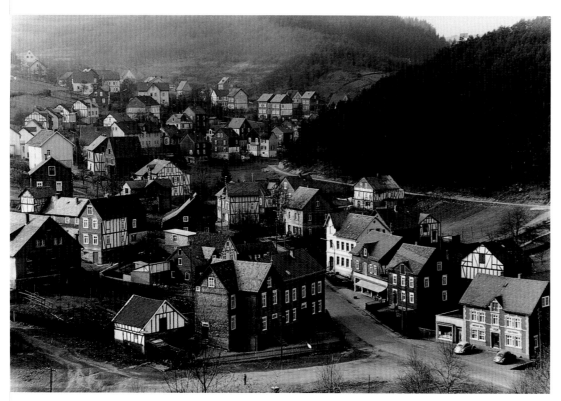

Bernd and Hilla Becher, *Gosenbach, Siegerland,* 1962 (No. 3)

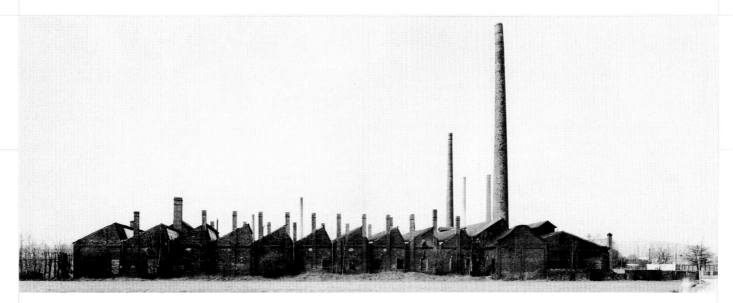

Bernd and Hilla Becher, *Ironworks in Hagen,* 1961 (No.1)

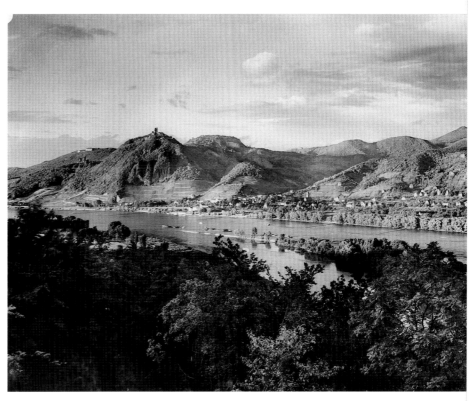

August Sander, *Siebengebirge: View from Rolandsbogen,* 1929/30 (No. 82)

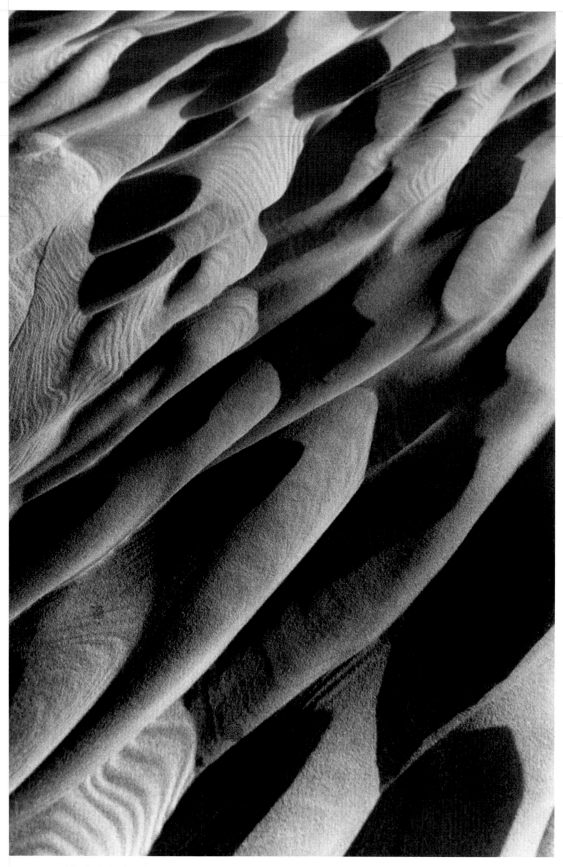

Alfred Ehrhardt, *Sharply Cut Hollows in Flat Sand,* n.d. (No. 20)

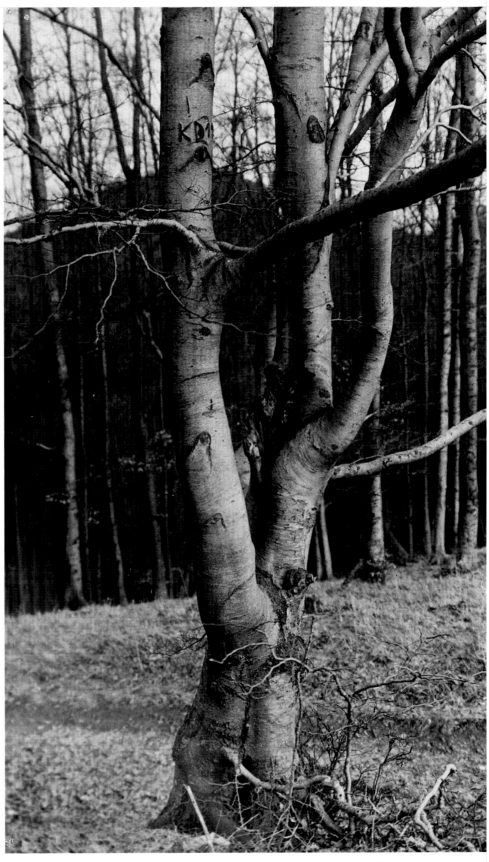

Albert Renger-Patzsch, *White Beechnut Tree on a Hill,* c. 1927/28 (No. 66)

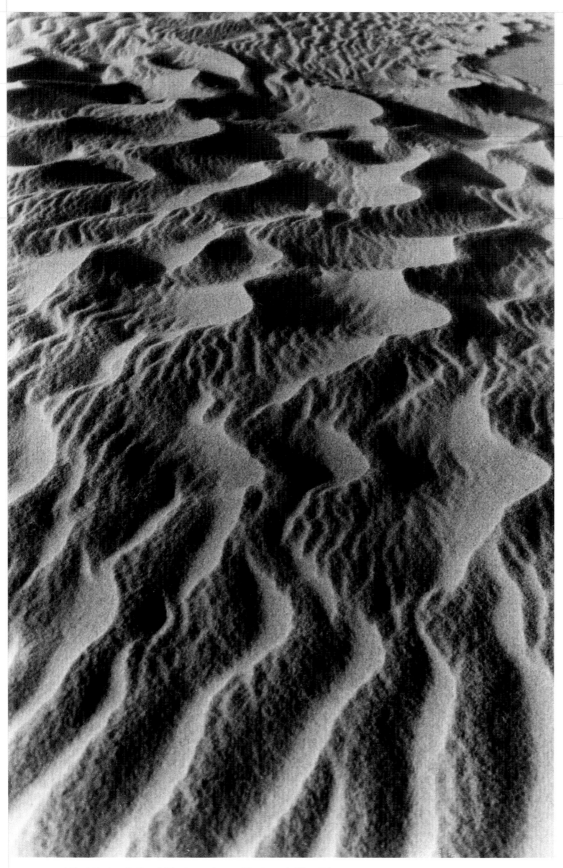

Alfred Ehrhardt, *Small Ripples on Large Ripples,* n.d. (No. 21)

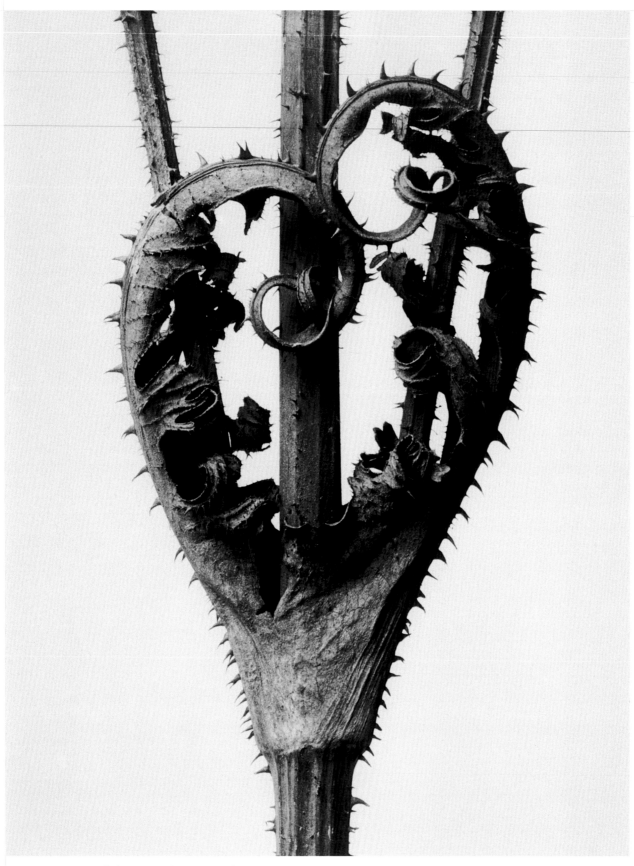

Karl Blossfeldt, *Dipsacus laciniatus, Fuller's Teasel,* 1900–1928 (No. 16)

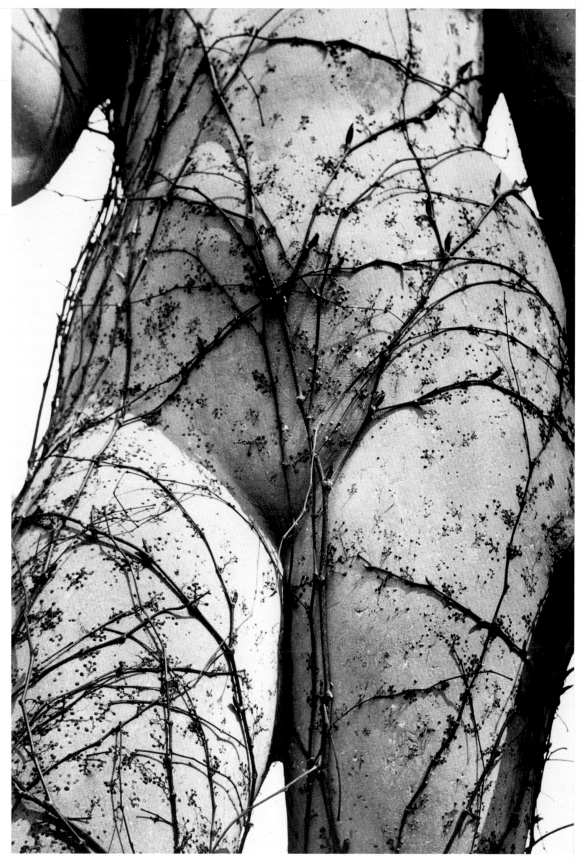

Vilém Reichmann, *Caught in a Snare,* 1940 (No. 60)

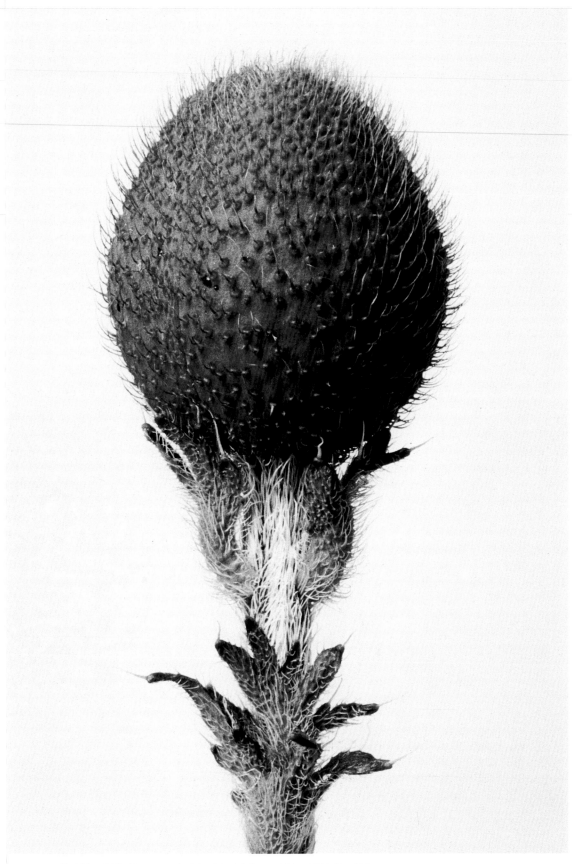

Karl Blossfeldt, *Papaver orientale, Oriental Poppy,* 1900–1928 (No. 17)

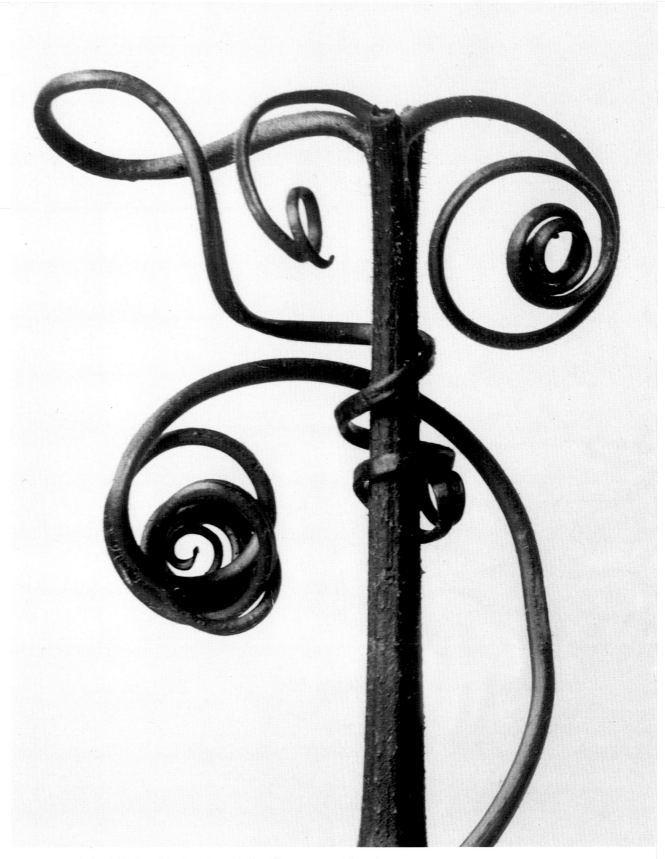

Karl Blossfeldt, *Cucurbita Pepo, Pumpkin Tendrils,* 1900–1928 (No. 15)

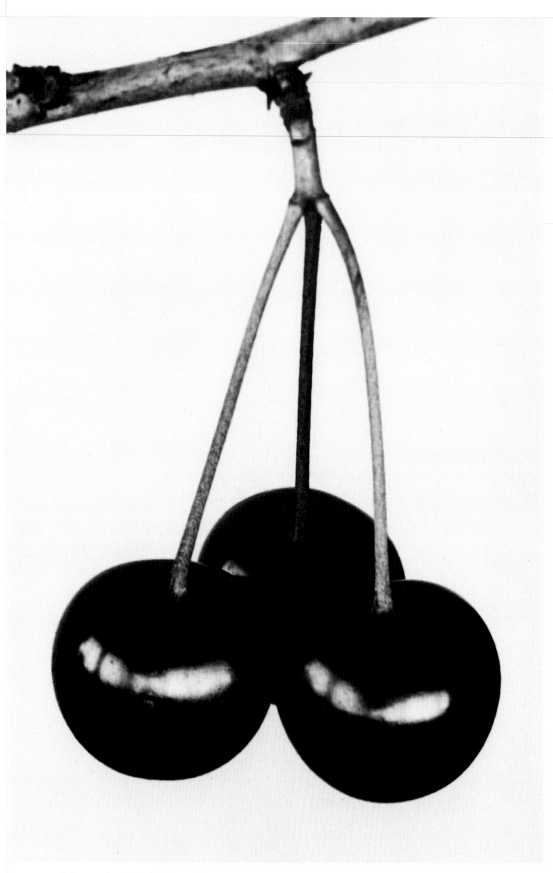

Folkwang-Auriga Verlag/Ernst Fuhrmann, *Prunus cerasus, Sour Cherries,* n.d. (No. 25)

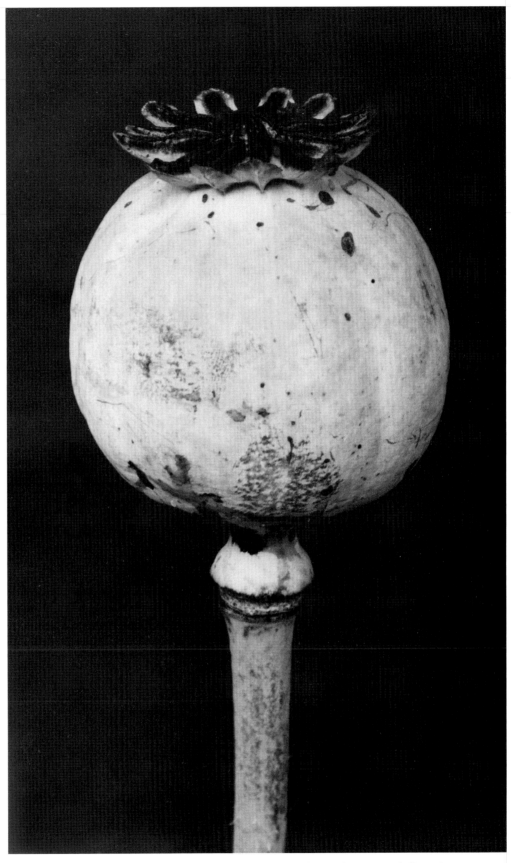

Folkwang-Auriga Verlag/Ernst Fuhrmann, *Papaver somnifer, Garden Poppy,* n.d. (No. 24)

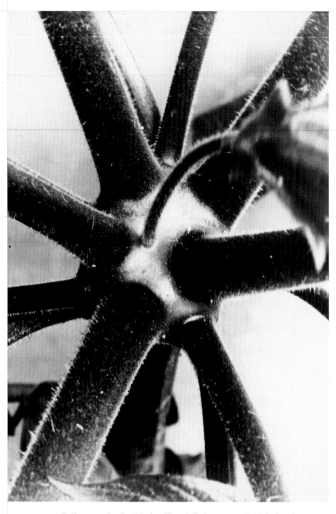

Folkwang-Auriga Verlag/Ernst Fuhrmann, *Untitled,* n.d.
(No. 27)

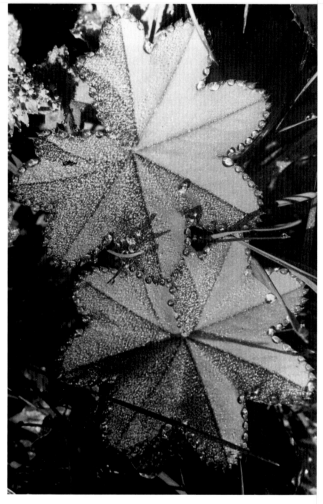

Folkwang-Auriga Verlag/Ernst Fuhrmann, *Rosacea
alchemilla vulgaris,* n.d. (No. 26)

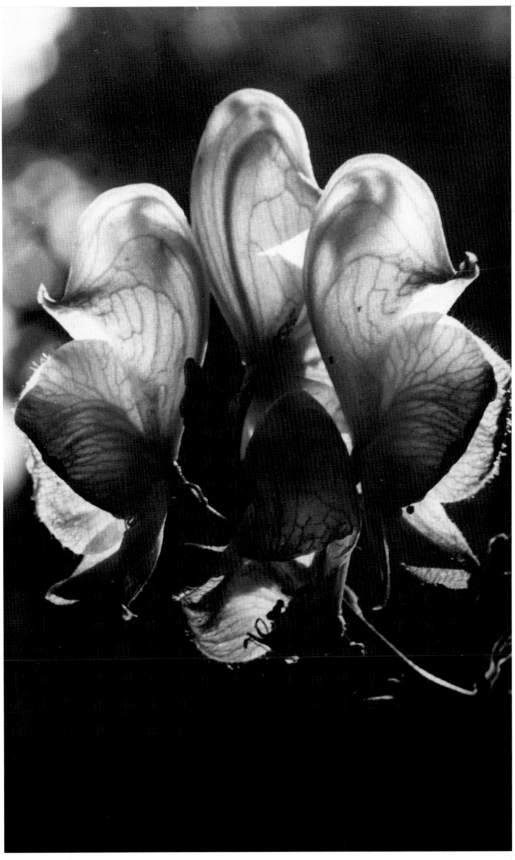

Folkwang-Auriga Verlag/Ernst Fuhrmann, *Untitled,* n.d. (No. 31)

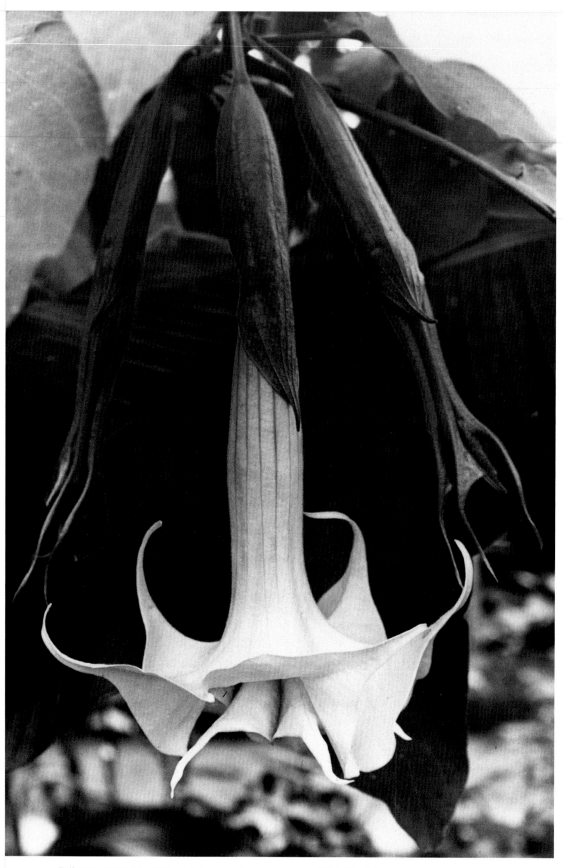

Folkwang-Auriga Verlag/Ernst Fuhrmann, *Datura artosea,* c. 1924 (No. 32)

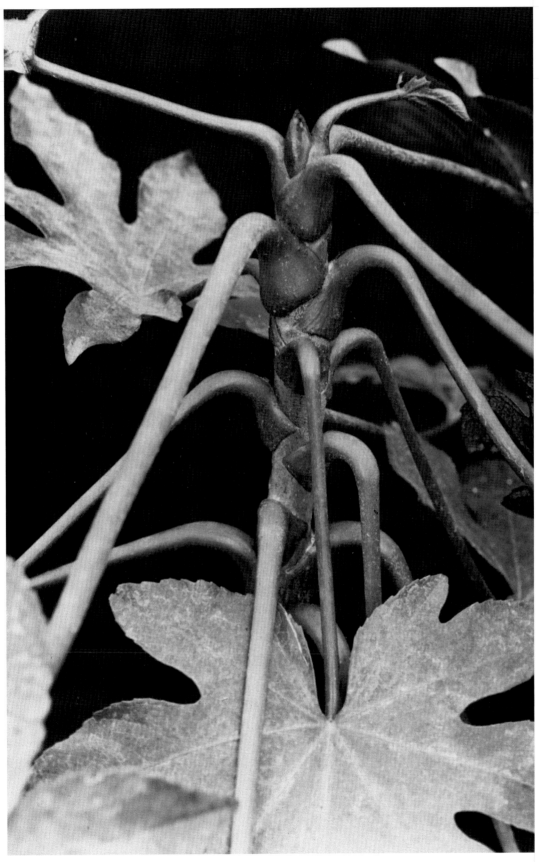

Folkwang-Auriga Verlag/Ernst Fuhrmann, *Aralia sieboldi, Exotic Ivy,* c. 1929/30 (No. 33)

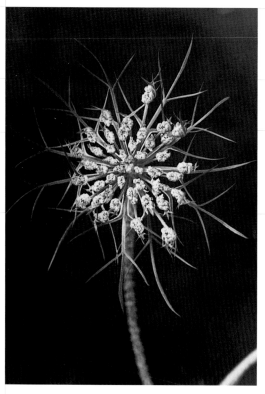

Folkwang-Auriga Verlag/Ernst Fuhrmann,
Daucus carota, Wild Carrot, n.d. (No. 23)

Unknown, *Untitled,* n.d. (No. 103)

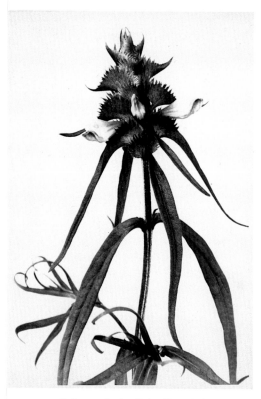

Folkwang-Auriga Verlag/Ernst Fuhrmann,
Untitled, n.d. (No. 29)

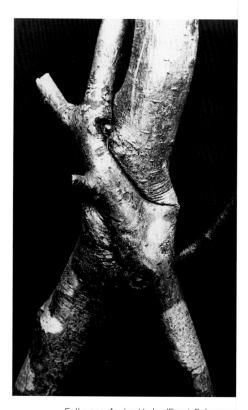

Folkwang-Auriga Verlag/Ernst Fuhrmann,
Untitled, n.d. (No. 30)

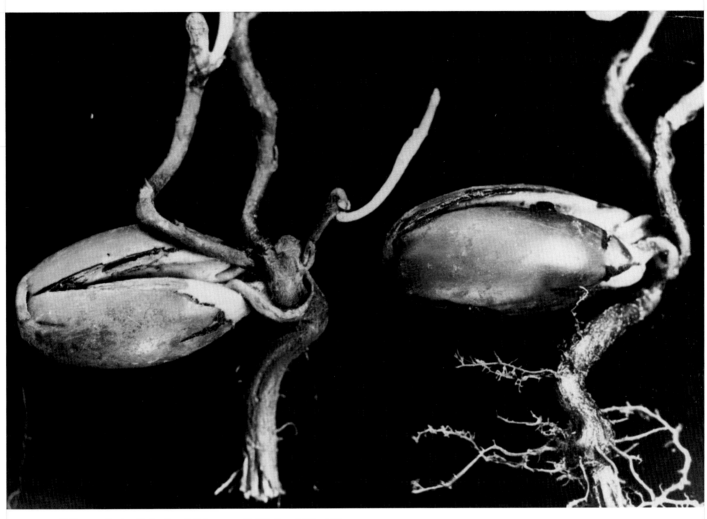

Folkwang-Auriga Verlag/Ernst Fuhrmann, *Untitled,* n. d. (No. 28)

Albert Renger-Patzsch, *Choir Stalls of Kappenberg*, c. 1921–1925 (No. 63)

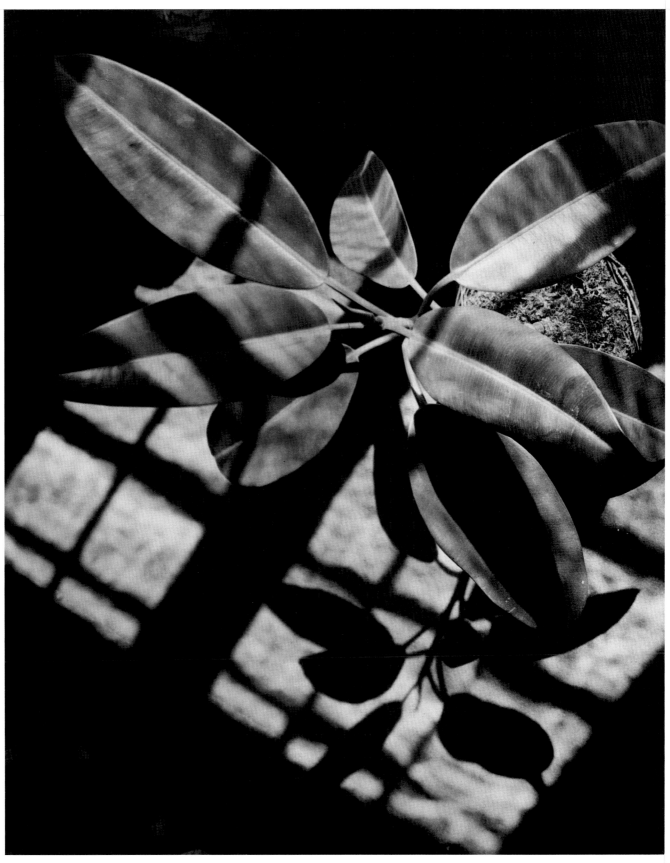

Lotte Sandau, *Rubber Tree,* 1930s (No. 71)

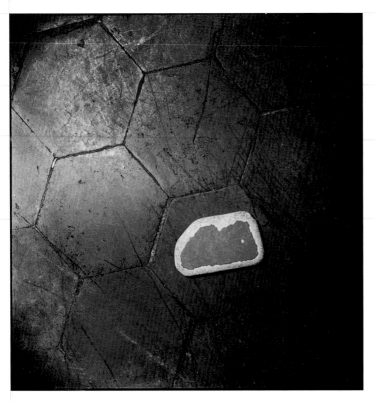

WOLS, *Untitled (Slice of Bread),* c. 1938/39 (No. 128)

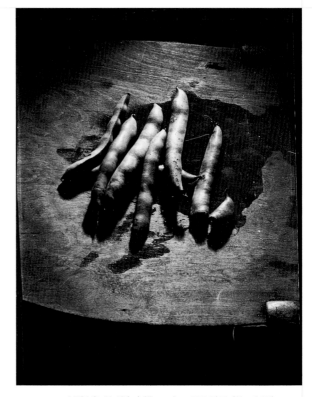

WOLS, *Untitled (Beans),* c. 1938/39 (No. 127)

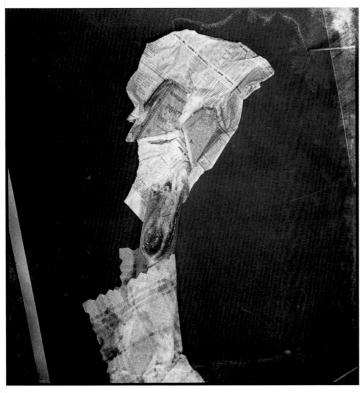

WOLS, *Untitled (Baguette Head),* c. 1938/39 (No. 126)

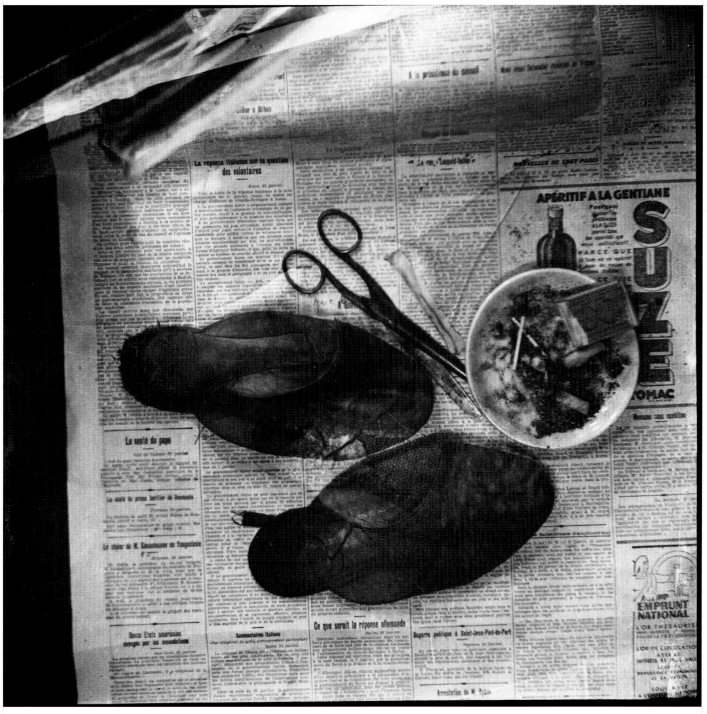

WOLS, *Untitled,* n.d. (No. 116)

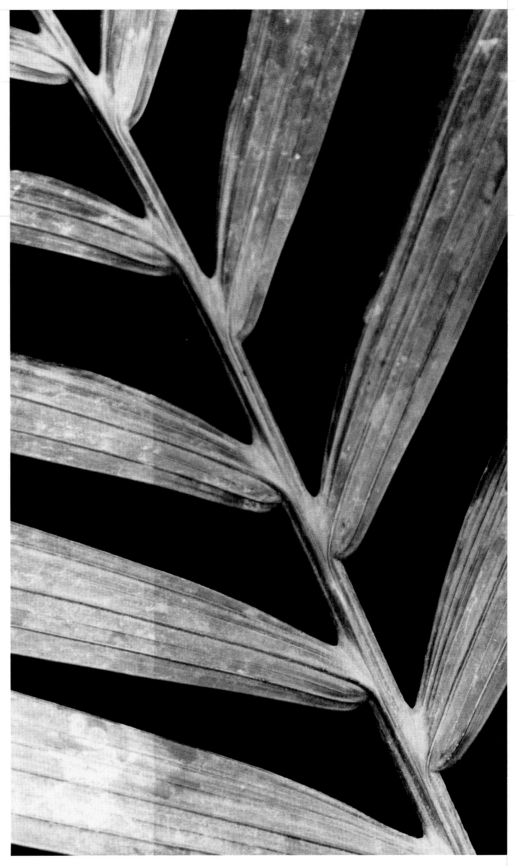

Folkwang-Auriga Verlag/Ernst Fuhrmann, *Kentia forsteriana,* c. 1929/30 (No. 22)

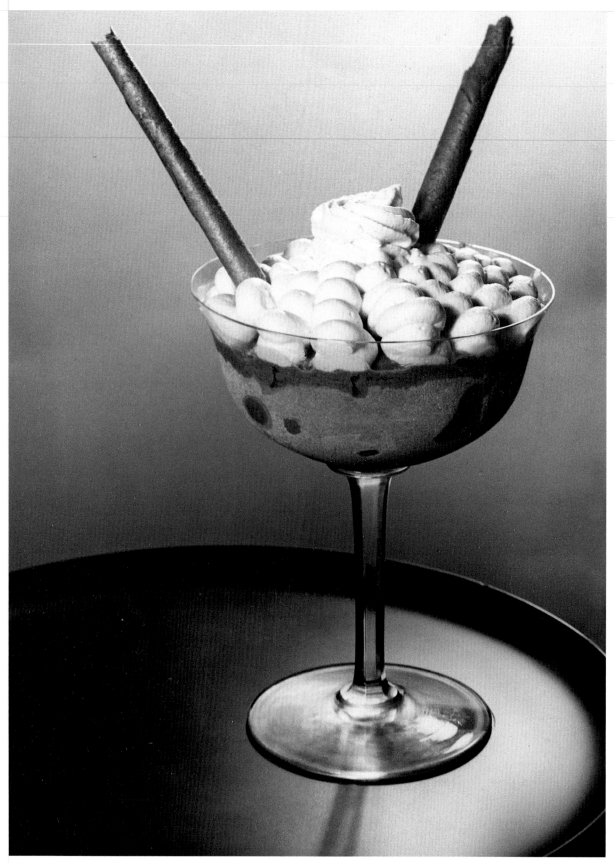

Albert Renger-Patzsch, *Kaba,* 1926/27 (No. 64)

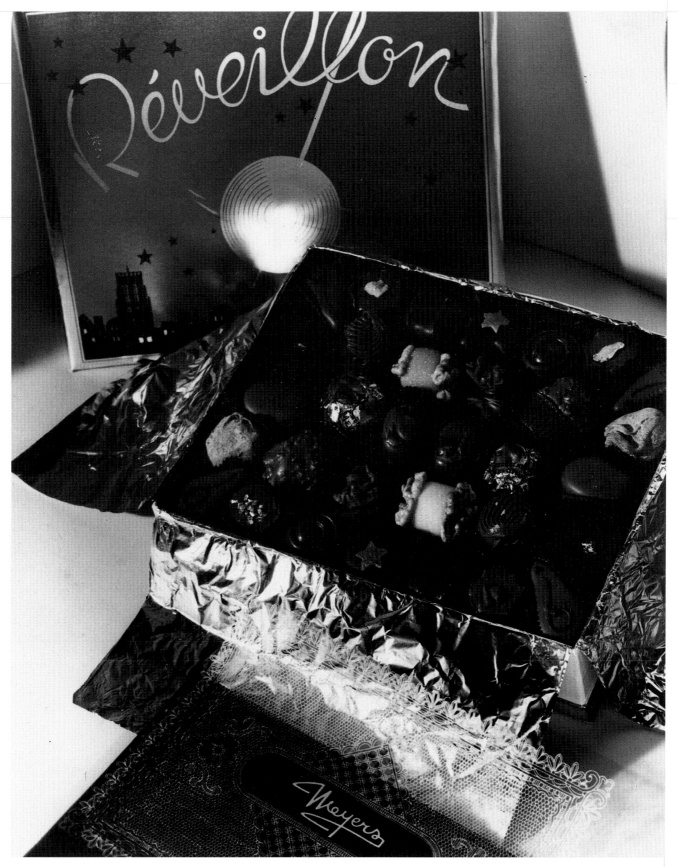

Willy Kessels, *Untitled,* n.d. (No. 43)

Willy Zielke, *Osram Light Bulbs,* c. 1933 (No. 131)

All works are in the collection of the Norton Museum of Art, West Palm Beach, Florida, Gift of Baroness Jeane von Oppenheim.
If not otherwise noted, all images are gelatin silver prints.

BERND AND HILLA BECHER

1 Page 111
Eisenwerk in Hagen (Ironworks in Hagen, Germany), 1961
Signed (Bernhard Becher), dated and titled on verso
6 x 15 5/8 in. (15.2 x 39.7 cm), 98.78

2 Page 110
Wildener Straße, Salchendorf (Wildener Street, Salchendorf, Group of Framework Houses of the Siegen Industrial Region, Germany), 1961
Signed (Bernhard Becher) and dated on verso
11 7/8 x 15 5/8 in. (30.1 x 39.7 cm), 98.87

Reproduced in:
Bernd und Hilla Becher: Fachwerkhäuser des Siegener Industriegebietes, Munich 1977, plate 338.

3 Page 110
Gosenbach, Siegerland (Group of Framework Houses of the Siegen Industrial Region of Gosenbach, Germany), 1962
Signed (Bernhard Becher), dated and titled on verso
11 x 15 5/8 in. (27.9 x 39.7 cm), 98.86

Reproduced in:
Bernd und Hilla Becher: Fachwerkhäuser des Siegener Industriegebietes, Munich 1977, plate 349.

4 Page 55
Zeche Neu-Iserlohn, Schacht 3, Bochum-Werne, Ruhrgebiet (Minehead Neu-Iserlohn, Pit 3, Bochum-Werne, Ruhr Area, Germany), 1963
Signed (Bernhard Becher), dated and titled on verso
15 3/4 x 11 3/4 in. (40 x 29.9 cm), 98.89

Reproduced in:
Bernd und Hilla Becher, exh. cat., Van Abbemuseum Eindhoven 1981, p. 20.

Bernd und Hilla Becher: Fördertürme, exh. cat., Museum Folkwang Essen 1985, p. 146.

Bernd und Becher: Vergleiche technischer Konstruktionen, cat. 22, Gegenverkehr e.V. Zentrum für aktuelle Kunst Aachen 1971, n.p.

5 Page 52
Kühltürme (Cooling Towers), 1963–1973
Typology of 9 prints
Signed and numbered (1–9) on verso (each)
9 3/8 x 7 1/8 in. (23.8 x 18.1 cm) each, 98.101a-i

Reproduced in:
Bernd und Hilla Becher, exh. cat., Van Abbemuseum Eindhoven 1981, pp. 58, 62.

Bernd und Hilla Becher: Serien, Deutsche Bank Collection, Mainz 1998, p. 45.

(Similar) *Bernd & Hilla Becher,* Geneva 1973, n.p.

6 Page 53
Kühltürme (Cooling Towers), 1963–1973
Typology of 9 prints
Signed and numbered on verso (each)
9 3/8 x 7 1/8 in. (23.8 x 18.1 cm) each, 98.102a-i

Reproduced in:
Bernd und Hilla Becher, exh. cat., Van Abbemuseum Eindhoven 1981, pp. 58, 62.

(Similar) *Bernd und Hilla Becher,* Geneva 1973, n.p.

7 Page 55
Silo für Kokskohle, Kokerei "Eschweiler Reserve" bei Aachen (Silo, Coking Plant "Eschweiler Reserve" near Aachen, Germany), 1966
Signed (Bernhard Becher), dated and copyright stamp on verso
15 5/8 x 11 1/4 in. (39.7 x 28.6 cm), 98.90

Reproduced in:
Bernd und Hilla Becher, exh. cat., Van Abbemuseum Eindhoven 1981, p. 99.

Bernd und Hilla Becher: Anonyme Skulpturen. Eine Typologie technischer Bauten, Düsseldorf 1970, n.p.

Bernd und Hilla Becher: Serien. Deutsche Bank Collection, Mainz 1998, p. 32.

Kahmen, Volker, *Photography as Art,* Tübingen 1974, p. 144.

8 Page 51
Doppelwasserturm Douay, Nordfrankreich (Double Watertower Douay, Northern France), 1967
Signed (Bernhard Becher, Hilla Becher) on verso
12 3/8 x 16 in. (31.4 x 40.6 cm), 98.100

Reproduced in:
Bernd und Hilla Becher, exh. cat., Van Abbemuseum Eindhoven 1981, p. 54.

Bernd und Hilla Becher: Serien. Deutsche Bank Collection, Mainz 1998, p. 102.

Bernd und Hilla Becher: Water Towers, Munich 1988, plate 175.

9 Page 54
Wasserturm, Köln-Kalk (Watertower, Cologne-Kalk, Germany), 1967
Inscribed (Herzliche Grüße Bernd) and copyright stamp on verso
9 3/8 x 7 1/8 in. (23.8 x 18.1 cm), 98.93

Reproduced in:
Bernd und Hilla Becher, exh. cat., Van Abbemuseum Eindhoven 1981, pp. 47, 52.

Bernd und Hilla Becher, Geneva 1973, n.p.

Bernd und Hilla Becher: Water Towers, Munich 1988, plate 92.

Steinhausen, Monika (ed.), *Bernd und Hilla Becher: Industriephotographie,* Düsseldorf 1994, p. 116.

10 Page 45
Zeche Concordia, Oberhausen (The Concordia Mine, Oberhausen, Germany), 1967

Signed, dated and titled on verso
15 15/16 x 12 in. (40.5 x 30.5 cm), 98.96

11 Page 54
Wasserturm, Duisburg, Heidrich (Watertower, Germany), c. 1975
Signed (Bernhard Becher), inscribed and copyright stamp on verso
9 1/15 x 6 7/8 in. (23 x 17.5 cm), 98.94

Reproduced in:
Bernd und Hilla Becher, Geneva 1973.

12 Page 55
Wasserturm, Findlay, Ohio, USA (Watertower), 1977
Signed (Bernhard Becher, Hilla Becher) and dated on verso
15 7/8 x 12 1/4 in. (40.3 x 31.1 cm), 98.91

Reproduced in:
Bernd und Hilla Becher, exh. cat., Van Abbemuseum Eindhoven 1981, pp. 50, 57.

Bernd und Hilla Becher: Grundformen, Munich 1993, plate 57.

Bernd und Hilla Becher: Water Towers, Munich 1988, plate 153.

BORIS BECKER

13 Page 56
Kölner Dom, Westfassade (Cologne Cathedral, West Facade), December 9, 1993
C-print
Ed. 11/15, edition for the Kölnischer Kunstverein, Cologne, 1993
Signed, dated, numbered and titled on verso
22 1/2 x 16 1/2 in. (57.2 x 41.9 cm), 98.103

14 Page 61
Feld 1297 (Field 1297), 1995
C-print

Ed. 7/20, edition for the Kölnischer Kunstverein, Cologne, 1996
Signed, dated, numbered and titled on verso
12 x 16 in. (30.5 x 40.8 cm)

Reproduced in:
Boris Becker: Felder, exh. cat., Galerie Fiedler Cologne 1995, n.p.

KARL BLOSSFELDT

15 Page 119
Cucurbita, Kürbisranken, 4 mal vergrößert (Plant Study, Cucurbita Pepo, Pumpkin Tendrils, Blown-up Four Times), 1900–1928, printed 1975
No. 10 from a portfolio of twelve photographs, ed. by Galerie Wilde, Cologne, in an edition of 50 (ed. 2/50)
Stamped and numbered by Galerie Wilde on verso
10 1/4 x 8 1/8 in. (26 x 20.6 cm), 98.117

Reproduced in:
Blossfeldt, Karl, *Urformen der Kunst,* Dortmund 1982, p. 117.

Karl Blossfeldt 1865–1932. Das Fotografische Werk, Munich 1981, plate 53.

Karl Blossfeldt: Wunder in der Natur, Leipzig 1946, p. 115.

Honnef, Klaus. *Karl Blossfeldt: Photographien 1900–1932,* exh. cat., Rheinisches Landesmuseum Bonn 1976, p. 105.

Nierendorf, Karl (ed.), *Urformen der Kunst. Photographische Pflanzenbilder von Professor Karl Blossfeldt,* Berlin 1936, p. 47.

Photosammlung Museum Ludwig, Museum Ludwig Cologne 1986, p. 215.

Steinorth, Karl. *Photographen der zwanziger Jahre,* Munich n.d., p. 35.

Wilde, Ann and Jürgen (eds.), *Karl Blossfeldt: Photographien,* Munich 1991, cover and plate 3.

16 Page 116
Dipsacus laciniatus, schlitzblättrige Karde, Weberdistel. Am Stengel getrocknete Blätter, 4 mal vergrößert (Plant Study, Fuller's Teasel, Stem with Desiccated Leaves, Blown-up Four Times), 1900–1928, printed 1975
No. 3 from a portfolio of twelve photographs, ed. by Galerie Wilde, Cologne, in an edition of 50 (ed. 2/50)
Stamped and numbered by Galerie Wilde on verso
10 1/4 x 7 15/16 in. (26 x 20.2 cm), 98.110

Reproduced in:
Blossfeldt, Karl, *Urformen der Kunst,* Dortmund 1982, p. 99.

Karl Blossfeldt 1865–1932. Das Fotografische Werk, Munich 1981, plate 44.

Karl Blossfeldt: Wunder in der Natur, Leipzig 1946, p. 2.

Honnef, Klaus, *Karl Blossfeldt: Photographien 1900–1932,* exh. cat., Rheinisches Landesmuseum Bonn 1976, p. 123.

Mellor, David (ed.), *Germany: The new Photography 1927–1933,* London 1978, p. 22.

Die Arbeit des Photographen, Kunstforum, 16, 1976, n.p.

Nierendorf, Karl (ed.), *Urformen der Kunst. Photographische Pflanzenbilder von Professor Karl Blossfeldt,* Berlin 1936, p. 41.

Photographie als Kunst 1879–1979, exh. cat., Tiroler Landesmuseum Ferdinandeum Innsbruck 1979, et al., p. 283.

Photosammlung Museum Ludwig, Museum Ludwig Cologne 1986, p. 214.

Steinorth, Karl, *Photographen der zwanziger Jahre,* Munich n.d., p. 35.

Wilde, Ann and Jürgen (eds.), *Karl Blossfeldt: Photographien,* Munich 1991, plate 18.

17 Page 118
Papaver orientale, orientalischer Mohn, Türkenmohn, Blütenknospe, 5 mal vergrößert (Plant Study, Oriental Poppy, Bud Blown-up Five Times), 1900–1928, printed 1975
No. 5 from a portfolio of twelve photographs, ed. by Galerie Wilde, Cologne, in an edition of 50 (ed. 2/50)
Stamped and numbered by Galerie Wilde on verso
10 1/4 x 7 1/8 in. (26 x 18.1 cm), 98.112

Reproduced in:
Honnef, Klaus, *Karl Blossfeldt: Photographien 1900–1932,* exh. cat., Rheinisches Landesmuseum Bonn 1976, p. 89.

Photosammlung Museum Ludwig, Museum Ludwig Cologne 1986, p. 215.

Wilde, Ann and Jürgen (eds.), *Karl Blossfeldt: Photographien,* Munich 1991, plate 20.

KATTINA BOTH

18 Page 59
Untitled (Shoes in Drawers), Celle, Germany, 1929
Signed on verso (Katt Both)
3 3/8 x 2 3/16 in. (8.6 x 5.6 cm), 98.121

Reproduced in:
Photography and the Bauhaus, The Archive-Center for Creative Photography, University of Arizona, Research Series, 21, March 1985, plate 18.

HERMANN CLAASEN

19 Page 38
Heimkehrer auf der Ruine seines Hauses (Returnee at the Site of the Ruins of His House), Cologne, Germany, 1947
Signed, photographer's stamp and inscribed with typewriter on verso
14 3/8 x 10 3/8 in. (36.5 x 26.4 cm), 98.728

Reproduced in:
(Detail) Claasen, Hermann, *Das Ende. Kriegszerstörungen im Rheinland,* Cologne 1983, p. 65.

(Detail) Claasen, Hermann, *Nichts erinnert mehr an Frieden. Bilder einer zerstörten Stadt,* Cologne 1985, p. 64.

ALFRED EHRHARDT

20 Page 112
Scharf geschliffene Hohlformen in ebener Sandfläche (Sharply Cut Hollows in Flat Sand. Probably from the Series "Kurische Nehrung"), n.d. (c. 1936)
Photographer's stamp on verso
9 3/8 x 6 1/4 in. (23.8 x 15.9 cm), 98.177

21 Page 114
Kleine Wellungen auf großen Wellungen (Small Ripples on Large Ripples. Probably from the Series "Das Watt"), n.d. (c. 1936)
Titled and photographer's stamp on verso
9 3/8 x 6 5/16 in. (23.8 x 16 cm), 98.179

FOLKWANG-AURIGA VERLAG / ERNST FUHRMANN

22 Page 135
Kentia forsteriana (Plant Study), c. 1929/30
6 5/8 x 4 1/16 in. (16.8 x 10.3 cm), 98.131

23 Page 126

Daucus carota, wilde Möhre (Plant Study, Wild Carrot), n.d. (c. 1930)

6 3/8 x 4 7/16 in. (16.2 x 11.3 cm), 98.188

24 Page 121

Papaver somnifer, Gartenmohn, ganze Kapsel (Plant Study, Garden Poppy, Whole Capsule), n.d. (c. 1930)

6 5/8 x 4 1/16 in. (16.8 x 10.3 cm), 98.199

25 Page 120

Prunus cerasus, Sauerkirsche (Plant Study, Sour Cherries), n.d. (c. 1930)

6 1/4 x 4 1/16 in. (15.9 x 10.3 cm), 98.195

Reproduced in:

Fuhrmann, Ernst, *Die Pflanze als Lebewesen*, Frankfurt 1930, p. 200.

26 Page 122

Rosacea alchemilla vulgaris, Frauenmantel (Plant Study), n.d. (c. 1930)

Titled on verso

6 1/4 x 4 1/8 in. (15.9 x 10.5 cm), 98.194

27 Page 122

Untitled (Plant Study), n.d. (c. 1930)

6 11/16 x 4 9/16 in. (17 x 11.6 cm), 98.191

28 Page 127

Untitled (Plant Study, Sprouting Seeds), n.d. (c. 1930)

4 7/16 x 6 7/16 in. (11.3 x 16.4 cm), 98.209

29 Page 126

Untitled (Plant Study), n.d. (c. 1930)

6 11/16 x 4 9/16 in. (7 x 11.6 cm), 98.204

30 Page 126

Untitled (Plant Study), n.d. (c. 1930)

6 9/16 x 4 1/8 in. (16.7 x 10.5 cm), 98.196

31 Page 123

Untitled (Plant Study), n.d. (c. 1930)

6 9/16 x 4 1/8 in. (16.7 x 10.5 cm), 98.202

32 Page 124

Attributed to Albert Renger-Patzsch

Datura artosea (Plant Study, Blossom), c. 1924

6 3/8 x 4 3/8 in. (16.2 x 11.1 cm), 98.216

Reproduced in:

Photographische Korrespondenz, 63, 3, March 1, 1927, p. 82.

33 Page 125

Attributed to Fred Koch

Aralia sieboldi, exotische Efeuart (Plant Study, Exotic Ivy), c. 1929/30

6 11/16 x 4 3/8 in. (17 x 11.1 cm), 98.221

Reproduced in:

Fuhrmann, Ernst, *Die Pflanze als Lebewesen*, Frankfurt 1930, p. 192.

KARL GRILL

34 Page 24

Daisy Spies, Triadisches Ballett, Schlemmer-Hindemith, Musikfest Donaueschingen (The Dancer Daisy Spies, in Oskar Schlemmer's "Triadic Ballett," Music by Paul Hindemith, Music Festival at Donaueschingen, Germany), June 25, 1926

Blind stamp on recto; dated, inscribed and photographer's stamp on verso

9 x 6 5/8 in. (22.9 x 16.8 cm), 98.226

35 Page 25

Untitled (Photo Study of the Dancer Daisy Spies, First Public Performance, Oskar Schlemmer's "Triadic Ballet," Music by Paul Hindemith), July 25, 1926

Blind stamp on recto

9 x 6 9/16 in. (22.9 x 16.2 cm), 98.227

F. C. GUNDLACH

36 Page 29

Hamburg, 1957, printed 1983

Ed. 3/20

Signed, dated and numbered on verso

10 15/16 x 8 9/16 in. (27.8 x 21.8 cm), 98.232

CANDIDA HÖFER

37 Page 46

Bahnhof Stadelhofen Zürich (Stadelhofen Train Station Zurich, Switzerland), 1991

C-print

Ed. 4/6

Signed, dated, numbered and titled on verso

14 x 21 in. (35.6 x 53.3 cm), 98.736

Reproduced in:

Candida Höfer: Photographie, exh. cat., Fotomuseum im Münchner Stadtmuseum, Cologne 1992, p. 51 and plate 19.

LOTTE JACOBI

38 Page 27

Drehung (The Turn, the Dancer Claire Bauroff), Berlin, 1928, printed later

Signed on recto

9 3/4 x 7 in. (24.8 x 17.8 cm), 98.295

Reproduced in:

Beckers, Marion and Elisabeth Moortgat, *Atelier Lotte Jacobi: Berlin – New York,* exh. cat., Das Verborgene Museum Berlin 1997, et al., p. 110 and plate 54.

Lotte Jacobi 1896–1990. Berlin – New York – Deering, exh. cat., Museum Folkwang Essen 1990/91, p. 36.

Wise, Kelly (ed.), *Lotte Jacobi,* Danbury, New Hampshire 1978, p. 153.

39 Page 30
Lotte Lenya, Berlin, 1928, printed later
Signed on recto
7 1/2 x 8 3/4 in. (19.1 x 22.2 cm), 98.298

Reproduced in:
Beckers, Marion and Elisabeth Moortgat,
Atelier Lotte Jacobi: Berlin – New York, exh.
cat., Das Verborgene Museum Berlin 1997,
et al., p. 87 and plate 35.

*Berlin – New York: Schriftsteller in den 30er
Jahren. Fotografiert von Lotte Jacobi,* Marbach/
Neckar 1982, p. 87.

*Lotte Jacobi 1896–1990: Berlin – New York –
Deering,* exh. cat., Museum Folkwang Essen
1990/91, p. 20.

Photography in modern Europe, The St. Louis
Art Museum Spring Bulletin, (St. Louis,
Missouri 1996), p. 11.

Wise, Kelly (ed.), *Lotte Jacobi,* Danbury, New
Hampshire 1978, p. 139.

40 Page 30
*Kopf einer Tänzerin (Head of a Dancer, the
Russian Dancer Niura Norskaya),* Berlin, 1929,
printed later
Signed on recto
7 1/4 x 9 3/16 in. (18.4 x 23.3 cm), 98.299

Reproduced in:
Beckers, Marion and Elisabeth Moortgat,
Atelier Lotte Jacobi: Berlin – New York, exh.
cat., Das Verborgene Museum Berlin 1997,
p. 67 and plate 21.

*Lotte Jacobi 1896–1990: Berlin – New York –
Deering,* exh. cat., Die Fotografische Sammlung,
Museum Folkwang Essen 1990/91, cover.

Photography in modern Europe, The St. Louis
Art Museum Spring Bulletin, (St. Louis,
Missouri 1996), p. 10.

Wise, Kelly (ed.), *Lotte Jacobi,* Danbury, New
Hampshire 1978, p. 135.

PETER KEETMAN

41 Page 58
Spuren im Eis (Tracks on Ice), 1982
Copyright stamp on verso
11 3/4 x 8 3/4 in. (29.9 x 22.2 cm), 98.334

Reproduced in:
Sachsse, Rolf, *Peter Keetman. Fotoform,* ed. by
F. C. Gundlach, Berlin 1988, p. 93.

ANDRE KERTESZ

42 Page 75
Du-Dubon-Dubonnet (On the Boulevards), Paris,
1934
Signed and dated on verso
13 5/8 x 9 7/8 in. (34.6 x 25.1 cm), 98.341

Reproduced in:
Borhan, Pierre, *André Kertész: His Life and
Work,* Boston and New York 1995, p. 191.

Ducrot, Nicolas (ed.), *André Kertész: 60 Jahre
Photographie 1912–1972,* Düsseldorf 1972,
p. 129.

André Kertész: A Lifetime of Photography,
London 1982, p. 61.

André Kertész: De Paris et de New York,
exh. cat., Palais de Tokyo Paris 1986, p. 11.

André Kertész: Ma France, Paris 1990, p. 209.

André Kertész: Of Paris and New York, Chicago
1985, p. 194.

*André Kertész: Soixante-dix années de
photographie,* Paris 1987, plate 49.

Naef, Weston J., Sandra S. Phillips and David
Travis, *André Kertész: Of Paris and New York,*
exh. cat., The Metropolitan Museum of Art New
York 1995, et al., p. 194.

WILLY KESSELS

43 Page 137
Untitled (Chocolate Box), n.d. (1930–40s)
Photographer's stamp on verso
11 3/4 x 9 3/8 in. (29.9 x 23.8 cm), 98.344

JÜRGEN KLAUKE

44 Page 23
Sonntagsneurosen (Sunday's Neurosis), 1991
No. 1 from a portfolio of eight photographs, ed.
by Edition Gutsch, Berlin, in an edition of 30
(ed. 28/30 + 5)
Signed, dated, numbered and titled on verso
23 5/8 x 18 7/16 in. (60 x 46.8 cm), 98.359.1

Reproduced in:
Herzog, Hans Michael (ed.), *Jürgen Klauke:
"Prosecuritas",* Ostfildern 1994, p. 11.

UTE LINDNER

45 Page 43
Wilhelmshöhe (Auditorium), 1996
C-print
Ed. 1/1
Signed, dated, numbered and titled on verso
on mount
12 x 15 3/4 in. (30.5 x 40 cm), 98.379

ROBERT MAPPLETHORPE

46 Page 99
Baroness Jeane von Oppenheim, 1983
Signed and dated on verso
19 1/4 x 15 1/4 in. (48.9 x 38.7 cm), 98.405

LUCIA MOHOLY

47 Page 94
Franz Roh, 1926, printed 1983
Inscribed with typewriter on verso
15 5/8 x 11 1/2 in. (39.7 x 29.2 cm), 98.437

Reproduced in:
Deutsche Fotografie. Macht eines Mediums,
exh. cat., Kunst- und Ausstellungshalle der
Bundesrepublik Deutschland Bonn 1997, p. 252
and plate 42.

Photography and the Bauhaus, The Archive -
Center for Creative Photography, University of
Arizona, Research series, no. 21, March, 1985,
p. 22.

Photography in modern Europe, The St. Louis
Art Museum Spring Bulletin, (St. Louis,
Missouri 1996), p. 9.

Sachsse, Rolf, *Lucia Moholy,* Düsseldorf 1985,
p. 120.

Sachsse, Rolf, *Lucia Moholy: Bauhaus
Fotografin,* Bauhaus-Archive, Gegenwart
Museum Berlin 1995, p. 32.

48 Page 87
Walter Gropius, 1927, printed 1983
Signed, dated and titled on sticker on verso
15 7/8 x 11 3/4 in. (40.3 x 29.9 cm), 98.443

Reproduced in:
Sachsse, Rolf, *Lucia Moholy,* Düsseldorf 1985,
p. 128.

Sachsse, Rolf, *Lucia Moholy: Bauhaus
Fotografin,* Bauhaus-Archive, Gegenwart
Museum Berlin 1995, p. 119.

SIGMAR POLKE

49 Page 71
Untitled (Düsseldorf), 1969
Signed, dated and inscribed on verso
4 13/16 x 6 3/4 in. (12.2 x 17.2 cm), 98.462

Reproduced in:
(Similar) *Sigmar Polke: Photoworks. When
pictures vanish,* exh. cat., The Museum of
Contemporary Art Los Angeles 1996, p. 93.

50 Page 68
Untitled (Düsseldorf), 1970
Signed, dated and inscribed on verso
7 1/16 x 9 3/4 in. (17.9 x 24.8 cm), 98.451

51 Page 68
Untitled (Geneva), 1970
Signed, dated and inscribed on verso
8 1/2 x 8 11/16 in. (21.6 x 22.1 cm), 98.450

Reproduced in:
(Similar) *Sigmar Polke: Photoworks. When
pictures vanish,* exh. cat., The Museum of
Contemporary Art Los Angeles 1996, pp. 96, 97.

52 Page 70
Untitled (Geneva), 1970
Signed, dated and inscribed on verso
7 1/16 x 9 3/8 in. (17.9 x 23.8 cm), 98.452

Reproduced in:
(Similar) *Sigmar Polke: Photoworks. When
pictures vanish,* exh. cat., The Museum of
Contemporary Art Los Angeles 1996, pp. 96, 97.

53 Page 66
Untitled (Geneva), 1970
Signed, dated and inscribed on verso
7 1/8 x 9 3/8 in. (18.1 x 23.8 cm), 98.456

Reproduced in:
(Similar) *Sigmar Polke: Photoworks. When
pictures vanish,* exh. cat., The Museum of
Contemporary Art Los Angeles 1996, pp. 96, 97.

54 Page 69
Untitled (Geneva), 1970
Signed, dated and inscribed on verso
8 5/8 x 6 9/16 in. (21.9 x 14.3 cm), 98.454

Reproduced in:
(Similar) *Sigmar Polke: Photoworks. When
pictures vanish,* exh. cat., The Museum of
Contemporary Art Los Angeles 1996, pp. 96, 97.

55 Page 67
Untitled (Geneva), 1970
Signed, dated and inscribed on verso
9 3/8 x 7 1/8 in. (23.8 x 18.1 cm), 98.453

Reproduced in:
(Similar) *Sigmar Polke: Photoworks. When
pictures vanish,* exh. cat., The Museum of
Contemporary Art Los Angeles 1996, pp. 96, 97.

56 Page 71
Untitled (Geneva), 1970
Signed, dated and inscribed on verso
7 x 9 15/16 in. (17.8 x 25.2 cm), 98.457

Reproduced in:
(Similar) *Sigmar Polke: Photoworks. When
pictures vanish,* exh. cat., The Museum of
Contemporary Art Los Angeles 1996, pp. 96, 97.

57 Page 58
Untitled (Geneva), 1970
Signed, dated and inscribed on verso
9 1/2 x 7 1/16 in. (24.3 x 17.9 cm), 98.458

Reproduced in:
(Similar) *Sigmar Polke: Photoworks. When
pictures vanish,* exh. cat., The Museum of
Contemporary Art Los Angeles 1996, pp. 96, 97.

58 Page 70

Untitled (Hamburg), 1971

Signed, dated and inscribed on verso

4 5/8 x 6 5/8 in. (11.8 x 16.8 cm), 98.461

Reproduced in:

(Similar) *Sigmar Polke: Photoworks. When
pictures vanish,* exh. cat., The Museum of
Contemporary Art Los Angeles 1996, p. 98.

59 Page 41

Untitled (Reflection), 1992

Ed. 23/28

Signed, dated and numbered on verso

9 15/16 x 6 7/8 in. (23.8 x 17.5 cm), 98.463

VILEM REICHMANN

60 Page 117

Caught in a Snare (from the series "Forsare"),
Osidla, Brno, 1940

Signed, titled and photographer's stamp on
verso; inscribed on agency's sticker on verso of
mount

9 3/8 x 6 1/4 in. (23.8 x 15.9 cm), 98.795

Reproduced in:

Primus, Zdenek (ed.), *Vilém Reichmann:
Fotografien,* Berlin 1989, p. 33.

Vilém Reichmann, Czech Republik 1994,
plate 41.

61 Page 87

Sibilla (from the series "Magic"), 1975

Inscribed on verso (NN)

15 5/8 x 11 3/4 in. (39.7 x 29.9 cm), 98.470

62 Page 60

*Some Figures of Different Sexes and Tempera-
ments (from the series "Metamorphoses"),* 1965

Signed, dated and inscribed on verso

11 1/4 x 15 1/4 in. (28.6 x 38.7 cm), 98.469

ALBERT RENGER-PATZSCH

63 Page 128

*Das Chorgestühl von Kappenberg (Choir Stalls
of Kappenberg, Germany),* c. 1921–1925

Stamped on verso

6 5/8 x 9 1/8 in. (16.8 x 20.6 cm), 98.478

Reproduced in:

(Similar) *Albert Renger-Patzsch: Das
Chorgestühl von Kappenberg,* Berlin 1925, p. 33.

(Similar) Stamm, Rainer, *Der Folkwang-Verlag:
Auf dem Weg zu einem imaginären Museum,*
Frankfurt/Main 1999, p. 129.

64 Page 136

*Kaba (Kaffee Hag Advertisement, Bremen,
Germany),* 1926/27

Photographer's stamp on verso

8 15/16 x 6 5/8 in. (22.7 x 16.8 cm), 98.491

Reproduced in:

Albert Renger-Patzsch: Frühe Fotografien,
exh. cat., Würzburg 1997, p. 35.

65 Page 50

Laufkran (Crane), c. 1927/28

Titled and photographer's stamp on verso

9 1/8 x 6 5/8 in. (23.2 x 16.8 cm), 98.488

Reproduced in:

(Similar) Heise, Carl Georg (ed.), *Albert
Renger-Patzsch: Die Welt ist schön,* Munich
1928, plates 80, 92.

66 Page 113

*Weißbuchenstamm auf der Höhe (White Beech-
nut Tree on a Hill),* c. 1927/28

Titled and photographer's stamp on verso

9 1/16 x 5 7/16 in. (23 x 13.8 cm), 98.475

67 Page 41

*Haus Rocca Vispa in Ascona, Blick ins Treppen-
haus (House "Rocca Vispa" in Ascona, View of
the Staircase, Switzerland),* 1928

Inscribed and stamped by Carl Weidemeyer
(architect) on verso

8 7/8 x 6 1/2 in. (22.5 x 16.5 cm), 98.489

ALEXANDER RODCHENKO

68 Page 89

Artist Varvara Stepanova in Pushkino, 1927,
printed 1993 (from glass negative 10 x 15 cm)

No. 8 from portfolio *Rodchenko – Never Seen
Before* of twenty photographs, ed. by Galerie
Alex Lachmann, Cologne, in co-operation with
the Rodchenko family in an edition of 20
(ed. 1/20)

Numbered and photographer's stamp on verso

11 5/8 x 8 5/8 in. (29.5 x 21.9 cm), 98.514

69 Page 54

*Ladder (from the series "House at Mjas-
nitzkaja"),* 1925, printed 1993 (from glass
negative 4 x 6.5 cm)

No. 14 from portfolio *Rodchenko – Never Seen
Before* of twenty photographs, ed. by Galerie
Alex Lachmann, Cologne, in co-operation with
the Rodchenko family in an edition of 20
(ed. 1/20)

Numbered and photographer's stamp on verso

11 3/8 x 9 in. (28.9 x 22.9 cm), 98.509

Reproduced in:

(Variation) Gassner, Hubertus, *Rodchenko
Fotografien,* Munich 1982, plate 8.

(Variation) Lavrentiev, Alexander, *Alexander
Rodchenko: Photography 1924–1954,* Cologne
1995, p. 118.

70 Page 49

Stairs, 1930

Photographer's stamp on verso

6 7/8 x 9 1/4 in. (17.5 x 23.5 cm), 98.516

Reproduced in:

Boettger, Tete and Gerd Unverfehrt (eds.),
Rodtschenko: Fotograf. 1891–1956, exh. cat.,
Münchner Stadtmuseum, Munich 1989, p. 74
and plate 56.

Gassner, Hubertus, *Rodchenko Fotografien,*
Munich 1982, plate 143.

Keller, Ulrich, Herbert Molderings and Winfried
Ranke (eds.), *Beiträge zur Geschichte und
Ästhetik der Fotografie,* Lahn-Gießen 1977,
p. 82.

Lavrentiev, Alexander, *Alexander Rodchenko:
Photography 1924–1954,* Cologne 1995,
p. 51 and plate 188.

*Alexander Rodtschenko: Fotografien
1920–1938,* exh. cat., Bauhaus Archive,
Museum für Gestaltung Berlin 1978, p. 101.

LOTTE SANDAU

71 Page 131

Gummibaum (Rubber Tree), 1930s

Photographer's stamp on verso

8 7/16 x 8 7/16 in. (21.4 x 21.4 cm), 98.490

AUGUST SANDER

72 Page 33

*Soldatische Größenunterschiede (Different
Heights of Soldiers),* France, 1915

Signed and dated on recto of mount; titled on
verso of mount

8 3/4 x 6 3/8 in. (22.2 x 16.2 cm), 98.520

Reproduced in:

August Sander: Menschen ohne Maske. Lucerne
and Frankfurt/Main 1971, plate 126.

73 Page 37

*Brühler Flötenquartett anläßlich des 4. Rheini-
schen Kammermusikfestes (Flute Quartet of
Brühl, on the Occasion of the 4th Chamber
Music Festival, from Left: Heinrich Albert,
Gustav Kaleve, Karl Wilke, Willi Lamping),*
Brühl, Germany, 1925

Artist's blind stamp on recto

10 7/16 x 8 in. (26.5 x 20.3 cm), 98.518

74 Page 28

*Der Schauspieler Carl de Vogt (The Actor Carl
de Vogt),* 1925–1930

Artist's blind stamp on recto; photographer's
stamp on verso

8 13/16 x 6 7/16 in. (22.4 x 16.4 cm), 98.523

75 Page 37

Malerin (Painter), 1925–1930

Artist's blind stamp on recto; artist's sticker on
verso of mount

9 7/16 x 5 3/4 in. (24 x 14.6 cm), 98.554

76 Page 37

Jungbauern (Young Farmers), c. 1926

Artist's blind stamp on recto; inscribed on verso

9 1/8 x 6 3/4 in. (23.2 x 17.2 cm), 98.538

77 Page 85

Kleinstädterin (Small-towner), 1926

Artist's blind stamp on recto; dated on verso
and on recto of mount

11 3/8 x 8 1/2 in. (28.9 x 21.6 cm), 98.551

78 Page 87

Der Maler (The Painter Anton Räderscheidt),
Cologne, Germany, 1926, printed 1986

Artist's blind stamp on recto; sticker of the
August Sander Archive, New York on verso of
mount

9 15/16 x 7 1/8 in. (25.2 x 18.1 cm), 98.559

Reproduced in:

Die Arbeit des Photographen, Kunstforum, 16,
1976, n.p.

Kahmen, Volker, *Photography as Art,* Tübingen
1974, p. 87 and plate 137.

August Sander, New York 1977, p. 2.

August Sander: 1876–1964, exh. cat., La Fun-
dación caja des Pensiones Madrid 1986, p. 117.

August Sander: Menschen ohne Maske, Lucerne
and Frankfurt/Main 1971, plate 139.

*August Sander: Photographs of an Epoch.
1904–1959,* exh. cat., New York 1980, p. 73.

Sander – Becher, exh. cat., Ständige Vertretung
der Bundesrepublik Deutschland, Cologne 1980,
p. 32.

Sander, Gunther (ed.), *August Sander,* Leipzig
1982, p. 92.

Sander, Gunther (ed.), *August Sander: Men-
schen des 20. Jahrhunderts. Portraitphotogra-
phien 1928–1952,* Munich 1980, p. 318.

*Zeitgenossen: August Sander und die Kunst-
szene der 20er Jahre im Rheinland,* exh. cat.,
Photographische Sammlung/SK Stiftung Kultur
Cologne 2000, p. 103.

79 Page 87

*Abgeordneter (Member of Parliament, the
Democrat Johannes Scherrer),* 1927

Artist's blind stamp on recto

11 1/4 x 8 5/16 in. (28.6 x 21.1 cm), 98.519

Reproduced in:

150 Jahre Fotografie III, Kunstforum, 16, 1976, p. 302.

Sammlung Gruber: Photographie des 20. Jahrhunderts, Museum Ludwig Cologne 1984, p. 371.

Sander, August. *Antlitz der Zeit. Sechzig Aufnahmen Deutscher Menschen des 20. Jahrhunderts von August Sander,* (Reprint of the published book by Kurt Wolff 1929), Munich 1976, p. 42.

August Sander, New York 1977, p. 29.

August Sander 1876–1964, exh. cat., La Fundación caja des Pensiones Madrid 1986, p. 107.

August Sander: In der Photographie gibt es keine ungeklärten Schatten!, exh. cat., August Sander Archive/Stiftung City-Treff Cologne 1994/95, p. 123.

August Sander: Menschen ohne Maske, Lucerne and Frankfurt/Main 1971, plate 119.

August Sander: Photographs of an Epoch. 1904–1959, exh. cat., New York 1980, p. 67.

August Sander: Siebzig Fotografien aus dem J. Paul Getty Museum, exh. cat., Stiftung Bahnhof Rolandseck 1988, n.p.

Sander, Gunther (ed.), *August Sander,* Leipzig 1982, p. 85.

Sander, Gunther (ed.), *August Sander: Menschen des 20. Jahrhunderts. Portraitphotographien 1928–1952,* Munich 1980, p. 27.

80 Page 33
Westerwälder Bauernmädchen (Farm Girls from Westerwald), 1927
Artist's blind stamp on recto; titled on verso
9 x 6 1/2 in. (22.9 x 16.5 cm), 98.548

81 Page 33
Wandernde Zimmerleute (Itinerant Carpenters), Hamburg, 1928
Artist's blind stamp on recto; signed and dated on recto of mount
9 x 6 1/4 in. (22.9 x 15.9 cm), 98.553

Reproduced in:
Sander, Gunther (ed.), *August Sander: Menschen des 20. Jahrhunderts. Portraitphotographien 1928–1952,* Munich 1980, p. 103.

82 Page 111
Das Siebengebirge: Blick vom Rolandsbogen (Siebengebirge: View from Rolandsbogen, Germany), 1929/30
Artist's blind stamp on recto
9 1/8 x 11 9/16 in. (23.2 x 28.9 cm), 98.536

Reproduced in:
August Sander: In der Photographie gibt es keine ungeklärten Schatten!, exh. cat., August Sander Archive/Stiftung City-Treff Cologne 1994/95, p. 201.

August Sander: Landschaften, exh. cat., Munich 1999, p. 10 and plate 2.

August Sander: Photographs of an Epoch. 1904–1959, exh. cat., New York 1980, p. 90.

August Sander: Rheinlandschaften. Photographien 1929–1946, Munich 1981, plate 5.

83 Page 37
Kölner Arbeiterfamilie verzehrt ihr Abendessen "Quellmann und Hering" (A Worker Family in Cologne at Dinner, "Jacket Potatoes and Herring"), 1930s
Artist's blind stamp on recto; typed note (probably for press information) fixed on recto; titled on verso;
6 1/4 x 7 5/8 in. (15.9 x 19.8 cm), 98.544

84 Page 109
Puderbach, Westerwald, Germany, 1930s
Signed, numbered (36) and titled on recto; titled on verso
6 1/4 x 8 1/2 in. (15.9 x 21.6 cm), 98.528

85 Page 103
Puderbach, Westerwald, Germany, 1930s
Signed, numbered (49) and titled on recto
6 1/4 x 8 1/16 in. (15.9 x 20.5 cm), 98.526

86 Page 102
Puderbach, Westerwald, Germany, 1930s
Artist's blind stamp, signed, numbered and titled on recto; titled on verso
6 3/4 x 9 1/8 in. (17.2 x 23.2 cm), 98.527

87 Page 102
Puderbach, Westerwald, Kirche in Niederwambach (Church at Niederwambach, Germany), 1930s
Signed, numbered (42), titled and artist's blind stamp on recto; titled on verso
6 1/4 x 9 1/16 in. (15.9 x 23 cm), 98.529

88 Page 109
Puderbach, Westerwald, Ruine Reichenstein (Ruins of Reichenstein, Germany), 1930s
Signed, numbered (41), titled and artist's blind stamp on recto; titled on negative; titled on verso
6 1/2 x 9 in. (16.5 x 22.9 cm), 98.530

89 Page 104
Puderbach, Westerwald, Ruine Reichenstein (Ruins of Reichenstein, Germany), 1930s
Signed, numbered (46), titled and artist's blind stamp on recto; titled on verso
4 5/8 x 6 3/4 in. (11.8 x 17.2 cm), 98.534

90 Page 104

Puderbach, Westerwald, Straße nach Reichen-stein (Road to Reichenstein, Germany), 1930s
Signed, numbered (45), titled and artist's blind
stamp on recto; titled on verso
4 11/16 x 6 3/4 in. (11.9 x 17.2 cm), 98.533

91 Page 103

*Der Westerwald, Frühlingslandschaft (Spring
Landscape, Germany),* 1930s
Signed, numbered (62) and artist's blind stamp
on recto; titled on verso
5 7/8 x 8 1/16 in. (14.9 x 20.5 cm), 98.531

92 Page 108

*Der Westerwald, Straße vom Wiedbachtal nach
Neitersen (Road from Wiedbachtal to
Neitersen, Germany),* 1930s
Signed, dated, numbered, inscribed and artist's
blind stamp on recto; inscribed and copyright
stamp on verso
6 13/16 x 9 3/16 in. (17.3 x 23.3 cm), 98.525

93 Page 108

*Der Westerwald, Wiedbachtal, alte Ölmühle
(Old Oil Mill, Germany),* 1930s
Signed, numbered, titled and artist's blind stamp
on recto; inscribed and copyright stamp on verso
6 3/8 x 8 15/16 in. (16.2 x 22.7 cm), 98.532

JÖRG SASSE

94 Page 64

Hamburg, 1992
C-print
Ed. 4/25
Signed, dated, numbered and titled on verso
10 15/16 x 14 7/8 in. (27.8 x 37.8 cm),
98.560

KARL HUGO SCHMÖLZ

95 Page 44

Untitled (Thread), n.d. (1940–50s)
Signed and photographer's stamp on verso
8 7/8 x 6 13/16 in. (22.5 x 17.3 cm), 98.561

96 Page 73

*Köln, Dom und Trümmer (Cologne, Cathedral
and Ruins),* c. 1945
Signed and photographer's stamp on verso
7 3/4 x 6 3/8 in. (18.9 x 16.2 cm), 98.566

Reproduced in:
(Similar): *Photographie des 20. Jahrhunderts,*
Museum Ludwig Cologne 1996, p. 601.

97 Page 40

*Pesch-Passage, Köln (Entrance to Pesch-Store,
Cologne, Germany),* c. 1957
Signed and photographer's stamp on verso
9 1/16 x 7 3/4 in. (15.4 x 19.7 cm), 98.565

98 Page 55

*St. Alban, Köln (Church of St. Alban, Cologne,
Germany),* 1957
Signed and photographer's stamp on verso
9 x 6 3/4 in. (22.9 x 17.2 cm), 98.568

Reproduced in:
(Variation): *Photographie des 20. Jahrhunderts,*
Museum Ludwig Cologne 1996, p. 602.

ADOLF SCHNEEBERGER

99 Page 62

Filmspulen (Film Spools), 1931
Photographer's stamp on verso
10 1/8 x 9 1/2 in. (25.7 x 24.1 cm), 98.570

Reproduced in:
(Variation) Dufek, Antonin, *Adolf Schneeberger,*
Prague 1983, plate 61.

(Variation) *Photography in modern Europe,*
The St. Louis Art Museum Spring Bulletin,
(St. Louis, Missouri 1996), p. 55.

LOTTE STAM-BEESE

100 Page 59

*Papierübung aus dem Vorkurs Josef Albers
(Paper Construction for Josef Albers "Prelimi-
nary Course," Bauhaus, Dessau, Germany),* 1927
Signed, dated and inscribed on verso
4 3/8 x 3 1/16 in. (11.1 x 7.8 cm), 98.575

Reproduced in:
Bauhaus Photographie, Düsseldorf 1982, p. 192
and plate 92.

ANTON STANKOWSKI

101 Page 60

Erbsen (Peas), 1928
Photogram
Ed. of 3
Signed, dated and numbered on verso
7 x 9 1/2 in. (17.8 x 24.1 cm), 98.574

Reproduced in:
(Similar) *Anton Stankowski: Fotografie,*
exh. cat., Graphische Sammlung, Staatsgalerie
Stuttgart 1992, p. 63 and plate 44.

UMBO (OTTO UMBEHR)

102 Page 96

Menjou en gros (Six Dummies), 1928,
printed 1979
Ed. 40/50

Dated and numbered on verso of mount; signed
in the negative
6 5/16 x 7 7/8 in. (16 x 20 cm), 99.100

Reproduced in:
Gebrauchsgrafik, International Advertising Art,
7, July 1930, p. 44.

Das Illustrierte Blatt, 24, 15 June 1929, p. 682.

Molderings, Herbert, *Umbo. Otto Umbehr.*
1902–1908, Düsseldorf 1996, plate 83.

Umbo: Photographien 1925–1933, exh. cat.,
Spectrum Photogalerie im Kunstmuseum
Hanover 1979, p. 66 and plate 24.

UNKNOWN

103 Page 126
Untitled (Macaroni Negative Print, Bauhaus,
Dessau, Germany), n.d. (c. 1928)
3 1/16 x 3 1/8 in. (7.8 x 7.9 cm), 98.716

Reproduced in:
Bauhaus Fotografie, Düsseldorf 1982, p. 43.

DR. PAUL WOLFF

104 Page 32
Hitler Jugend (Hitler Youth), 1936
Photographer's stamp with order number on
verso
9 3/8 x 7 in. (23.8 x 17.8 cm), 98.613

105 Page 76
Warten auf die Olympischen Spiele in Berlin,
Olympiastadion (Waiting for the Olympic Games
in Berlin, Olympic Stadium), 1936
Photographer's stamp with order number on
verso
9 7/16 x 7 in. (24 x 17.8 cm), 98.630

Reproduced in:
(Similar) Wolff, Dr. Paul, *Was ich bei den*
Olympischen Spielen 1936 sah, Berlin 1936,
plate 5.

106 Page 86
Bergführer in den Dolomiten (Mountain Guide
in the Dolomites), 1936
Photographer's stamp with order number on
verso
9 1/4 x 6 1/4 in. (23.5 x 15.9 cm), 98.621

107 Page 33
Abendgespräch Zuhause (Conversation in the
Evening at Home), 1937
Photographer's stamp with order number on
verso
7 x 9 1/4 in. (17.8 x 23.5 cm), 98.629

108 Page 62
Conerci (Spools), 1937
Inscribed and photographer's stamp with order
number on verso
6 1/2 x 9 3/8 in. (16.5 x 23.8 cm), 98.606

109 Page 34
Ferienfreuden, handfeste Taue (Enjoying the
Holidays, Strong Ropes), 1937
Photographer's stamp with order number on
verso
9 x 6 1/2 in. (22.9 x 16.5 cm), 98.622

110 Page 59
Textilindustrie: Spinnerei, Kreuzspulen ver-
schiedener Art (Textile Factory: Spinning Mill,
Different Kinds of Cross Spools), 1937
Photographer's stamp with order number and
titled with typewriter on sticker on verso
9 1/2 x 6 5/8 in. (24.1 x 16.8 cm), 98.608

111 Page 36
Jungsport (Physical Education for the Young),
1938
Photographer's stamp with order number on
verso
9 7/16 x 7 1/8 in. (24 x 18.1 cm), 98.612

112 Page 35
Badeurlaub am Nordseestrand (Holidays at the
Seaside at North Sea Beach, Germany), 1939
Photographer's stamp with order number on
verso
9 1/2 x 6 3/4 in. (24.1 x 17.2 cm), 98.624

Reproduced in:
(Similar) Wolff, Dr. Paul, *Sonne über See und*
Strand. Ferienfahrten mit der Leica, Frankfurt/
Main 1936, plate 55.

113 Page 48
Die neue Rheinbrücke bei Duisburg (New Bridge
over the Rhine River at Duisburg, Germany),
1939
Photographer's stamp with order number and
titled with typewriter on sticker on verso
9 1/2 x 6 13/16 in. (24.1 x 17.3 cm), 98.599

114 Page 58
Textilfabrik, Spulen (Textile Factory, Spools),
1943
Photographer's stamp with order number and
titled with typewriter on sticker on verso
9 1/8 x 7 in. (23.2 x 17.8 cm), 98.615

Reproduced in:
(Similar) Ehrhardt, Paul G., *Zellwolle. Vom*
Wunder ihres Werdens, with photographs by
Dr. Paul Wolff, Frankfurt/Main 1938, plate 46.

WOLS (ALFRED OTTO WOLFGANG SCHULZE)

115 Page 77
Untitled (Clochards in Paris), n.d.
(c. 1932–1942), printed 1976 by Georg Heusch
4 15/16 x 7 3/8 in. (12.5 x 18.7 cm), 98.640

Reproduced in:
Glozer, Laszlo, *Wols. Photograph,* Kestner-
Gesellschaft Hanover, cat. 3, Munich 1978,
plate 13.

116 Page 133
Untitled (Composition on Newspaper), n.d.
(c. 1932–1942), printed 1976 by Georg Heusch
6 1/4 x 6 1/2 in. (15.9 x 16.5 cm), 98.697

117 Page 40
Untitled (Hand and Coins), n.d.
(c. 1932–1942), printed 1976 by Georg Heusch
6 x 8 1/4 in. (15.2 x 21 cm), 98.681

Reproduced in:
(Similar) Glozer, Laszlo, *Wols. Photograph,*
Kestner-Gesellschaft Hanover, cat. 3, Munich
1978, p. 64.

118 Page 93
Untitled (Portrait), n.d. (c. 1932–1942),
printed 1976 by Georg Heusch
6 1/2 x 6 3/4 in. (16.5 x 17.2 cm), 98.633

119 Page 91
Untitled (Portrait of Nicole Boubant), n.d.
(c. 1932–1942), printed 1976 by Georg Heusch
6 5/16 x 6 1/16 in. (16 x 15.4 cm), 98.668

120 Page 41
Untitled (Radio Parts on a Mirror), n.d.
(c. 1932–1942), printed 1976 by Georg Heusch
7 3/4 x 5 1/4 in. (19.7 x 13.3 cm), 98.648

Reproduced in:
Glozer, Laszlo, *Wols. Photograph,* Kestner-
Gesellschaft Hanover, cat. 3, Munich 1978, p. 91.

121 Page 106
Untitled (Walkway with Pylons), n.d.
(c. 1932–1942), printed 1976 by Georg Heusch
6 7/16 x 5 7/8 in. (16.4 x 14.9 cm), 98.652

122 Page 97
Untitled (Portrait of Sabine Hettner), c. 1935,
printed 1976 by Georg Heusch
6 1/4 x 6 3/4 in. (15.9 x 17.2 cm), 98.683

Reproduced in:
*Sammlung Gruber: Photographie des 20.
Jahrhunderts,* Museum Ludwig Cologne 1984,
p. 415.

Wols: Photographien Aquarelle Druckgraphik,
exh. cat., Fundació Joan Miró with Goethe
Institut Barcelona and Institut für Auslands-
beziehungen Stuttgart 1991, p. 40 and plate 9.

123 Page 77
*Untitled (Décollage, Advertising on Wall,
Paris),* n.d. (c. 1938), printed 1976
by Georg Heusch
6 5/8 x 6 5/8 in. (16.8 x 16.8 cm), 98.689

Reproduced in:
Glozer, Laszlo, *Wols. Photograph,* Kestner-
Gesellschaft Hanover, cat. 3, Munich 1978,
plate 26.

Wols. De Schilder als Fotograaf, exh. cat.,
Gemeentemuseum The Hague 1999, p. 19 and
plate 22.

Wols: Photographien Aquarelle Druckgraphik,
exh. cat., Fundació Joan Miró with Goethe
Institut Barcelona and Institut für Auslands-
beziehungen Stuttgart 1991, p. 44 and
plate 13.

124 Page 92
Untitled (Portrait of Sonia Mossé), n.d.
(c. 1938), printed 1976 by Georg Heusch
6 1/4 x 6 1/2 in. (15.9 x 16.5 cm), 98.663

Reproduced in:
Glozer, Laszlo, *Wols. Photograph,* Kestner-
Gesellschaft Hanover, cat. 3, Munich 1978,
plate 13.

125 Page 107
*Untitled (Probably Montparnasse Cemetery in
Paris),* n.d. (c. 1938), printed 1976 by Georg
Heusch
8 3/8 x 6 3/8 in. (21.3 x 16.2 cm), 98.671

Reproduced in:
Wols als Photograph, exh. cat., Von der Heydt-
Museum Wuppertal 1978, plate 45.

Wols: Photographien Aquarelle Druckgraphik,
exh. cat., Fundació Joan Miró with Goethe
Institut Barcelona and Institut für Auslands-
beziehungen Stuttgart 1991, p. 35 and plate 4.

126 Page 132
Untitled (Baguette Head), c. 1938/39, printed
1976 by Georg Heusch
6 3/8 x 6 5/16 in. (16.2 x 16 cm), 98.657

Reproduced in:
Glozer, Laszlo, *Wols. Photograph,* Kestner-
Gesellschaft Hanover, cat. 3, Munich 1978, p. 88
and plate 144.

Mehring, Christine, *Wols Photograph,* exh. cat.,
Busch-Reisinger Museum, Harvard University
Art Museums Cambridge, Massachusetts, 1999,
pp. 2, 56.

Wols als Photograph, exh. cat., Von der Heydt-
Museum Wuppertal 1978, plate 80.

127 Page 132
Untitled (Beans), c. 1938/39, printed 1976 by
Georg Heusch
8 9/16 x 6 1/4 in. (21.8 x 15.9 cm), 98.631

Reproduced in:
Glozer, Laszlo, *Wols. Photograph,* Kestner-
Gesellschaft Hanover, cat. 3, Munich 1978,
p. 94, plates 86, 158.

Mehring, Christine, *Wols. Photograph,* exh. cat.,
Busch-Reisinger Museum, Harvard University
Art Museums Cambridge, Massachusetts, 1999,
p. 80.

Wols: Photographien Aquarelle Druckgraphik,
exh. cat., Fundació Joan Miró with Goethe
Institut Barcelona and Institut für Auslands-
beziehungen Stuttgart, 1991, p. 54 and
plate 23.

128 Page 132
Untitled (Slice of Bread), c. 1938/39, printed
1976 by Georg Heusch
6 3/8 x 6 1/2 in. (16.2 x 16.5 cm), 98.680

Reproduced in:
Glozer, Laszlo, *Wols. Photograph,* Kestner-
Gesellschaft Hanover, cat. 3, Munich 1978,
p. 101.

Mehring, Christine, *Wols. Photograph,* exh. cat.,
Busch-Reisinger Museum, Harvard University
Art Museums Cambridge, Massachusetts, 1999,
p. 89.

129 Page 59
Untitled (View in Bucket), c. 1938/39, printed
1976 by Georg Heusch
6 1/4 x 6 1/2 in. (22.2 x 16.5 cm), 98.692

Reproduced in:
Glozer, Laszlo, *Wols. Photograph,* Kestner-
Gesellschaft Hanover, cat. 3, Munich 1978,
p. 11, plates 4, (similar) 91.

Mehring, Christine, *Wols. Photograph,* exh. cat.,
Busch-Reisinger Museum, Harvard University
Art Museums Cambridge, Massachusetts, 1999,
p. 44.

(Similar) *Wols. De Schilder als Fotograaf,* exh.
cat., Gemeentemuseum The Hague 1999, p. 20
and plate 25.

WILLY ZIELKE

130 Page 58
Glasverzerrung I (Glass Distortion I), 1929,
printed 1982
No. 4 from the portfolio *Willy Zielke Photo-
graphie 1929–1935* of twelve photographs, ed.
by Christian Bouqueret, Michèle Chomette and
Willy Zielke, Paris and Berlin, in an edition of
50 (ed. 4/50 + 6 e. a.)
Signed, dated, numbered and titled on verso
9 1/8 x 6 7/8 in. (23.2 x 17.5 cm), 98.705

Reproduced in:
Willy Zielke: Photographien 1923–1937, exh.
cat. on the occasion of 8th Rencontres Interna-
tionales de la Photographie in Arles, Musée
Réattu, Arles 1982, p. 9 and plate 5.

131 Page 139
Osram Glühlampen (Osram Light Bulbs),
c. 1933, printed 1982
No. 7 from the portfolio *Willy Zielke Photo-
graphie 1929–1935* of twelve photographs, ed.
by Christian Bouqueret, Michèle Chomette and
Willy Zielke, Paris and Berlin, in an edition of
50 (ed. 4/50 + 6 e.a.)
Signed, dated, numbered and titled on verso
9 1/8 x 7 in. (23.2 x 17.8 cm), 98.708

Reproduced in:
Willy Zielke: Photographien 1923–1937, exh.
cat. on the occasion of 8th Rencontres Interna-
tionales de la Photographie in Arles, Musée
Réattu, Arles 1982, p. 19.

PIET ZWART

132 Page 54
Factory Chimney, 1931
Photographer's stamp on verso
6 13/16 x 4 15/16 in. (17.3 x 12.5 cm),
98.715

Reproduced in:
Retrospektive Fotografie: Piet Zwart, Düssel-
dorf 1981, plate 42.

Piet Zwart 1885–1977, Monografieën van
Nederlandse fotografen, no. 5, Amsterdam
1996, p. 133.

GERARD A. GOODROW

BERND AND HILLA BECHER
(B. 1931 in Siegen/B. 1934 in Potsdam)

After an apprenticeship as a decorator in Siegen from 1947 to 1950, Bernd Becher studied at the academies of art in Stuttgart (1953–1956) and Düsseldorf (1957–1961), where, in 1959, he began working together with Hildegard Wobeser, whom he would marry two years later in 1961. Hildegard Wobeser began her career as an apprentice photographer in Potsdam (1953–1957) and later, after moving to Düsseldorf in 1957, studied at the Academy of Art in Düsseldorf from 1958 to 1961, where she founded the Department of Photography. Together, Bernd and Hilla Becher developed the concept of a highly objective, systematic topology of workers' housing and industrial buildings. The encyclopedic nature of their photographs on the whole is as rigid as their exclusive focus on architectural structures based on fundamental patterns or designs, including half-timbered houses in industrial regions, mine heads, water towers, blast furnaces, winding towers, etc. Each of these types of structures displays minor variations in details. Whereas the common patterns of the structures are due to their function, the variations between them are frequently based on regional differences. The black and white photos are all shot from a similar perspective and then presented as groups or series. In this sense, they are clearly related to earlier objective photographers in Germany, especially Albert Renger-Patzsch, August Sander and Karl Blossfeldt. Like Blossfeldt's *Urformen* (primary forms), the Bechers' work is based on the principal of *Grundformen* (fundamental forms). From the very beginning, their photographs have been situated between traditional objective photography and Conceptual Art. In 1969, they published their first book, to which they gave the programmatic title *Anonymous Sculptures – A Typology of Technical Buildings.* Their association with the medium of sculpture became apparent with this publication, and they would soon gain the recognition and support of the American Minimalist sculptor Carl Andre, who wrote an article on their photographs in the magazine *Art Forum* in 1972. In 1990, they represented the Federal Republic of Germany at the XLIV Biennale in Venice and received the prize for sculpture. In 1976, Bernd Becher began teaching at the Academy of Art in Düsseldorf, where he soon became the most influential photography professor of his generation, generating a group of young artist-photographers known internationally as the "Becher School." This group includes such prominent personalities as Boris Becker, Andreas Gursky, Candida Höfer, Thomas Ruff and Thomas Struth. Bernd and Hilla Becher live and work in Düsseldorf and Munich.

BORIS BECKER
(B. 1961 in Cologne)

Boris Becker studied with Wolfgang Ramsbott at the College of the Arts in Berlin from 1982 to 1984, and attended the Academy of Art in Düsseldorf from 1984 to 1990, where he was a student of Bernd and Hilla Becher. Although still studying, he already had his first solo exhibition at the Artothek in Cologne in 1991. That same year, he was included in the exhibition "Six Young German Photographers" at the Ileana Sonnabend Gallery in New York. One year later, in 1992, he completed his Master of Fine Arts in the class of Bernd Becher. The following year, he was awarded a working grant from the State of Schleswig-Holstein. In 1996 and 1997, with the assistance of a Villa Massimo grant, Becker worked in Rome on his extensive series of "Fields," large-scale color landscape photographs of details of fields, most of which depict no horizon line. As in his close-up images of architectural details, the "Fields" become nearly abstract, underscoring the artist's intention of directing the viewer's attention away from the motif and toward the formal properties of the photograph. In 1997, he was included in the exhibition "Sous le signe de Renger-Patzsch" at the Musée de l'Elysée in Lausanne and, in 1998, he was honored with the

first comprehensive exhibition of his photographs at the Kunstmuseum in Bonn. Boris Becker lives and works in Cologne, where, in 1996, he was awarded the Chargesheimer Prize for Young Photography.

KARL BLOSSFELDT
(Schielo, Harz 1865–1932 Berlin)

Karl Blossfeldt worked as an apprentice sculptor and molder in an art foundry in Mägdesprung, Harz, from 1881 to 1884. Here, he began taking photographs of plants as patterns for cast iron designs. His talent was soon recognized and he received a grant from the Marktwald Foundation to study drawing, modeling, style and practical music at the School of the Royal Prussian Museum of Applied Arts in Berlin from 1884 to 1889. This was followed by a second grant from the Prussian government for future teachers of natural history from 1890 to 1896. During numerous sojourns and travels to Italy, Greece and Northern Africa with his drawing teacher, Moritz Meurer, he made bronze model reproductions, reliefs and photographs of plants for classroom studies. In 1896, he published his first photograph, which was used as an illustration in a text by Meurer. He continued to publish on a regular basis through 1909. In 1898 he began teaching at the School of Applied Arts, which later became the College of the Visual Arts, in Berlin, where he taught until his death in 1932. For his courses, "Modeling from Living Plants," "Plants in Applied Arts" and others, he established an archive of plates with images of plants, which continued to grow over the years. The scientific nature of Blossfeldt's photographs is underscored by their titles, which include not only the Latin terms of the plants and their German translations, but also precise descriptions of individual details and the number of times they were enlarged. These studies are completely objective, with neither backgrounds nor shadows to disturb the viewer: the image of the plant takes up the whole picture plane. In 1925, the Galerie Neumann-Nierendorf in Berlin acquired the rights to his photos. It was here that he also had his first exhibition of plant photographs. In 1928, he published his first book, *Urformen der Kunst* (Art Forms in Nature) with the Verlag Ernst Wasmuth in Berlin. This book was so popular that Blossfeldt became an overnight success and, as early as one year later, in 1929, a second edition went into print. To this day, *Art Forms in Nature* is considered a paradigm of serial photography. His second book, *Wundergarten der Natur* (Wonder-Garden of Nature), was published by the Verlag für Kunstwissenschaft in 1932, shortly before he died in Berlin.

KATTINA BOTH
(Waltkappel 1905–1985 Kassel)

Although she studied photography, Kattina Both later became a free-lance architect who took photographs as studies for her own working methods and archive. She did not, however, consider herself a professional photographer. Her vision was both innovative and unique. From 1924 to 1928, she studied with László Moholy-Nagy at the Bauhaus. It was here that she was introduced to photography as one of many possible tools at the disposal of architects to be employed to help activate the creative process. Both was active as a photographer for only four years, from 1928 and 1932, and the photographs made during this time were her own personal experiments and never commissioned. Like Florence Henri, who studied at the Bauhaus at the same time, Both's work is characterized by the experimental vision typical of Moholy-Nagy and his students. For Both, photography was an exercise in visual perception. Thus, in all of her photographs, the image or content plays a subservient role to formal and compositional questions. The strong diagonals and unusual perspectives of her photographs of everyday objects, street scenes and shop windows place her within the experimental, avant-garde tradition of contemporaneous female photographers associated with the Bauhaus, including Florence Henri, Lucia Moholy and Lotte Stam-Beese.

HERMANN CLAASEN
(Cologne 1889–1987 Cologne)

Hermann Claasen began making photographs when he was only 14 years old, using an old cigar box that he himself transformed into a simple camera. He worked in his father's textile business until 1929, at the same time being active as an amateur photographer. In 1930, after a brief internship with Willy Otto Zielke, he became a full-time, free-lance photographer. Beginning in 1937, he was head of the master classes of the "Fotografen-Handwerk." As a result of a handicap that affected his ability to walk, he was relieved of serving as a soldier in the Second World War. On May 31, 1942, Claasen lost his entire archives during a bombing raid in Cologne. During and after the war, he photographed the ruins

of his home city, as well as the people in and around Cologne. After 1945, the subject was broadened to include the entire Rhineland. Claasen's images of the city of Cologne in ruins are among the most moving from that period. A selection of these photographs was published in 1947 under the ominous title *Gesang im Feuerofen* (Hymn in the Fiery Furnace) and complemented by an exhibition in a ruined tower of the medieval gate of Cologne titled "Köln – Tragödie einer Stadt" (Cologne – The Tragedy of a City). Claasen's legacy is honored by the Kreissparkasse in Cologne, which awards an annual prize for young photography in his name.

ALFRED EHRHARDT
(Triptis, Thuringia 1901–1984 Hamburg)

Following his studies in music and art, Alfred Ehrhardt studied painting and graphics in Hamburg. From 1927 to 1928, he then attended the Bauhaus in Dessau, where he was a student of Schlemmer, Albers and Kandinsky. It was here that he became interested in the more experimental aspects of photography. Following his studies at the Bauhaus, he worked as a free-lance artist in Hamburg. From 1931 to 1933, he taught "Materialism" at the State School of Applied Art in Hamburg, followed by a two-year sojourn in Asco, Denmark, where he held a seat as Professor at the Danish Academy. From 1935 on, he also worked as an organist in Cuxhaven. It was during this time that he began his studies of nature and landscape photography in Germany. From 1937 to 1941, he published numerous books on his nature studies, including his first book *Das Watt* (1937), as well as *Kurische Nehrung* (1938) and *Island* (1939), and worked free-lance for several magazines. His photographs of beaches and coastlines, sand dunes and the effects of waves on sand gained him widespread acclaim. From 1945 on, he concentrated primarily on the making and producing of documentary nature films, whereby his first documentary film on this topic was released as early as 1937. His films accorded him widespread acclaim both in Germany and abroad. In addition to his experimental landscape photography, Ehrhardt became interested in macroscopic and microscopic photography, and published several books on this topic, including *Kristalle* (Crystals) in 1939 and *Muscheln und Schnecken* (Shells and Snails) in 1941.

ERNST FUHRMANN
(Hamburg 1886–1956 New York)

Although frequently discussed in the literature on photography of the New Objectivity, the poet and philosopher Ernst Fuhrmann was, in fact, not a photographer himself, but rather employed various photographers to take pictures for him. According to Fuhrmann, this "division of labor" between the photographer as technician and the philosopher as "visionary" was not only necessary, but also desirable. From 1919 through 1935, he served as Director of the highly influential Folkwang Verlag in Hagen, one of the most important strongholds for photography of the New Objectivity in Germany. He later taught at the acclaimed Folkwang School in Essen, collecting there, from 1923 to 1930, a body of over 3,000 plates, including some by Albert Renger-Patzsch, who had also worked for the Folkwang Verlag. During his later tenure at the Auriga Verlag in Darmstadt, he expanded his archive of botanical studies and introduced Renger-Patzsch to the world of plants. Fuhrmann's groundbreaking book *Die Pflanze als Lebewesen* (The Plant as a Living Being) was published in Frankfurt am Main in 1930. Whereas Blossfeldt focused primarily on the scientific and decorative aspects of plants, Fuhrmann developed his own brand of "biosophy," whereby plants are regarded not merely as vegetables, but rather as living creatures. He saw in his details of plants parallels to human and animal bodily organs, including the lower lips of flowers and sexual organs, such as the ovaries and the uterus. He also talked about the behavior of plants, or about the notion that some plants have a strong or weak "personality." His botanical studies were frequently enlarged up to ten times to facilitate a more thorough examination of the plant's details and "biological" nature, comparing the joints to the muscles or organs of animals. In addition to these botanical studies, Fuhrmann also published a book in 1923 on the philosophy of the ornament titled *The Meaning of Objects.*

KARL GRILL
(Neustadt, Austria, 1889–1966 Donaueschingen)

Little is known about the photographer Karl Grill. He opened his own photographic studio in Donaueschingen in 1921. His introduction to the world of art photography came when he was commissioned with documenting the Music Festival for Modern Dance in Donaueschingen, where Oskar Schlemmer presented the first public performance of his *Triadisches Ballett* in June 1926. For many years, through the late eight-

ies, Grill's black and white documentary portraits of Daisy Spies and other ballerinas from this and other performances were attributed to Oskar Schlemmer. Although their historical significance lies in their role as documents of Schlemmer's work for the theatre, Grill's photographs are autonomous works of art with a keen attention to detail, lighting and perspective. Karl Grill died in Donaueschingen in 1966. His son Karl carries on the family tradition of having a photographic studio in Donaueschingen and continues to work for the Music Festival.

F.C. GUNDLACH
(B. 1926 in Heinebach, Hessen)

Professor F. C. Gundlach studied at the Photography School of Rolf Nehrdich in Kassel before working as an assistant for various commercial and fashion photographers in Stuttgart and Paris. From 1952, he worked as a freelance photojournalist for film and women's magazines, first in Stuttgart and then, from 1956, in Hamburg, where he concentrated on fashion photography. His images of high fashion from the fifties and sixties were instrumental in changing the image of those decades in Germany. In the seventies, he shifted his focus from taking photographs to collecting them and soon became one of the most obsessive collectors of the history of photography throughout Europe. In 1993, he founded an agency for professional photographers and began assembling an extensive collection on the history of photography. In 1985, he was honored with a comprehensive exhibition and catalogue of his own fashion photography in Bonn and Berlin. From 1986 to 1991, he held a chair as Professor at the College of the Arts in Berlin. In addition to this broad range of activities, he also owned and ran a private gallery for photography in Hamburg and worked as a curator of numerous exhibitions of works from his own and other collections. The core of his collection revolves around the human figure in, as he has stated on numerous occasions, "all [its] transience and fragility." His dedication to young art photographers in Germany and abroad is unparalleled. His most recent exhibition of works by young artists, "Emotions & Relations", was held at the Kunsthalle in Hamburg 1998 and included works by members of the so-called "Boston Group" of the eighties and nineties, especially Nan Goldin, Mark Morrisroe and Jack Pierson. F. C. Gundlach lives in Hamburg.

CANDIDA HÖFER
(B. 1944 in Eberswalde)

From 1963 to 1964, Candida Höfer completed an internship in the photographic studio of Karl Hugo Schmölz and Walde Huth in Cologne. She then studied photography, from 1964 to 1968 at the Cologne "Werkschule" with Arno Jansen. After her graduation from the "Werkschule," she worked from 1968 to 1970 in the photo studio of Werner Bokelberg in Hamburg. By 1970, she was already an established photographer, and had published her pictures in the German magazine *Interfunktionen*. In 1975, she exhibited her works for the first time in the Konrad Fischer Galerie in Düsseldorf. As a student at the Academy of Art in Düsseldorf, first trying her hand at documentary film in the class of Ole John from 1973 to 1976, she then intensified her skills in art photography in the class of Bernd Becher from 1976 to 1982. Since, however, she was older than her fellow students and had already begun her career as a photographer before coming to the academy, she is probably the most autonomous of all the so-called Becher students. Höfer's small-scale color photography features interiors of public architecture, including museums, institutions, libraries, churches and, since the early nineties, zoological gardens. Although each of these public spaces can be characterized as a meeting place or living space, the inhabitants are rarely, if ever, present; that is to say, Höfer's interiors are unpopulated, leaving the viewer with merely traces of human intervention. It is the function of the building that lies at the core of Höfer's photography, not the building itself. For this reason, she chooses to portray more than anything else the interiors of public spaces in favor of their facades. Each photograph maintains its autonomy regardless of the series to which it belongs. Each space receives its own special treatment with regard to the standpoint of the camera, perspective, balance, details and lighting. Thus, unlike the Bechers, whose photographs point out the similarities between various types of industrial architecture, Höfer focuses on the uniqueness of each public space. Since 1997, she holds a chair as Professor for Photography at the State College of Design in Karlsruhe. Candida Höfer lives and works in Cologne.

LOTTE JACOBI
(Thorn, West Prussia 1896–1990 Concorde,
New Hampshire)

Although her first passion was film, Lotte (Johanna Alexandra) Jacobi began as early as 1908 to experiment with a simple, hand-made camera. Her father maintained a photographic studio in Berlin and her great-grandfather had earned his living by making Daguerreotypes. From 1914 to 1916, she attended courses in art history and literature at an academy in Posen, and studied photographic and film technique from 1925 to 1927 at the Bavarian State Academy of Photography in Munich. At the same time, she continued her studies of art history at the university there. In addition to her formal studies, she also worked for a brief period in the studio of John Heartfield in 1929. Jacobi soon became a much sought after photographer for theatre, dance and portraits, especially for the numerous illustrated magazines so popular in the Weimar Republic. In 1929, for example, her famous portrait of the artist Käthe Kollwitz graced the cover of the first issue of the feminist magazine *Die schaffende Frau* (The Creative Woman). Other sitters included the dancers Niura Norskaya and Claire Bauroff, as well as the singer and actress Lotte Lenya. From 1927 to 1935, she worked freelance in her father's studio in Berlin. After the death of her father in 1935, Lotte Jacobi sold her photographic studio in Berlin to the industrial and commercial photographer Hein Gorny and immigrated to New York. Here, as well, she specialized in portraits of intellectuals and celebrities, including Albert Einstein, Thomas Mann, Eleanor Roosevelt, Alfred Stieglitz and J. D. Salinger. In addition to her commissioned work, she also learned technique of the photogram in 1946 and, in the fifties, she began experimenting with abstract photography. Her "Luminograms," camera-less and object-less photographs, depicted nothing more than the interaction of light with light-sensitive paper. In 1955, she moved to Manchester, New Hampshire, where she founded the Currier Gallery of Art and taught at the University of New Hampshire in Durham. Her photographs were included in the legendary exhibition "Abstraction in Photography" at the Museum of Modern Art in New York in 1951. She was honored with her first retrospective in 1973 at the Folkwang Museum in Essen, organized by Otto Steinert.

PETER KEETMAN
(B. 1916 in Wuppertal-Elberfeld)

Peter Keetman's father was a passionate amateur photographer and enrolled his son, without his knowledge, in the Bavarian State Academy of Photography in Munich, where he studied with Hans Schreiner from 1935 to 1937. From 1937 to 1939 he worked as an apprentice with Gertrud Hesse in Duisburg. Immediately after this, from 1939 to 1940, he worked in the studio of the industrial photographer Carl-Heinz Schmeck in Aachen. He served for a brief period in the Second World War, after which, from 1947 to 1948, he returned to the academy in Munich to complete his master's degree. In 1948, he met Adolf Lazi, who had just opened his new private school for photography in Stuttgart. Through Lazi, Keetman came into contact with a group of photographers in southern Germany involved in what was later to become known as Subjective Photography. Although he had worked as an industrial photographer before the war, he would soon embrace the new artistic photography and, in 1949, was a founding member of the *fotoforum* group in Stuttgart. Together with the other members of the group, Toni Schneiders, Wolfgang Reisewitz, Ludwig Windstoßer, Siegfried Lauterwasser and Heinz Hajek-Halke, he exhibited his work at the "Photo- und Film-Ausstellung" in Cologne in 1950. Since 1952, to supplement his artistic work, he worked as an independent industrial and commercial photographer and, in co-operation with graphic artists, he designed product packaging and advertisements. In April 1953, he traveled to Wolfsburg on his own initiative and, without an official commission, shot a series of photographs documenting the work in the automobile factory there. These were later published in a book titled *Eine Woche im Volkswagenwerk* (One Week in the Volkswagen Factory). In the early sixties, he began experimenting with "industrial abstraction," for which, for example, he arranged rows of pins into abstract compositions, or photographed construction sights as all-over abstract compositions, or details of tools, such as his famous detail of the screw-pump. Other examples of his images are drops of oil, snow-covered plants, cell forms or filigree spiral drawings, as well as close-up details of plants and automobiles, transforming the objects into pure forms. Keetman has been a member of the German Photographic Society (DGPh) since 1951. In 1969, he was named an honorary member of the newly founded Association of freelance Photo-Designers, and in 1981 he was awarded the David Octavius Hill Medal by the Society of German Photographers (GDL) and named an honorary member. Peter Keetman lives and works in Marquartstein.

ANDRE KERTESZ
(Budapest 1894–1985 New York)

As a child, André Kertész supposedly found a handbook on photography in his attic and decided then and there to become a photographer. After his father died, however, he moved into his foster parents' home and studied at the Academy of Commerce and later worked, like his foster father, at the Budapest stock exchange. In 1912, he purchased his first camera, an Ica 4.5 x 6 cm, and began making photographs of street scenes in Budapest. In 1914, he served in the Austro-Hungarian army and, during the First World War, was stationed in Central Europe and the Balkans. One year later, he began working as a photographer. In 1918, his complete archive of negatives was destroyed and he went back to work at the stock exchange. In 1922, he was granted an honorary degree in photography from the Hungarian Photographic Society and moved to Paris that same year, selling his prints for 25 French Francs to earn a meager living. He soon began working for numerous illustrated magazines, especially *VU* (1928–1935) and *Art et Médecine* (1930–1936). It was also during this time that he started work on his highly acclaimed "Distortions" of mainly female nudes with the help of a mirror, thus breaking away from the documentary nature of photography. He was associated with the Surrealists in Paris, and was a close friend of Piet Mondrian. After meeting the artist in early 1926, his work became more formalist, with greater emphasis on geometric structure. In 1927, he had his first solo exhibition in the gallery "Au Sacre du Printemps" and, one year later, met Brassaï, whom he would then introduce to photography. Kertész is, however, perhaps best known for his special understanding of human nature, focusing on the "how" and "where" of people's lives. He was an innovator in the use of the Leica 35mm camera, which gave him the flexibility and immediacy that he needed for his work. In 1929, he participated in the legendary "Internationale Ausstellung des Werkbundes 'Film und Foto'" in Stuttgart. He immigrated to the United States in 1936, again losing more than half his archives. In New York, he worked first as a freelance photographer and then went under contract for one year with Keystone Studios. In 1949, he received an exclusive contract with Condé Nast Publications in New York, where he remained until 1962, when, after a severe illness, he resumed working freelance. He received an honorary doctorate from the Royal College of Art and was a member of the French Legion of Honor. In 1984, he donated his entire archive of negatives to the French Ministry of Culture.

WILLY KESSELS
(Dendermode 1898–1974 Brussels)

Little is known about the Belgian photographer Willy Kessels except that he worked primarily in Brussels from the thirties through the fifties. His motifs ranged from still life images of pralines, glasses and bottles of medicine to plant and insect studies, as well as train station workers and female nudes, often photographed from the rear and with their heads cropped and their contours highlighted by a dramatic play of shadows. The still life photographs of bottles of medicine were made in the mid-thirties for advertisements for the pharmaceutical industry. During this time, he was also associated with the Belgian Surrealist movement and made portraits of, among others, the artist Henry van de Velde, as well as photographs of works of art, including the sculptures of Archipenko. He began experimenting with abstract photographic compositions, photograms, photomontages, multiple exposures and negative imagery at the same time.

JÜRGEN KLAUKE
(B. 1943 in Kliding/Cochem)

Jürgen Klauke moved to Cologne in 1964 to study graphics at the College of Art and Design and later taught there from 1970 to 1975. From 1980 to 1986, he held various chairs as guest professor at the academies of art in Hamburg, Munich and Kassel. In 1988, he was named Professor for Art and Photography at the University in Essen, a position he held through 1994, after which he accepted a professorship at the new Academy of Media Arts in Cologne, where he is still active today. Klauke began his artistic career with drawings, and turned to photography in 1970. From the very beginning, he focused primarily on socially critical self-portraits, creating performances exclusively for the camera. In 1971, he published the book *Ich & Ich – Tageszeichnungen und Fotosequenzen* (I & I – Daily Drawings and Photo Sequences). In 1973, he was given his first one-person exhibition at the Rheinisches Landesmuseum in Bonn. Klauke refused to follow the analytical and systematic mode so typical of German photography in the late sixties. Deliberately provocative, his peculiar self-portrait photographs represent a biting critique of bourgeois Catholic society in Germany. His topics range from sexuality and androgyny to questions of identity and the abuse of authority. In most cases, humor and irony serve to soften the impact of the artist's confrontation with these and other existential questions. In 1977, he participated in the

"documenta 6" exhibition In Kassel and, ten years later, in "documenta 8." In the late seventies and early eighties, when the rest of the German art world was turning toward a new form of painterly expressionism, Klauke became introspective, contemplative and reserved. His large series of works made between 1980 and 1982 under the title "Formalisierung der Langeweile" (Formalization of Boredom) accorded him international acclaim. Ten years later, on the occasion of his large-scale exhibition at the Kunsthalle in Baden-Baden in 1992, Klauke began a new series of works under the title "Sonntagsneurosen" (Sunday Neuroses). Here, the artist addresses some of the greatest themes of humanity, including love, death, interpersonal relationships, sexual drive and cultural identity. Jürgen Klauke lives and works in Cologne.

UTE LINDNER
(B. 1968 in Arnsberg)

From 1990 to 1995, Ute Lindner studied art in the classes of Gerhard Merz, Floris M. Neusüss and Urs Lüthi at the University in Kassel. During this time, she spent one year on a study sojourn in Berlin, and worked as an intern in 1992–1993 at the Institute of Contemporary Arts in London. In 1993, while still a student at the university, she was included in the influential exhibition "Deutsche Kunst mit Photographie – Die 90er Jahre" (German Art with Photography – The Nineties), organized by the Deutsche Fototage in Frankfurt am Main. In 1995, she was awarded a work grant from the State of Lower Saxony, followed in 1996 by various grants and awards, including a studio grant from the Cité Internationale des Arts in Paris, where she was also honored with a one-woman exhibition titled "Temps de Pose." Here, she experimented with photochemical processes and developed her so-called "Cyanograms," which consist of photo emulsion between two plates of glass. In all of her photographic works, Lindner seeks the interface between painting and photography. Ute Linder lives and works in Berlin.

ROBERT MAPPLETHORPE
(Queens, New York, 1946–1989 New York)

Although he first wanted to become a musician, Robert Mapplethorpe decided instead to study painting, sculpture and commercial design at the Pratt Institute in Brooklyn. During his studies there, from 1963 to 1969, he also worked on several underground films. In 1968 he met the singer Patti Smith and, one year later, moved with her into the legendary Chelsea Hotel. Mapplethorpe was introduced to photography by his friend, John McEndry, then Curator of Prints and Photography at the Metropolitan Museum of Art. To begin with, he collected old photographs by other photographers, which he used to make photo-collages, first with religious themes, and later pornographic images.

In 1972, he met the teacher and collector Sam Wagstaff and started making his own photographs with a Polaroid camera. He began working with a large format Polaroid camera in 1973, and was honored with his first solo exhibition, "Polaroids," at the Light Gallery in New York that same year. It was also in 1973 that he met Andy Warhol and Brigid Polk and was introduced to the New York art world. Throughout his turbulent career, Mapplethorpe preferred classical themes and subject matters, including still life, flowers, portraits and nudes. His compositions were always rigid and precise. In 1976, he began using a Hasselblad and produced his first color photographs. That same year he published his photographs in Andy Warhol's magazine *Interview*. By 1977, Mapplethorpe had achieved international acclaim and participated in the "documenta 6" exhibition in Kassel. One year later, he shot the black and white film *still moving/patti smith*. After meeting Lisa Lyon, the first female world champion bodybuilder, in 1980, he made his first portraits of her. Lyon continued to be a favored model and muse for Mapplethrope throughout his career. In 1983, he published *Lady Lisa Lyon*; this was followed one year later by the film *Lisa Lyon*. In 1985, he specialized in making platinum prints, frequently using canvas and silk instead of photographic paper as his support. Throughout the eighties, he also worked as a commercial photographer for *Vanity Fair, Stern, Harper's Bazaar, Geo* and *Elle*. In 1988, he founded the Robert Mapplethorpe Foundation for AIDS research and the support of artistic photography. His first retrospective at the Whitney Museum of American Art that same year became a public and political scandal throughout the United States. Robert Mapplethorpe died as a result of AIDS in 1989 in New York City.

LUCIA MOHOLY
(Karlin/Prague 1894–1989 Zollikon/Zurich)

The photographer, archivist and critic, Lucia Moholy, studied literature, art history and philosophy in Prague from 1910 to 1912, and immigrated to Germany in 1915. From 1916, she worked as an editor for numerous magazines and as a lector for various publishers in Wiesbaden, Leipzig and Berlin. In 1920, she met László Moholy-Nagy, whom she married one year later. Beginning in 1922, she worked closely together with Moholy-Nagy on art theoretical texts and photographic experiments, including the photogram technique. When Moholy-Nagy went to teach at the Bauhaus in Weimar, she studied photography at the School of Applied Arts in Leipzig. During this time, she began making portraits of her friends and colleagues at the Bauhaus, including the architects Martin Gropius and the art historian Franz Roh, who was later active himself as an experimental photographer in the thirties. In 1926, Lucia Moholy documented the rebuilding of the Bauhaus in Dessau and made photographs of various products from the Bauhaus studios. She moved to Berlin with Moholy-Nagy in 1928 and worked together with him there. At the same time, she also worked as a stage photographer for the opera and held a chair as docent at the Johannes Itten Art School. One year later, in 1929, she separated from Moholy-Nagy and, from 1930 to 1932 lived together with the politician Theodor Neubauer. In 1933, after the arrest of Neubauer, she fled to Paris via Vienna and lost her complete archives of negatives in the process. After her divorce from Moholy-Nagy in 1934, she immigrated to London, where she specialized in portrait photography and taught at the London School of Printing and Graphic Arts. In 1939, she published her groundbreaking book on the cultural history of photography *One Hundred Years of Photography*. In 1942, she began making photographs of important cultural heritage, first for the American Council of Learned Societies, and later for the UNESCO. In 1959, she moved to Zollikon near Zurich, where she worked as a journalist and attempted to reconstruct her lost archive. Lucia Moholy was the first at the Bauhaus to master the technical knowledge of photography, and her numerous photographs of architecture, interiors and products made her one of the most outstanding and authentic chroniclers of the Bauhaus before 1928. Lucia Moholy died in Zollikon in 1989.

SIGMAR POLKE
(B. 1941 in Oels, Silesia)

Sigmar Polke fled from Silesia to Thuringia with his family in 1945 and moved to Western Germany via Berlin in 1953, where he settled in Düsseldorf. He studied glass painting there from 1959 to 1960, before entering the State Academy of Art in 1961, where he studied painting in the classes of Gerhard Hoehme and Karl Otto Goetz through 1967. It was here that, in 1966, he began his intensive investigation of photochemical techniques as an extension of his experiments with painting. In 1966, he also had his first one-man exhibition at the Galerie René Block in Berlin. From 1970 to 1971, he held a guest-professorship at the School of Visual Arts in Hamburg, and was later named Professor, teaching there from 1977 to 1991. In 1975, he represented Germany, together with Georg Baselitz and Blinky Palermo, at the XIII Bienal de São Paulo, where he was awarded the prize for painting. In 1977, he had his first exhibition of photographs at the Kunstverein in Kassel, together with projections by his close friend and colleague Achim Duchow. In 1986, he represented Germany at the XLII Biennale di Venezia, where he exhibited his experimental paintings and photographs, which explored photography as an alchemical process. His innovation was honored with the Golden Lion for Painting. Because it is more the process of photography than the finished product that interests the artist, most of Polke's photographs are unique prints that he develops himself. In 1990, he was honored with his first comprehensive retrospective exhibition of his photographic works at the Kunsthalle in Baden-Baden, including examples from nearly three decades of photographic experimentation. It was only after this exhibition that the true significance of his photographic work for his complete oeuvre became apparent to a larger audience. This was followed by a large-scale travelling exhibition organized by the Museum of Contemporary Art in Los Angeles under the programmatic title "When Pictures Vanish" in 1995. That same year, he was awarded the Carnegie Prize in Pittsburgh, Pennsylvania. Sigmar Polke's photographs lie somewhere between photography and painting. The borders between the two seemingly divergent media are blurred, with emphasis placed on the process of picture making beyond the limitations of media, as well as on how pictures are read and interpreted. Although Polke's photographs appear chaotic and coincidental, they are indeed carefully composed and painstakingly made by the artist himself. The seemingly "home-made" character of the unique prints stresses the subjectivity of the medium and brings the "hand of the artist," his style and his signature, so to speak, into play. Sigmar Polke lives and works in Cologne, where he continues to work in all media.

VILEM REICHMANN
(Brno 1908–1991 Brno)

From 1930 to 1945, Vilém Reichmann worked as a self-taught photographer and, under the pseudonym "Jappy," also as a popular cartoonist. During this time, he was a member of numerous leftist cultural organizations and associations, including the *Levá fronta* (Left Front). After the Second World War, he became a free-lance photographer and worked primarily in his home city of Brno. During this time, he participated in numerous Czech and international exhibitions. He also published his photographs in various magazines at the time, including *Revue Fotografie* (1959 and 1962) and *Československá Fotografie* (1963, 1965, 1966 and 1975). It was during the early post-war period that he developed a unique, lyrical surrealist style of metaphoric photography. The influences in his work range from textural abstraction and Arte Povera to absurdist humor and Pop Art. One of Reichmann's most significant contributions to post-war photography, however, was his use of open-ended narrative series, the most important of which is, without a doubt, his stream-of-consciousness cycles "Metamorphoses" (1965) and "Magics" (1975). In 1961, Václav Zykmund published a comprehensive book on Reichmann's cycles under the auspices of the State Publishing House of Literature, Music and Art in Prague. In 1988, he was honored with a large-scale retrospective exhibition at the Galerie hlavního města Prahy in Prague and the Galerie 4 in Cheb. Vilém Reichmann died in 1991 in Brno.

ALBERT RENGER-PATZSCH
(Würzburg 1897–1966 Wamel/Soest)

At the age of only 14, inspired by his father's amateur interest in photography and photographic techniques, Albert Renger-Patzsch was already proficient in the complicated techniques of shooting, developing and printing his own photographs. From 1916 to 1918, he served in the First World War, after which he studied chemistry at the Technical College in Dresden. He broke off his studies in 1921, however, before completing his exams, to dedicate himself fully to photography. He found his first job in the field in 1922 at the Folkwang Verlag in Hagen, where he held the position of head of the picture archive. His primary responsibility there was to photographically document artistic and ethnographic objects from various museums. During this time, however, his main passion was botanical studies. In 1923, he published his first article on this topic in the *German Camera Almanac*. It was in this publication that he established his future stylistic parameters, especially his insistence on sharp, precise imagery, and thus distanced himself from the "artistic" photography so popular at the time. That same year, he married Agnes von Braunschweig and quit his position at the Folkwang Verlag to work for a press photo agency in Berlin, and then as a bookkeeper for a drug store in Kronstadt, Rumania. In 1924, Ernst Fuhrmann, then Director of the Folkwang Verlag, convinced Renger-Patzsch to return to Germany and take up his old position in the company. One year later, however, he began work as a freelance photographer in Bad Harzburg and published his first book of photographs, *Das Chorgestühl von Kappenberg* (The Choir Stalls of Kappenberg). In 1925, perhaps the most decisive year in Renger-Patzsch's career as a photographer, he became a member of the Deutscher Werkbund and had his first exhibition in his own studio and a second one in the Folkwang Verlag in Hagen. He also met Hanns Krenz, then Managing Director of the Kestner-Gesellschaft in Hanover. Krenz showed his photographs to the art historian Carl Georg Heise, who later became a close friend and supporter of the photographer. In 1927, Heise enabled Renger-Patzsch to obtain his first large-scale exhibition in Lübeck. He also helped him to publish *Die Welt ist Schön* (The World is Beautiful) in 1928 and wrote the introduction. This book placed the photographer as the leader of a definitive photographic style called "New Objectivity." During the Second World War, he served for only a brief period as a soldier and soon became a war photojournalist. In 1944, he lost both his apartment and his studio in Essen, as well as a large portion of his negatives in a bombing raid. As a result, he moved to a small farmhouse in the village of Wamel near Soest and began working primarily as an author. After this, he focused gradually on landscapes, architecture, and botanical studies. He also continued making his much acclaimed industrial photographs, although it was not until 1993 that these were duly honored with a comprehensive publication and exhibition at the Museum Ludwig in Cologne.

ALEXANDER RODCHENKO
(St. Petersburg 1891–1956 Moscow)

One of the most versatile artists of the Russian avant-garde, Alexander Rodchenko was a painter, sculptor, photographer, graphic artist, commercial designer and furniture designer. From 1910 to 1914 he studied painting at the Kasan School

of Art with Nikolai Feshin and Georgij Medwedew. It was here that he met Warwara Stepanova, whom he married in 1911. Rodchenko and Stepanova would work together as artists and designers in the service of the Soviet State throughout their entire lives. In 1914, they moved to Moscow and studied graphics at the Stroganov School of Applied Art, where he came into contact with Kasimir Malevich in 1915 and, two years later, with Vladimir Tatlin. After several teaching positions and memberships in official artist unions, he began in the early twenties to design film and photography magazines, especially *Kino-fot* and *Kino-Pravda*. In 1923, he began using the newly invented technique of photomontage for books and posters. It wasn't until 1924, after he felt that the source material for his photomontages was becoming limited, that he started making his own photographs, soon discovering that this was the true medium of his time. That same year, he published his photographs for the first time in the magazine *LEF*, which he founded one year earlier together with Vladimir Majakovsky. These initial photographs focused primarily on portraits of his friends and colleagues, most notably Majakovsky, for whom he illustrated numerous books and designed several stage sets and costumes. Rodchenko and Majakovsky would work time and again in close co-operation until the death of the latter in 1930. By 1926, his photographs had attained such a high level of praise that he was included in the momentous exhibition "10 Years of Soviet Photography." Rodchenko's greatest contribution to photography lies in the introduction of what was to become known as "New Vision," an innovative approach to photography with extreme perspectives and diagonal pictorial horizons to correspond with the "New Age." His photographic portraits, as well as his images of athletes, architectural details and street scenes are characterized by a Constructivist penchant for a rigid geometry of diagonal lines and grids. His photographs of stairs and ladders, especially from around 1930, are among the most well-known images of this kind. In 1928 he purchased a Leica to achieve greater flexibility and mobility when shooting his photographs. That same year he published a manifest-like text titled *Ways of Contemporary Photography*, in which he outlined his goal of achieving a new way of seeing and perceiving the on-coming modern age through unexpected perspectives and a Cubist-Constructivist aesthetic. In 1930, he became one of the founding members of the *October* group, the most important association for photographic and cinematographic art at the time.

LOTTE SANDAU
(dates unknown)

Little is known about the life and work of Lotte Sandau. She was related to the photographer Ernst Sandau and probably worked in the family studio of Vogel & Sandau in Berlin from 1938 to 1944 and later, from 1947 to 1963, in Bonn. She specialized in portrait photography and botanical studies with dramatic lighting. Her work from the twenties is included in the collection of German fashion photographer F. C. Gundlach in Hamburg, and was exhibited in the momentous exhibition "Deutsche Fotografie – Macht eines Mediums 1870–1970" (German Photography – The Power of a Medium 1870–1970) in the Kunst- und Ausstellungshalle der Bundesrepublik Deutschland in Bonn in 1997.

AUGUST SANDER
(Herford an der Heller, Siegerland 1876–1964 Cologne)

The most renowned German photographer of the 20th century, August Sander was an important forerunner of conceptual photography propagated today by Bernd and Hilla Becher and their numerous students. After working for several years in mining, followed by military service, Sander studied painting in Dresden in 1901–1902. From 1902 to 1910, he worked in his own photography and painting studio in Linz, Austria. In 1910, he moved to Cologne, where he founded a new photographic studio. In 1924, he began work on the most important project of his entire oeuvre, *Menschen des 20. Jahrhunderts* (People of the Twentieth Century), an encyclopaedia or atlas of portraits, which was to be the primary focus of his work well into the fifties. His intention here was to record groups of people from different social levels in Germany, from artists and musicians, doctors and aristocrats, to farmers and circus performers. The planned book was not published, however, until 1980, 16 years after his death, by his son Gunther in co-operation with Ulrich Keller. He did, however, publish other books, including *Deutschenspiegel* (German Reflection) and *Antlitz der Zeit* (Faces of the Time), which included sixty portraits. Published in 1929, it is considered to be one of the first "photo books" ever made. Like Albert Renger-Patzsch's *The World is Beautiful, Faces of the Time* is revolutionary in that it presented photographs more as works of art than as mere images. Sander's interest in human typologies can be compared with the scientific investigations of a sociologist. He systematically collected images of human types, the clothing or uniform char-

acterizing the individual as much as the pose of the sitter. The sitter was always placed in the exact center of the image to focus the viewer's attention on the subtle differences between the individuals. Perhaps because of their completely democratic nature, Sander's photographs were censored by the National Socialists, who confiscated the remainder of the books, as well as the plates and clichés and destroyed them. Lesser known are Sander's series of architectural photographs of old Cologne and landscapes, especially of the Rhineland and Westerwald, made between 1933 and 1945. In 1944, his studio and archives were destroyed and Sander moved to Kuchhausen in Westerwald. His photographic legacy was almost completely forgotten until, in 1951, L. Fritz Gruber presented his photographs in an exhibition at the "photokina" in Cologne. As a result, his photos of old Cologne were acquired by the Municipal Museum of Cologne. Today, the August Sander Archives are housed in the cultural foundation of the Stadtsparkasse in Cologne.

JÖRG SASSE
(B. 1962 in Bad Salzuflen)

Jörg Sasse studied in the class of Bernd Becher from 1982 to 1987 at the Academy of Art in Düsseldorf. He later taught there as a docent from 1988 to 1989 and, in 1993, was a guest docent at the Merz Academy in Stuttgart. Like Candida Höfer, a fellow student of Bernd and Hilla Becher, Sasse has continued to maintain his autonomy, borrowing only the cool objectivity of his professors and transforming this into something highly subjective. His details of banal, everyday interiors, shop window decorations and common household objects are characterized by a peculiar, "seventies" aesthetic. Strangely artificial in their brutal reality, his photographs have the immediacy of snapshots, while at the same time being highly structured and composed. The objects and interiors depicted in his photographs are never altered or arranged for the camera. Their uniqueness lies rather in the selection of the particular detail, as well as in their bold coloration and objective point of view. The relationships between the various objects and design elements in his photographs take on an almost Surrealist or Dada tone reminiscent of the strange sculptural objects of Marcel Duchamp and Man Ray. He had his first solo exhibition at the Academy of Art in Düsseldorf in 1987 and, in 1989, was awarded the 1st German Photo-Prize by the Museum for Photography in Braunschweig. In 1992, he was honored with the first comprehensive exhibition of his photographic work at the museum of the

Institut Mathildenhöhe in Darmstadt. Jörg Sasse lives and works in Düsseldorf.

KARL HUGO SCHMÖLZ
(Grafertshofen / Weissenhorn 1917–1986 Lahnstein)

Karl Hugo Schmölz worked from 1932 to 1935 as an apprentice to Arthus Ohler in Stuttgart and, later, with his father, the renowned architectural photographer Hugo Schmölz (1879–1938) in Cologne. In 1937 he became chief photographer in his father's studio, the "Fotowerkstätte Hugo Schmölz," and took over completely after his father died in 1938. In 1939, he became a member of the Society of German Photographers (GDL). Throughout his long career, he produced photographs of buildings by some of the most acclaimed architects in Germany, for example Adolf Abel, Bruno Paul, Dominikus & Gottfried Böhm, Wilhelm Riphahn, Rudolf Schwarz and Hans Schilling. After the defeat of the National Socialists in 1945, he documented the destruction of Cologne with a large-format camera. Like his father's photographic documentation of Cologne in the twenties and thirties, these works were done freelance without an official commission. Unlike Hermann Claasen, who is equally known for his images of Cologne in ruins, Schmölz always remained completely objective and precise, without any of Claasen's sentimentality and nostalgia. In 1948, he finally completed his master's diploma in photography. Since 1950, and especially in the sixties, he worked for advertising agencies. With these commercial works and his freelance photographs of Cologne in ruins, he soon became one of the most important chroniclers of the reconstruction of Germany from an industrial and commercial aspect. During this time, he met and married the Stuttgart photographer Walde Huth and, in 1958, founded a new joint studio called "schmölz + huth." As a result, fashion and portrait photography was included in the repertoire of his studio for the first time, with Schmölz concentrating on furniture photography. Today, his archive contains the best documentation of modern design in Germany, from Interlübke and Eugen Schmidt to Thomé and Draenert. His final commission, granted just before his death in 1986, was to make a detailed documentation of the newly opened Wallraf-Richartz-Museum/Museum Ludwig in Cologne. Although the commission was never completed, his studies are among the most poignant images of the architecture of this world-famous museum and landmark in Cologne.

ADOLF SCHNEEBERGER
(Choceň 1897–1977 Prague)

Adolf Schneeberger is one of the most influential Czech photographers of the twenties. Although expelled from the ČKFA, he subsequently co-founded the *Fotoklub Praha* in 1922, from which he was quickly expelled as well, along with Jaromír Funke and Josef Sudek. In 1924, finally, he co-founded the ČFS, which, similar to the *Fotoklub Praha*, was an association dedicated to straight photography. He served as the President of the ČFS from 1924 through 1929. He was re-admitted to the ČKFA in 1931–1933, and designed the official poster for the annual exhibition in 1931. His artistic photography can be compared with the concurrent "New Objectivity" of his German colleagues, with tendencies towards Constructivism and Functionalism. Although conflict-ridden, Schneeberger was to have a profound influence on the development of avant-garde photography in Prague, and he exhibited regularly with numerous clubs and has since been featured in nearly every survey of Czech photography between the First and Second World Wars. In 1983, Antonín Dufek published the first comprehensive monograph on the acclaimed but controversial photographer, covering the years 1919 through 1948.

LOTTE STAM-BEESE
(Reisicht, Silesia 1903–1988 Krimpen)

Little is known about the photographer Lotte Stam-Beese. She dabbled in photography at the Bauhaus, where she was a student of Josef Albers in the late twenties, and later became an architect. She was married to the Dutch architect Mart Stam, who was a guest docent at the Bauhaus in 1928 and 1929, where he lectured on elementary building theory and city construction. It is assumed that he exerted great influence on Stam-Beese and might have introduced her to architecture. Her material studies of corrugated cardboard, made for a course headed by Albers at the Bauhaus, show a keen attention to detail, the result becoming almost completely abstract. Her other photos of the late twenties, especially her close-up details of portraits, concentrating on the eyes, also display the characteristic Bauhaus aesthetic of unusual perspective and dramatic lighting effects. In addition to her work in portraiture, she also made a number of photographs depicting details of industrial objects, for example light bulbs.

ANTON STANKOWSKI
(Gelsenkirchen 1906–1998 Esslingen)

Anton Stankowski worked as an apprentice church painter from 1921 to 1926, after which he studied with Max Burchartz at the Folkwang School of Design in Essen from 1926 to 1928. There he was introduced to avant-garde photographic techniques. In the late twenties and early thirties, his photographic work was characterized by abstracted, random compositions based on rhythm and movement. He worked as a painter and graphic designer in Zurich from 1929 through 1937, where he was denounced and deported from Switzerland. It was during his time in Zurich that he began experimenting with photography in the form of collages, photomontages and photograms. Photography soon became the primary element in his graphic designs. In 1937, after his deportation from Switzerland, he moved to Stuttgart, where he worked primarily as graphic designer and fought for the equal standing and union of fine and applied art. During this time, he came into contact with the artists Richard Paul Lohse, Carlo Vivarelli and Herbert Matter, each of whom would have a profound effect on his graphic designs. From 1940 to 1945, he served in the Second World War and was taken prisoner from 1945 to 1948, after which he began working as a free-lance graphic and commercial artist once again. At the same time, he pursued painting and, from 1949 to 1951, he also worked as the editor-in-chief of the *Stuttgarter Illustrierte*. From 1962 to 1975, he was the German President of the Alliance Graphique Internationale. In 1964, he taught as a guest docent at the College of Design in Ulm. From 1969 to 1972, he became head of the visual design group for the 20th Olympic Games held in Munich in 1972. In 1976, he was awarded the title of Professor by the State of Baden-Württemberg. In 1978, his work was included in the momentous exhibition "Das experimentelle Photo in Deutschland 1918–1940" (The Experimental Photograph in Germany 1918–1940) at the Galleria del Levante in Munich. He spent the last years of his life painting and not taking photographs.

UMBO
(Düsseldorf 1902–1980 Hanover)

From 1921 to 1923, Otto Maximilian Umbehr, known as UMBO, studied at the Bauhaus in Weimar with Johannes Itten, Walter Gropius, Paul Klee and Wassily Kandinsky. In 1923, he moved to Berlin, where he worked with Walter Ruttmann. From 1926, he worked as a studio portrait pho-

tographer and photojournalist, supported by the painter Paul Citroen (like UMBO, a student of Itten), through whom he was introduced to photography. In 1928, he worked as a photojournalist with Simon Guttman at the "Dephot" (Deutscher Photodienst). At the same time, he held a teaching position at the Johannes Itten Art School in Berlin. He made photomontages for Walter Ruttmann's film *Berlin*, and soon became one of the leading avant-garde photographers in Germany, enjoying international acclaim. From 1933 to 1943, after the Dephot was disbanded by the National Socialists, he worked as a freelance photographer primarily in Berlin. He served as a soldier in the Second World War, during which he lost his complete archives of negatives and prints. After the war, in 1945, he moved to Hanover, where he worked as a photojournalist and commercial photographer. He became the in-house photographer for the Kestner-Gesellschaft in 1948. At the same time, he taught photography in Hanover, Hildesheim and Bad Pyrmont. He began making photograms in the forties and experimented with photomontages from the fifties onwards. It wasn't until the late seventies, however, that his reputation as an avant-garde photographer became fully recognized. In 1978, his works were included in the exhibition "Das experimentelle Photo in Deutschland 1918–1940" (The Experimental Photograph in Germany 1918–1940) at the Galleria del Levante in Munich. In 1996, finally, he was honored in Hanover with a comprehensive retrospective titled "UMBO – From the Bauhaus to Photojournalism."

DR. PAUL WOLFF
(Mühlhausen, Upper Alsace 1887–1951 Frankfurt/Main)

The dentist and self-taught amateur photographer Dr. Paul Wolff came into contact with photography in 1920 and obtained his first Leica as a prize while visiting an exhibition of photography in Frankfurt am Main in 1926. He founded a photographic agency in that city in 1922, specializing in travel and commercial photography, later including industrial photography. In 1931, he became a member of the Society of German Photographers (GDL). A 1933 a Leica advertisement made him an overnight success and he quickly became a star among the German photographers of the period. One year later, in 1934, he published his first book, *My Experiences with the Leica*, which he dedicated to Oskar Barnack, the inventor of the 35mm format. This book was then released in a second color edition in 1948. His botanical studies of the thirties were highly objectified and display similarities to the works of Karl Blossfeldt. From 1935 to 1942, he

published numerous other texts and books on the 35mm format and began providing training courses for photojournalists. During the National Socialist regime in Germany, he made numerous photographs of athletes and Hitler Youths at play, as well as of the Olympic games and stadium in Berlin in 1936. His work in 1943–1944 concentrated primarily on the documentation of site-specific artworks. Then, in 1944, he lost most of his glass plates. Luckily, the smaller negatives were stored elsewhere and were thus saved. These would later, after 1945, form the basis of his new archive, assembled and administered primarily by Alfred Tritschler, with whom he shared a photographic studio in Frankfurt. Wolff is perhaps best known for his urban studies and industrial buildings in large cities, specifically Frankfurt am Main and Manhattan. He later proceeded to experiment with industrial abstractions including extreme perspectives similar to the photographs of Alexander Rodchenko. In 1989, a comprehensive biography and analysis of his photography was published by the Adam Opel AG in Rüsselsheim with the title *Dr. Paul Wolff – Pioneer of 35mm Format*. His influence on amateur photography of the fifties in Germany is unparalleled.

WOLS
(Berlin 1913–1951 Paris)

Alfred Otto Wolfgang Schulze, alias WOLS, was 11 years old when he received his first camera. In 1919, he moved with his family from Berlin to Dresden, here he became friends with Fritz Bienert, Fritz Löffler and Otto Dix. In 1931, he left school and learned photography in the studio of Genja Jonas in Dresden. He spent a brief period in 1932–1933 at the Bauhaus in Weimar, where he studied in the classes of László Moholy-Nagy and Mies van der Rohe. After this, he traveled for the first time to Paris and was soon accepted into the circle of Fernand Léger, Amédée Ozenfant, Joan Miró, Salvador Dalí, Max Ernst, Jean-Paul Sartre and others. In September 1933, he left Germany out of opposition and never returned. He began working as a photographer and went on several sojourns to Spain and the Spanish island of Ibiza. In 1937, receiving a commission as the official photographer of the fashion pavilion at the World Expo in Paris, he adopted the name WOLS. (His name on a telegram addressed to him was accidentally reduced to this abbreviated version.) Subsequently, his photographs of the "Pavillon de l'Elégance" were published under the name WOLS. Known primarily for his portraits, taken from various perspectives, his most moving work was done on the streets of Paris. Loneliness and cold-

ness characterizes most of his photos. When he photographed the streets of Paris, they were empty streets, occasionally including homeless people. His photographs of steep staircases and dirty gratings have an abstract quality as a result of their being taken out of context and presented as pure form. Many of the people he photographed are portrayed with closed eyes, or only portrayed in detail, so that the true personality of the sitter was never fully discernible. The fragmentary nature of his motifs soon became his trademark. In 1939, he spent 14 months in a detention camp, during which time he created hundreds of drawings and watercolors. After this, no other photographs were made. Upon his release from the detention camp, he spent five years, from 1940 to 1945, in the South of France. He had his first solo exhibition in 1946 at the Galerie Drouin in Paris. In 1947, he participated in numerous exhibitions in Paris, New York and Milan. His work as a photographer is characterized primarily by his great interest in coincidence and chance: "Coincidence is a great master, since it is, namely, no coincidence. Coincidence exists only in our eyes. It is a journeyman of the Master, the 'Universe'."

WILLY ZIELKE
(Lodz/Poland 1902–1989 Bad Pyrmont)

After studying railroad engineering in Taschkent, Russia, Willy Otto Zielke immigrated to Munich with his family in 1921, where he studied photography at the Bavarian State School of Photography. From 1928 he held a seat there as "Master Teacher." Among his more famous students were Hubs Flöter, Kurt Julius and Erwin von Dessauer. From 1930 to 1935, he realized numerous films with great success and, at the same time, became one of the most published "object" photographers in Germany. In addition to his commissioned work, Zielke also made a name for himself as a freelance photographer, focusing primarily on nudes. His first film, *Arbeitslos* (Unemployed), was such a success that he was invited to make another one on the occasion of the 100th anniversary of the railway Nuremburg-Fürth, which he titled *Das Stahltier* (The Steel Animal). In 1935, this film was censored by the National Socialists. In 1936, he was then producer for the prologue to Leni Riefenstahl's film *Olympiade*. This was followed by several years in a sanatorium, from which he was released in 1943 to work on Riefenstahl's *Tiefland* (Lowlands) project. After the Second World War, Zielke worked as a translator in Potsdam from 1945 to 1951, and then returned to West Germany to work as an

industrial filmmaker. In his capacity as a filmmaker, he frequently employed the pseudonym Victor Valet. Willy Zielke began experimenting with color photography as early as 1933, and from 1945 to 1947, he taught photography in Düsseldorf. In the fifties, he taught at the BiKla School in Düsseldorf. Upon retirement, he was succeeded by the Cologne photographer Chargesheimer.

PIET ZWART
(Zaandijk/Amsterdam 1885–1977 Leidschendam/ The Hague)

Together with Paul Schuitema and Gerrit Kiljan, Piet Zwart was one of the most important pioneers of "New Photography" in The Netherlands. Initially trained as an architect at the Technical College in Delft and the Rijksschool voor Kunstnijverheid, with a specialization in interiors, he began doing graphic design work in 1921, which eventually lead him to photography. In 1923, he learned about the principles of the photogram from El Lissitsky, who was in The Netherlands at the time. Several years later, he used photograms in an advertising brochure for the Nederlandse Kabelfabriek (NKF) in Delft. In 1928, for the NKF as well, he used photography for the first time. Between 1928 and 1933, he completed numerous designs for this firm, all characterized by playful typographical experiments and the combination of photography and typography so common in the twenties. In 1924, he worked as a draftsman with the architect Jan Wils, one of the founders of the "De Stijl" movement. He taught design in Rotterdam from 1919 to 1933, and in 1931 at the Bauhaus in Berlin. Around 1930, in response to the conservative, pictorial photography that dominated The Netherlands at that time, Zwart and his colleagues made an effort in the spirit of the Bauhaus to establish modern photographic training in art academies. As a result, in 1931, the academy in The Hague started a new training course in the advertising department, focusing on the use of photography. Although he himself used photography exclusively in graphic design, in his articles and lectures Zwart also emphasized the social and scientific significance of the medium. His ideas and those of his colleagues inspired and stimulated the first generation of Dutch documentary photographers. His own photographs after 1927, formerly having often used images by other photographers for his graphic designs, are characterized by their sharpness, their objectivity and their dynamism with regard to camera perspective. In addition to his commissioned work, he also made his own personal experiments in photography,

recording textures and plays of lines, including images of spider webs, drops of water on the branches of trees, as well as close-up details of everyday objects. He was one of the few Dutch artists (along with Jan Kamman, Paul Schuitema, Gerrit Kiljan and Henri Berssenbrugge) to be included in the highly acclaimed "Internationale Ausstellung des Werkbundes 'Film und Foto'" in Stuttgart in 1929, where he exhibited examples of his photo-typographic work.

Catalogue Published by:
Hatje Cantz Verlag
Senefelderstraße 12
73760 Ostfildern-Ruit
Germany

Printed in Germany

ISBN 3-7757-0973-8 (English)
ISBN 3-7757-0970-3 (German)

Distribution in the USA:
D.A.P., Distributed Art Publishers, Inc.
New York, N.Y.

Foreword by:
Dr. Christina Orr-Cahall, Director, Norton
Museum of Art, West Palm Beach, Florida

Catalogue Concept: Susanne Anna,
Baroness Jeane von Oppenheim
Editorial Staff: Ingrid Nina Bell, Natalie Gaida,
Victoria Scheibler
Designer: Christina Hackenschuh
Typesetting: Weying digital, Ostfildern-Ruit
Copy Prints: Friedrich Rosenstiel
Reproduction: C + S Repro, Filderstadt
Printed by: Dr. Cantz'sche Druckerei,
Ostfildern-Ruit

Funded through the generous support of the
Alfred Freiherr von Oppenheim Foundation for
the Advancement of Scholarship and the
Ralph H. and Elizabeth C. Norton Philanthropic
Trust.

Cover illustration: Folkwang-Auriga
Verlag/Ernst Fuhrmann, *Prunus cerasus
(Sour Cherries),* c. 1930 (detail)